Artists in My Life

Artists in My Life

MARGARET RANDALL

New Village Press • New York

Published in the United States by New Village Press
bookorders@newvillagepress.net
www.newvillagepress.org

New Village Press is a public-benefit, nonprofit publisher

Distributed by NYU Press

Publication Date: April 2022

First Edition

Library of Congress Cataloging-in-Publication Data

Names: Randall, Margaret, 1936– author.
Title: Artists in my life / Margaret Randall.
Description: First edition. | New York : New Village Press, 2022. |
Summary: "A collection of intimate and conversational accounts of the
artists that have impacted the poet activist Margaret Randall on her
own creative journey. As makers of art, social commentators, women in
a world dominated by male values, and in solitude or collaboration with
communities, each artist is also seen in the context of the larger artistic
arena. Through her reflections, Randall also takes on questions about
visual art as a whole and its lasting political influence on the world."
—Provided by publisher.
Identifiers: LCCN 2021033785 (print) | LCCN 2021033786 (ebook) |
ISBN 9781613321584 (paperback) | ISBN 9781613321591 (hardcover) |
ISBN 9781613321607 (ebook) | ISBN 9781613321614 (ebook other)
Subjects: LCSH: Artists. Classification: LCC N40 .R36 2022 (print) |
LCC N40 (ebook) | DDC 700.92—dc23
LC record available at https://lccn.loc.gov/2021033785

Cover design: Lynne Elizabeth
Cover image: Elaine de Kooning, "Meg Randall," 1960.
Courtesy of National Museum of Women in the Arts
and Elaine de Kooning Trust.
Interior design & composition: Leigh McLellan Design

This book is for Robert Schweitzer

*This magic at the very root of human existence,
creating a sense of powerlessness and at the same
time a consciousness of power, a fear of nature
together with the ability to control nature,
is the very essence of all art.*
ERNST FISCHER

Sometimes with art it is important just to look.
MARINA ABRAMOVIĆ

Contents

List of Illustrations

CHAPTER 8 The Great Gallery and *Our History Is No Mystery*:
Two Murals Across Time

CHAPTER 9 Gay Block Looks at People and Shows Us
Who They Are

CHAPTER 12 Barbara Byers: Surviving in Art

Foreword

MARY GABRIEL

I remember the first biography I ever read. I even remember where it was in the school library—on the second shelf from the bottom in the far left corner of the room. I was in third grade and already in love with the smell of books and the solemnity of that room where the written word was so precious that you couldn't speak above a whisper. It was a Catholic school, so sacred spaces were familiar. The library seemed to be one of them, its pages brimming with prayers.

The book I chose that day in 1963 was a biography of Mary Todd Lincoln. Though I remember the room and the book and the book's cover—yellow-gold, with reddish print—I have no idea why I wanted to read it. It is certain no one in my house had mentioned her. And I'm fairly sure my third-grade class wasn't studying her. It may have been because, coming as I did from a household of immigrants, her name sounded so profoundly *American* and I thought maybe she would help me learn to be one, too. But now I wonder if, unknowingly, I picked that book over the hundreds of others in the library because it was the story of a woman's life.

There weren't many. Of course, there were the lives of the saints, but as those stories were told then, they seemed more fairy tale than history. There were books about the odd queen—as in the British monarchs, not the more exciting variety—which amounted to still more fairy tales. Probably Amelia Earhart's name graced a book jacket, but I might have been confused by all those vowels, and in any case, I wasn't much of an adventurer. Mary Todd Lincoln would have seemed approachable, solid, someone an eight-year-old girl felt she could learn from and consider a friend.

And I did. I remember enjoying the book immensely. We lived in my grandmother's house, and in my grandfather's room, the closet was filled with books he had read, though I'd never seen him do so. I thought reading must be something one did in secret, and so I would make a tent out of the bedsheets and read underneath them by lamp-light. It was perfect for Mary's story. I was in a pup tent during the Civil War, living Mary's tragic life alongside her. Except that it wasn't Mary's life at all. It was her husband's. She was a full character only when it came time to grieve, but when it was time to act, to make history, it was Abe's story. It didn't bother me particularly, because that was how the world worked. Men lived and women watched and very often suffered the consequences of both.

As I grew older, I continued to read biographies about women—mainly more "wives of" stories because that was what seemed to be available. And then, in 1973, while reading a biography of Zelda Fitzgerald, I recognized that genre of biography for the perversion of history that it was. By then, I was living alone with my mother in a soulless apartment that had a wretched postage stamp–size swim-ming pool carved into a parking lot beside a grocery store's rubbish bins. Drugs were one way to escape it, books another. Combining the two, I took speed and stayed up all night reading about poor brilliant Zelda, who had inspired so many of her husband's books but who ultimately suffered the fate that history showed belonged to women

with a brain who didn't use it: madness. Lightbulb time. I was sick to death of that narrative. I was tired of reading about women twisting and turning and destroying themselves in the shadows of and in service to great men.

Of course, I didn't reach that conclusion in isolation. At around that time, across the United States women's studies departments were born to teach the history of women who *didn't* exist in the orbit of a man, who existed as their own planet. It was exciting to learn about them—the activists, the artists, the medical doctors and scientists, the religious figures who were actual flesh and blood people, the lawyers, the spies—even (maybe especially) the lady scoundrels. None of their stories was easy. All those women had made sacrifices, and many suffered lives of loneliness and despair. But at least they suffered for a reason grander than a man and his ambition. At least they suffered because they had their own goals and dreams and talent and pride and a sense of justice, and they had the courage to act on those feelings. And that meant that others could, too.

Pardon me for stating the obvious, but it came to me as something of a revelation in those days, after finally discovering so many remarkable women, just how important it was to read their stories. As old Karl Marx said, the ruling class (he didn't specifically mention white men, but in his day that was a given) writes the history of its society, which is to say it writes its *own* history, and in so doing minimizes the importance of all others. Through the years, that lopsided tale becomes the accepted truth, and those who are not of the ruling class—women, nonheterosexuals, minorities, indigenous people, the poor—have no story. They are not part of history. And when they are gone, they no longer exist. And yet, they did and do. So, short of a revolution, how are these nonexistent people made whole? Where do we find them as we struggle to free ourselves from conditions that would likewise render us speechless and invisible? The simplest way is to rewrite the story by telling it a new way with a new voice.

It seems that even many of the best autobiographies and biographies are guilty of describing a subject's life the way the ruling class describes history. They can be myopic. The subject of the book is presented as an individual actor, plowing along toward a glorious climax that has brought him or her to the world's attention in the first place. The books describe the markers in that person's life: the births, the deaths, the marriages, the education, the careers, the awards, and the accomplishments. But one's life is not comprised of highlights, no matter how high they might be. Real life is the story of engagements and impacts and connections, near and far. It is a wave, spreading outward, expanding, so that in reality one's own story is actually a collection of many others' stories. Where do I end and you begin? It is impossible to say because we are nourished by interactions—with one another, with nature, with animals, with art, with what or whom we consider God—and all of that becomes part of us. It is us. It has made us who we are. To find the secrets of oneself, therefore, it is necessary to look elsewhere. That is what Margaret Randall has done in her book. She has revealed who she is by introducing us to those who nourished her, by telling their stories. The people she meets impact her physically, spiritually, artistically, and socially and, in the process, inform her life and her work. Margaret has rewritten the story and found a new way to tell it.

It is a thrilling approach to autobiography because it is so embracing and alive. It's like being invited to a banquet peopled with the myriad characters she has met and loved and learned from along the journey she calls her life. She introduces us, the readers, to her greater world while introducing the characters who share this volume to one another. And, with each introduction, with each anecdote as she adds people and places to her narrative, she adds a few more brushstrokes to her self-portrait. We witness the artist being created. And it is a joy to behold. It is also a joy to read. Finally.

I think of all those poor women condemned to history as append-
ages, and all those fascinating lives reduced to mere events on a cal-
endar, when they were acknowledged by history at all, and I imagine
how exhilarating their stories would have been if they had been told
the way Margaret has told hers; if we had read their life stories as acts
of creation, not as faits accomplis. Because isn't that the reason we
read history? So that it impacts and informs us and becomes part of
our story? In reading *Artists in My Life,* we, the readers, become part
of Margaret's expanding universe, and she becomes part of ours. We
get a seat at the banquet. Thank you, Margaret, for having invited us.

Ireland, February 2021

Foreword

ED MCCAUGHAN

A photographer's eye, a poet's voice, a woman's sensibilities, a revolutionary feminist's consciousness, an oral historian's understanding of biography bounded by time and place: Margaret Randall brings all these to this meditation on some of the artists and artworks most meaningful to her life. Some of the artists are Margaret's lifelong friends, some are early mentors, others only known to her through the work they left, one she met in a dream, one she married. Painters, photographers, sculptors, architects, from different countries, environments, and times. Some among the most famous twentieth-century artists, some not well known or largely forgotten, some who painted on canyon walls thousands of years ago, others creating with the latest digital technology.

Margaret finds and allows us to perceive connections among these seemingly disparate art forms, personalities, and eras. She encourages us to rethink Shinkichi Tajiri's sculpture *Made in USA,* created in Minneapolis in 1965, in light of George Floyd's murder and the public art of resistance it generated. In a stunning passage weaving together her

readings of ancient Horseshoe Canyon pictographs, the mysterious Nazca Lines in Peru, Leandro Katz's photography, and a mural in San Francisco, Margaret gives each work deeper meaning.

Whether Margaret is describing an artist's finished work or a landscape that provides its inspiration, the photographer's eye registers the exquisite details of light, color, line, and texture, and the poet finds the precise words to convey these wonders. She has an encyclopedic knowledge, acquired through years of pursuing her endless curiosity with constant study, which allows her to understand and explain what she sees.

Margaret examines a Leandro Katz photograph and sees it "exudes a feeling of wetness that evokes waiting until the last possible moment to lift a darkroom print from the developer, just as it has attained its point of saturation." In rendering visible a painting by Jane Norling, she is able to explain: "Here Jane's black lines are thin, broken, and scattered, sometimes painted and repainted again to produce an intentionally unfinished texture that gives the work exceptional depth." Because she has contemplated Central New Mexico's landscape over a lifetime, her photographer's eye and poet's voice allow us to imagine the land in which several of these artists worked: "hulks of blue-gray on the horizon and, closer in, hillocks of striated reds and oranges, golds and mauves and creamy beiges undulating beneath a sky that is vast and almost always blue." Describing a familiar trail in Utah, she knows the precise words—cairns and chukars—to name the stone mounds and birds she encounters on her walk.

In my experience, women artists bring exceptional depth and sensitivity to writing about other artists. I'm thinking, for example, of the loving portrait of the photographer Robert Mapplethorpe in Patti Smith's memoir *Just Kids* and Elena Poniatowska's perceptive and historically grounded biography of the photographer and graphic artist Mariana Yampolsky.[1] Women artists seem to approach under-

standing other artists with generosity and lack of arrogance, with a holistic understanding that there's much more behind the art than individual genius, more behind "success" than egotistic drive. The artists and their art are made up of family and community history, social isolation and collective participation, systems of social injustice and inequality, love and rejection, nurturing relationships and abuse, struggles with one's own body and with sometimes frightening desires, efforts to heal, the quest for identity and self-recognition, the need to be seen and heard, a particular time and space.

In Margaret Randall's approach to these artists and their work, we find a profound understanding of Stuart Hall's contention that "we all write and speak from a particular place and time, from a history and a culture which is specific," and of his perception that "all discourse is 'placed,' and the heart has its reasons."[2] Margaret writes, "I am interested in how artists navigate the time and space they inhabit," reminding me of an essay I once wrote about women artists "navigating the labyrinth of silence" they face in an art world dominated by men.[3] While artists like Elaine de Kooning, Ferdi Tajiri-Jansen, and Sabra Moore inhabited quite different times and places, one consistent feature of their experience is patriarchy's domination of society. Margaret offers profound insights into the very different means by which these women attempted to navigate that reality.

De Kooning, for example, created her art at a time when the New York art world was dominated by the Abstract Expressionist movement, itself dominated by men and male sensibilities. Edmund White recalls a friend who "thought of herself as a bold abstractionist and she slashed and dabbed at her canvas with a palette knife or big wide housepainting brushes. The worst thing in those days was to be 'weak' or 'delicate' or 'unresolved.' We all subscribed to the belief that only men, only heterosexual men, were cut out to be painters."[4] Margaret explains that de Kooning rejected the term *woman painter* and insisted

on "making it on male terms." De Kooning recognized the power of her art, but, "a product of her time and gender, Elaine experienced this power as eminently male."

On the other hand, Margaret reveals that Ferdi Tajiri-Jansen "lived at a time and in a world that allowed her the freedom" to express her sexuality in feminist terms. She and her artist husband managed to create a mutually supportive family built on respect and equality, an unusual and crucial factor in allowing her to become the artist she was. When trying to understand Sabra Moore's work, Margaret identifies "several discreet periods in Sabra's life [that] can be felt again and again in her art," including, for example, her East Texas childhood, a stint in the Peace Corps in Guinea, a life-threatening abortion, an abusive relationship, and her activism in the women's movement in New York City.

The reality of a powerful women's movement radically changed the time and space in which women artists could create. In my own work on Mexican and Chicana feminist artists, I was repeatedly moved by their stories of the creative and social power that was unleashed once they began to organize and work together as women. As I read Margaret's accounts of how women artists struggled to overcome the obstacles that they faced in professions dominated by men, I was reminded of Mexican feminist artist Magali Lara's description of what it was like when she and other women artists began to form collectives and collaborative projects in the late 1970s and 1980s: "Among the women, it was so different: the opening was total and very strong. We could talk about anything and say anything. There was no teacher and disciple. We were equals—distinct, different, but equal. We set out to create a feminine culture, which has to do with the emotional part of life and with how social identity is formed, and to talk about sexual identity, which in Mexico is to talk about power."[5] Margaret, with her lifelong experience as a feminist artist, has lived similar moments, understands deeply how a social movement can change time and place,

and she brings that understanding, in eloquent prose, to the lives and art examined here.

I want to highlight one final feature of this book, which is Margaret's well-placed emphasis on the importance of the physical place, the very land in which the creative process unfolds. In explaining, for example, about how she experiences Mary Elizabeth Jane Colter's building the Watchtower, located at the Grand Canyon, Margaret writes, "within it, you feel the ways in which Colter was connected to this land, this history, this unequaled place on earth." And when revealing the process behind Jane Norling's landscape abstractions, she notes, "Preparation would begin in her own contact with a particular place: familiarity birthing discovery." Margaret further links these observations to the notion of "nature as mentor" that Lucy Lippard used to frame an essay on the Nazca Lines in Peru. Margaret's and Lippard's reflections reminded me of the words of Hawaiian scholar Manulani Aluli Meyer: "If a people develop a relationship with a place and people for countless generations, they will be in full dialogue with what that place and people have to teach. These are epistemological points that bring us to ancient clarity that highly mobile Anglo-Americans often do not possess: (1) place educates, (2) beauty develops our thinking, and (3) time is not simply linear."[6]

How fortunate we are that Margaret Randall has shared these texts about the extraordinary artists and art in her extraordinary life.

Oaxaca, Mexico, January 2021

Preface

Why is it that visual art—drawing, painting, sculpture, photography, architecture—grabs me and, in particular instances, feels as if it changes me at the molecular level? Where does the image continue to live in my memory and how do art and memory interact? How do reason and intuition come together in art? In what ways is art necessary to the health of society? What does it take to be an artist? What is it about the work of certain artists that touches my emotions? Do women and men make art differently? What have women artists had to give up in order to make their art? What does anyone who devotes his or her life to making art have to give up in societies that don't support artistic creativity? How do sexual identity—male, female, lesbian, gay, transgender, and nonbinary—as well as class, race, and ethnicity impact the making of art? Does great art change the viewer? Does it change the artist? How does art act upon human relationships? Upon the environment? Upon the future? Can art calm violence, heal the human spirit? How has art making preserved ancient ways of telling or recast itself across cultures and centuries? What impact do new—or old—technologies have on the art-making

process? How does art travel through time? Are visual artists different from the rest of us; how are they shaped by the ways in which they understand and render perception, perspective, energy, scale, color, line?

I wrote this book to try to answer these questions, and to honor a few of the artists whose work has changed me.

Artists in My Life

Elaine de Kooning
Paints a Secret

I had a bit of money and decided to spend it on a dress. Something I could wear to a party unlike those back home, where a matching sweater set was considered evening attire. In 1958, among the creative geniuses of New York's downtown art scene, originality and exuberance beckoned. And every color in the rainbow lured from behind the window of that small Village shop. I didn't even try it on. I knew its floating formlessness would fit, put down my money, and took the monogram-embossed paper bag. Elaine's loft was three blocks east on Broadway, across from Grace Church. I rang the downstairs bell, pushed when I heard the lock release, and took the narrow stairs two steps at a time. At the studio door, I could hear my friend's familiar "It's open! Come on in!"

She welcomed me with an expansive smile but didn't stop painting and was already concentrated on the canvas again. I opened the bag and held up the simple chiffon folds of rainbow stripes suspended from thin spaghetti straps. Those straps launched a cascade of gauzy transparent fabric flowing the length of the dress, so that in good light

the body's outline would be visible beneath it. The dress moved. It danced. It would make any woman wearing it feel like dancing.

Elaine let out a little squeal of delight ending in a sound I couldn't read. She set her paintbrush down and wiped her hands on her overalls, then on a rag hanging from the side of the easel. In one lithe motion, she disappeared into the sleeping space behind a white screen hung with scarves and necklaces and a small corkboard with bold earrings arranged in rows. That screen separated her bedroom from her work area, as makeshift but innovative as the rest of the loft. When she emerged, she was holding the identical dress and laughing irrepressibly. Only she would have thought our both having bought the same outfit hilarious. I froze for a moment, deflated, then started to say I would take mine back: "I didn't know . . ." "No you won't." She was grinning now. "Who says we can't wear the same dress? A double whammy: We'll both knock 'em dead!" Such was Elaine's generosity of spirit and delight at dispelling worry.

Elaine de Kooning was one of the great painters of the twentieth century. Her brilliance, courage, craft, range, the progression of her work from earliest examples to those painted late in life, and shear output all attest to that. Like the dancer she'd trained to be in her younger years, she moved gracefully when striding through the city she'd made her own or entering a room and instantly becoming the adored center of any group. When she painted, she was totally absorbed, while at the same time perhaps talking animatedly with a friend who'd dropped by. In the late 1950s and early 1960s, I was often that friend.

We met in New Mexico in 1957, when she'd been a visiting art professor at the University of New Mexico. We became instant co-conspirators, and she would be an important mentor as well as one of my closest friends until I left for Latin America at the end of 1961. We remained in touch until a year or so before her death.

Born in 1918 and coming of age before the issue of gender was on our cultural radar, Elaine dismissed the label *woman painter* with an annoyed smile and flick of her wrist. "I'm an artist who happens to be a woman," she always said. Even in the 1970s and 1980s, when other female artists were claiming a womanist vision and protesting their absence from museums and uptown galleries, she wasn't part of that struggle. Making it on male terms was a goal she wouldn't relinquish. And with regard to her own artist's life at the time she lived, she was right.

Yet Elaine was an activist in many other areas. She became deeply involved in the Caryl Chessman case and fought against the death penalty. When Chessman was executed, she was devastated and took to her bed for days.[1] She was against the U.S. War in Vietnam. And she was interested in the Cuban Revolution. After I moved to that country, she asked if I thought I could get permission for her to paint Fidel Castro. I tried but couldn't pull it off. She engaged in more personal pursuits of justice as well, shocking some but imbuing others with a worldview she believed helped those who needed it most.

I had my first child in New York and, as a single mother, often needed a babysitter. Elaine convinced me to hire a young painter who had just been released from prison. "Imagine," she said, "if you trust him with what is most precious, your son, what a boost it will be to his self-confidence!" It never occurred to her that this might be a dangerous arrangement, and it wasn't. Her belief willed things to turn out as she expected. Elaine continued to help the man even after she discovered he'd stolen a piece of jewelry from her in order to buy drugs. "It's so hard to break the habit," she said, all but justifying the betrayal.

Elaine couldn't pass anyone in the street without making the person feel seen. She knew the name and story of the homeless man—shamefully, we called them "bums" in those days—who hung out on

the stoop of the building where she had her loft. She gave him money but also, more important, a listening ear.

Elaine was always generous with younger artists, often buying their work to encourage them and provide them with an injection of the cash that she knew they needed. In fact, she developed a lifelong practice of spending 25 percent of what she earned through the sale of her own paintings on those of beginning artists in whom she saw promise. It was a uniquely personal tithe. And she was always making gifts to her friends. I never really got involved in painting myself, but merely mentioning one day that I might like to try it elicited the gift of a fifty-dollar brush from her—a tool that startled me and one I never used.

In Albuquerque, I taught Elaine to drive, although it took three attempts for her to pass the test and get her license. "Three's got to be the lucky charm," she predicted. Two nights later, after too much to drink, she drove her secondhand car through the small front garden of her rental apartment in the city's picturesque Old Town, demolishing a flower bed and smashing the front room's large picture window. She laughed sheepishly and quickly found an adoring young male acolyte who was more than willing to clear the yard and replace the glass.

I took her to Ciudad Juárez, a five-hour drive in that era of the fifty-five-mile-an-hour speed limit. I remember those weekend trips as carefree and exuberant. We attended the Sunday-morning bull-fights at the Plaza Monumental, where Elaine—sketchbook at the ready—drew the glittering matadors in their gold-trimmed suits and the powerful bulls in every angle of the charge. Those sketches were the prelude to her famous bull series: explosions of movement and color from the Mexican fights and, much later, images that were quieter but just as intense, inspired by the prehistoric bulls she saw on the walls of caves in southern France.

From the moment they met, Elaine was devoted to the Dutch émigré painter Willem de Kooning.[2] She studied with him, considered him the most important of all the New York artists who were gaining prominence in the 1940s and 1950s, becoming known as Abstract Expressionists or Action painters. They married and had a few good years. Then their strong personalities clashed, he began seeing other women, she, too, had affairs, and they separated but never divorced. "Why should we divorce?" she would ask, and I knew it was a rhetorical question. When Bill needed Elaine's help, she was there. Much later, she stopped drinking and helped him stop. And when he became ill with dementia, she cared for him until she—unexpectedly—died before he did.

Elaine also wrote insightfully about artists and art, setting a high bar for those of us who attempt to speak or write about visual art. In that aspect of her career, she also never missed an opportunity to promote her husband's work. "Well, you know," she'd tell anyone willing to listen, "there's really no one like Bill." Her tone suggested that this was fact. It would be useless to disagree. When they were together, they were the royal couple of the New York art world. The fact that her career was overshadowed by his, along with the general discrimination a woman artist faced in the second half of the twentieth century, inevitably weighed against her.

Elaine's predilection for portraiture—she called it an "addiction," and once told an interviewer that she was "enslaved by it"—has often been considered a departure from, or in opposition to, her abstractions. To me, both concerns were of a piece. Her painterly energy and verve come through in the portraits, and her eye for the figure makes many of her abstractions curiously figurative.

Elaine came up at a time when no museums were run or curated by women, and when only some showed a few works by token females—Mary Cassatt, Frida Kahlo, Georgia O'Keeffe, Diane Arbus,

possibly Alice Neel or Louise Nevelson. Back then, only 1 to 3 percent of the pieces in major museums were by women. To understand how entrenched the discrimination was, I should say the ratio isn't much better today, hovering around 5 to 8 percent. But in Elaine's time, women artists who had been working for years found it almost impossible to show or sell, and even when they did, they weren't likely to be reviewed. Gender is absolutely central to this story. Elaine was forced to make her art in an overwhelmingly male and misogynist milieu. She used her deep intelligence and animated character to make it hers.

Writing about Renoir, Elaine began by saying, "There are two images the spectator gets from every work of art: one while looking at the work, the other—the after-image—while remembering the work. These two images are usually disparate. . . . The artist creates the after-image, the painter makes the painting."[3] This was Elaine's way of addressing the issue of process and product, form and content. For her, painting was what she did; artist was what she aspired to be. In her best paintings and most successful portraits, her unique talent, glass-full personality, tenacious energy, and extraordinary craft bring image and afterimage together. The spectator is assaulted, surrounded, drawn into a work that is all moment, action, experience. She tells a story, but it is one without beginning or end. Or, rather, the beginning is lost in the artist's intuitive memory and the end is yet to be determined. The distance between image and afterimage has been obliterated.

Her sister, Marjorie Luyckx, who knew and understood Elaine's artistic process as well as any critic, wrote, "In the end, she portrayed much more than just the physical qualities of her subject. She captured what determined the character, the body language, the very being of the person, even when the portrait was faceless, as in her well-known series of 'faceless' men. Often, too, the work was more than a portrait; it was a well-composed painting in and of itself."[4]

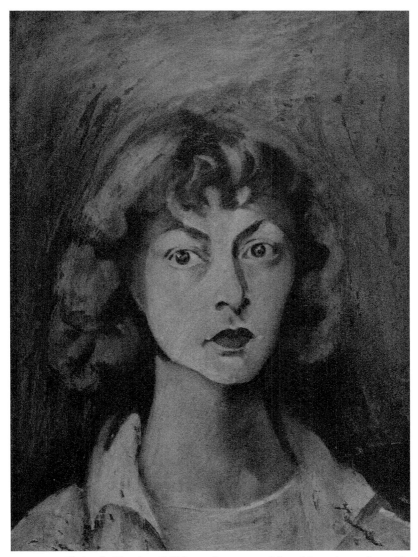

FIG. 1.1. *Elaine de Kooning, Self-Portrait, c. 1942. Oil on Masonite, 23 by 17⅜ inches. Courtesy of Michael and Susan Luyckx and Elaine de Kooning Trust.*

Elaine wrote about those whose work she reviewed under the heading "So and So Paints a Picture." Riffing on that, I called a gallery talk I was invited to give at her 2015 exhibition at the National Portrait Gallery "Elaine de Kooning Paints a Secret."[5] Having been her close friend, having known the subjects of the portraits on which I chose to focus, and having sat for one of them myself, I was privy to many of those secrets. I would not betray what I didn't think Elaine wanted made explicit. Decades after her death, I would merely tell a few stories and let my listeners' imaginations wander where they would. Here are those stories.

I start with this self-portrait for several reasons. First, because it is so direct and unembellished. No additions or details distract the viewer's eyes from the artist's stark presence. She knows and reveals herself. Naturally curly honeyed hair, flawless skin, slender neck, lush lips, and especially those large brown eyes set beneath quizzically raised brows, seem to say, Here I am. We see both vulnerability and self-affirming strength. Elaine painted this around 1942, perhaps a year before marrying Willem de Kooning but certainly while already studying with the painter she quickly came to see as the best of their generation. No doubt she was influenced by his masterful classical expertise. But she was already evolving her own style. Dressed simply, in what might well have been her painting clothes, the woman staring from the canvas nevertheless exudes a natural grace—the grace of a dancer, a discipline Elaine pursued earlier in her life but abandoned when painting claimed her completely.

For me, the eyes hold the secret in this self-portrait. The gaze is not directed toward the spectator, but slightly to the side, as if she is pondering her situation even as she fully inhabits the picture plane. I find a strange blend of resignation and determination, as if she already understood what it would take for her to be recognized as the artist she knew she would become.

I also want to begin with this self-portrait as a way of putting to rest absurd questions proffered by ignorant critics over the years who have wondered out loud whether or not Elaine could draw faces! Anyone who has paid attention to her range of portraiture understands the importance of gesture, an element she considered more emblematic than mere facial features. Where she has blurred over or painted out those features, there was always an eminently painterly reason for doing so. Elaine's solutions were always painterly.

Other portraits, in which she plumbed her subjects' features for all they were worth, sometimes in images in which we can actually see the subtle sifts of movement from mood to mood, attest to her skill in painting every sort of human expression. But none, perhaps, displays this talent more fully than this profoundly self-aware image.

Elaine de Kooning loved men in a primal and uncomplicated way. She was not privy, that I know of, to the discussions—still several decades into the future—about misogyny. Had she been, I believe she would simply have dispatched the issue by claiming a genuine and all-consuming heterosexuality. The last time we saw one another, a couple of years before her death, I told her I had come out as a lesbian. "Oh, I understand," she said, "there are so few good men left." I resisted the temptation to argue.

Elaine loved Bill and she loved other men. She painted many of them over the years: a few stand-alone images of celebrities, such as the soccer great Pelé or the poet Allen Ginsberg, but most often repeat portraits of close friends: her brothers, Peter and Conrad; her husband; Fairfield Porter; Edwin Denby; Tom Hess; and Aladar Marberger, who was her agent and friend until his death, shortly before her own. Her most famous subject, of course, was President John F. Kennedy.[6]

Elaine painted women, too. But her preference for the male gesture, the male body, male power and presence, was frank and unabashed. She also delighted in turning male artists' historic proclivity

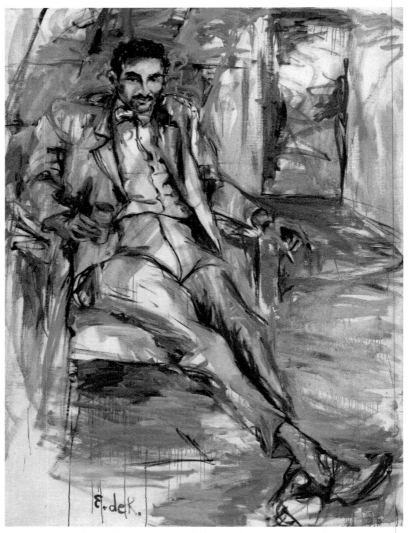

FIG. 1.2. *Elaine de Kooning, Harold Rosenberg #3, 1956. Oil on canvas, 80 by 59 inches. Courtesy National Portrait Gallery, Smithsonian Institution, and Elaine de Kooning Trust.*

for painting women, particularly nude women, on its head. When we think of Goya's and Renoir's voluptuous women's bodies, Gauguin's romanticized primitives, or even Picasso's and Willem de Kooning's grotesque distortions of the female form, Elaine's choices of pose and emphasis seem like a challenge to those male visions. Her portraits reflect her ability to see the whole human being.

For Elaine, sexuality was a substantial part of that human being. Harold Rosenberg was physically imposing. He was larger than life, as well, in terms of the power he wielded in the New York art world of the 1950s and 1960s. It was Rosenberg who coined the term *action painting*, and his essays on the subject can still be read in his book *The Tradition of the New.*[7] It was Rosenberg who actively supported Willem de Kooning's work, as opposed to one of the other notable critics of the day, Clement Greenberg, who favored Jackson Pollock. Harold Rosenberg was large in Elaine's life, important to her professionally and personally.

As in many of Elaine's other portraits of men, this one draws the viewer's gaze to the sitter's genitals. Above long legs thrust out toward the lower right-hand corner of the canvas and ending in casually crossed feet, a series of lines direct our eyes to that crease in Rosenberg's pants that hides what we can only imagine is one of the man's principal seductive features. I knew about the artist's longtime affair with the critic; although blithely willing to share some of her men, she once warned me away from Rosenberg. Clearly, he was important to her in a way others were not.

In this particular portrait, the powerful man is sprawled in a chair, a can of beer in one hand, a cigarette in the other. His presence, filling the left side of the canvas, is bordered on the right by a rapid and luminous path leading to a door; I read ongoing intellectual exploration. Rosenberg's slightly downcast expression is more thoughtful than commanding, undoubtedly speaking to what the painter considered to be his philosophical bent.

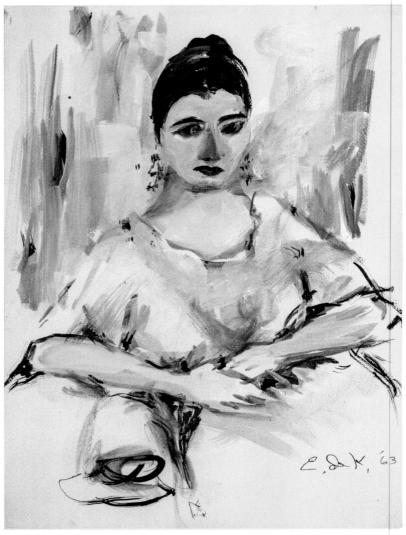

FIG. 1.3. *Elaine de Kooning, Meg Randall, 1960. Ink and gouache on paper,*
14½ by 11 inches. Courtesy National Museum of Women
in the Arts and Elaine de Kooning Trust.

This is power in its many dimensions. A product of her time and gender, Elaine experienced this power as eminently male. But in this multifaceted portrait, power is many-layered, as well: physical, intellectual, emotional, and also deeply personal. This portrait's secret is no secret.

Because I choose to make this tour chronological, we come next to a small ink and gouache portrait on paper that Elaine made of me in 1960. Clearly, it is one of the lesser pieces in the exhibition, but because I was there, I feel that what I can say about the experience of sitting for it may be of interest. As I've mentioned, Elaine never minded having visitors when she painted; she engaged with you fully even as she continued to work. On this particular afternoon I remember her pointing to a straight-backed chair and telling me, "Sit right there." She played a bit with the position of my arms and began to sketch—completing one portrait, putting it aside, and immediately starting another.

Seven images emerged from that session, each quickly completed in line with the artist's habit of working fast. Many years later, after I returned from a quarter century in Latin America and the U.S. government was attempting to deport me because of opinions expressed in some of my books, Elaine chose one of those images for a high-quality poster she donated to raise money for my legal defense fund. I believe the edition was limited to one hundred copies. They sold for twenty-five dollars each. I still have a few.[8]

An interesting aside is that Elaine hadn't signed those portraits when she made them. She customarily refrained from signing her work until she was getting ready to send it off to a show or sell it. When she prepared to add her signature to this one before sending it to be reproduced, she penned her iconic "E de K" and the date "1963." I knew the sitting had taken place in 1960, not 1963, both because I was pregnant with my son at the time (Gregory was born in the fall

of 1960) and because I had left the country by autumn of the follow-
ing year. You couldn't win an argument with Elaine, though, and she
insisted on using the 1963 date. Although her memory was as fallible
as any, her exuberant certainty when speaking about her work was
also linked to an innate self-confidence and conviction. I was pleased
when the curator of the National Portrait Gallery exhibition accepted
my memory of the date and labeled the work accordingly.

Another of these seven portraits became the frontispiece for my
early self-published poetry collection, *Ecstasy Is a Number*. That book,
filled with early and embarrassingly bad poems, contains other won-
derful sketches by Elaine, including a marvelous series of Thelonious
Monk playing at the Jazz Club, a tiny place where we went to together
on more than one occasion.

And this brings me to the secret I see in this portrait: By the time
Elaine and I met, she was an accomplished artist. I was eighteen years
younger, a novice poet just starting out. What did Elaine see in my
work? What made her willing to illustrate my incipient poems with
her own fully realized drawings?

I wasn't the only young friend of Elaine's in whom she saw more
than what we saw in ourselves, more than what we were at the time.
And it was her encouragement and support that helped us grow into
the artists we would become. This speaks of perceptivity and generos-
ity of spirit. Elaine painted many of the greats of her day, but she also
painted friends, relatives, and the scores of beginning artists she men-
tored along the way. We were all interesting to her. Her attention and
encouragement contributed to our thinking of ourselves as creative
beings, and to our embracing lives that gave us the experience we
needed to grow into those beings. She saw beyond the moment to a
future of possibility, thereby enabling younger artists to visualize who
they might become.

Many of the larger portraits in this exhibition are of men stand-
ing, singly or together, looking directly at the viewer as if taking on

the world. *The Loft Dwellers* depicts two younger painters who were close to Elaine at the middle of the twentieth century. Eddie Johnson (on the left) was a quiet but multitalented young man she met in New Mexico. He followed her to New York, frequently working as her studio assistant. Robert Corliss (on the right) was a New York artist, who also worked for Elaine from time to time. Johnson and Corliss were good friends.

Each also had his idiosyncrasies. Eddie was almost pathologically shy. Today it would be obvious that he suffered from some sort of PTSD associated with his childhood. Back then, it was simply a feature of his character no one talked about or understood. Eddie and I were close for many years. He was an interesting painter, photographer, and sculptor. Later in life, he became fascinated with computer art; the last time I saw him, he was working on an endless and highly original comic book. He died in 2012 in a small New Mexican town to which he'd retired almost as a recluse.

Robert was from a working-class New York family. Art might have been his salvation. But he became deeply addicted to drugs at a time when successful recovery programs were not yet available. I have no doubt that had they been, Elaine would have found a way to get him into one and paid for his treatment. Instead, he became trapped in a downward spiral of hustling to feed his habit, and his promising artistic output was curtailed. He died tragically in a flophouse fire in 1979.

It was characteristic of Elaine and her attitude toward those in whom she believed that, until long after her death, I thought Robert Corliss had entered that burning building trying to save a child. That was the narrative she told. To the end, she would present him as the person she hoped he would become: fully realized, heroic. I only learned the truth years later.

Look at this canvas. Eddie Johnson stares directly at the viewer with a fierce and tragic expression. He has no mouth, a clue to his painful difficulty speaking—or communicating in any way but through

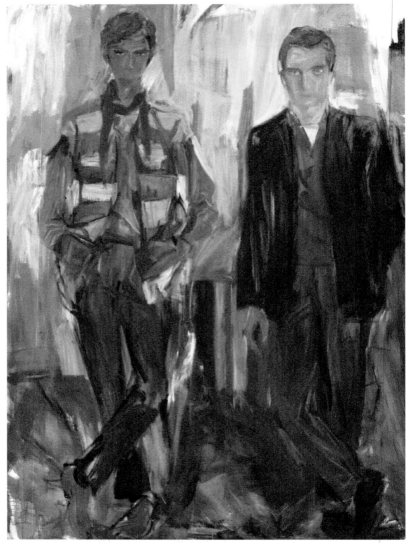

FIG. 1.4. *Elaine de Kooning, The Loft Dwellers, 1961. Oil on canvas, 90 9/16 by 67 1/16 inches. Courtesy the Shatan Family and Elaine de Kooning Trust.*

his art. Robert Corliss's eyes hold his secret: They avoid the viewer yet are filled with agony, the lost gaze of an addict forever struggling to overcome his disease. These are the loft dwellers, two out of hundreds of young men and women who inhabited illegal industrial spaces in downtown New York throughout the 1950s. Very few of them made it in the cruel world of marketable art.

To me, Elaine's portrait of Patia Rosenberg is one of the most fascinating in this exhibition. It is unusual, in that it depicts a female subject. It is also characteristic of the attention Elaine paid to many young girls, a number of them the daughters of close friends, as was also the case with Denise Lassaw (Ernestine and Ibram Lassaw's daughter) and Megan Fox (Connie Fox and Blair Boyd's daughter). But while her portraits of the latter two hide whatever secrets might have been first and foremost in their lives at the time, in hers Patia wears her secret right out there in facial expression and gesture.

Patia, daughter of Harold Rosenberg and May Tabak, had a dark and mysterious aura. Not a look that was likely to make a young girl of the 1950s comfortable or popular among her peers. Her parents also had a somewhat volatile relationship, which may have contributed to a degree of angst during Patia's teenage years. But looking at her serene gaze, we immediately grasp her inner awareness and determination. Her pose—face front, erect posture, hands folded over a book on her lap—provide further clues to all she held within. In fact, Patia Rosenberg would grow up to be a multitalented woman. Elaine, of course, saw that. In her portrait she revealed a secret that was more prophecy than hope. I'm sure her confidence in Patia's development also helped shape that development.

Elaine's sister, Marjorie Luyckx, was her longest and closest friend. As young siblings, they shared a bedroom. And throughout their lives they shared confidences no one else knew. Elaine was the genius artist. Marjorie was no less important in their relationship, in her role as confidante, organizer, support, mother of the three children Elaine never

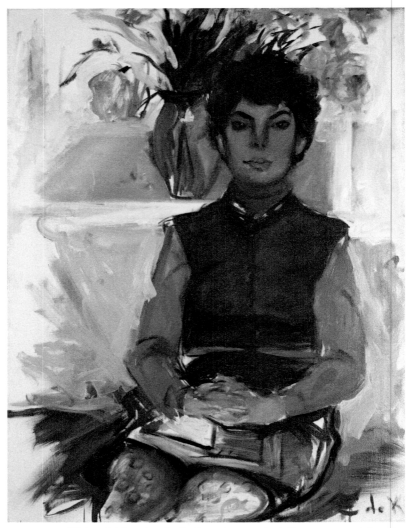

FIG. 1.5. *Elaine de Kooning, Patia Rosenberg, 1967. Oil on canvas, 48 by 36 inches. Courtesy Dr. and Mrs. Guy Fried and Elaine de Kooning Trust.*

had, and repository of the part of Elaine's life that remained hidden from public scrutiny.

I remember Marjorie as a powerful presence: strong, competent, and nurturing. For all her more practical nature, she understood and respected her sister's unconventional style and freewheeling life. When Elaine died of lung cancer, in 1989, Marjorie had been transcribing the contents of dozens of the painter's handwritten notebooks with an eye to helping her write her memoir. Following Elaine's death, she was the only person who could have continued that task. Sadly, she died a few years later, without having completed it. The whereabouts of those notebooks is not known. It is unfortunate that Elaine's life in her own words and her astute observations about her contemporaries and their work may remain forever inaccessible. These are secrets we need to know if we truly want to understand an important creative world that continues to feed us so richly.

I love this 1983 portrait of Marjorie. In a painting by a lesser artist, the busyness of leaves and colorful print blouse might lead the viewer's eyes away from the subject, detracting from her character and personality; Elaine blended it all perfectly. Behind her large glasses, Marjorie looks at a reality we cannot imagine. She is knowing and powerfully present, even when staring beyond the image's frame. Elaine has taken great care in this late work to present her sister as complex, interesting, alluring. The image expresses not only who Marjorie was to Elaine but also who she was to herself.

Some secrets are hidden beneath a veneer of subterfuge. Some are obvious, and we need only the passage of time and a more informed gaze for them to be revealed. Elaine de Kooning lived large. She couldn't abide the social hypocrisy or absurd rules our culture establishes so as to reject some ways of being while deeming others acceptable. When I look at her work, I am reminded of artists such as Leonardo da Vinci, who encoded secrets in many of his most famous works. Elaine did this, too, consciously or simply out of intuition.

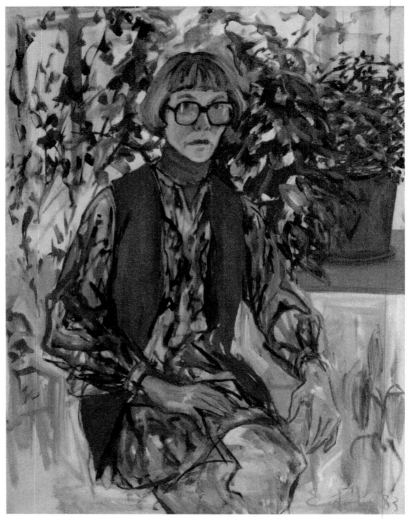

FIG. 1.6. *Elaine de Kooning, Marjorie Luyckx, 1983. Oil on canvas, 42 by 32 inches. Courtesy Michael and Susan Luyckx and Elaine de Kooning Trust.*

Shinkichi Tajiri
and Ferdi Tajiri-Jansen:
Remembering
an Extraordinary Family

This is my memory of an extraordinary family, one that defied traditional ideas of what a family is, modeled internationalism, and breathed artistic creativity. When we met, a mere two decades had passed since World War II pitted Germany, Italy, and Japan against the Allies. Even after Japan had lost the war, the United States dropped the first atomic bombs on the Japanese cities of Hiroshima and Nagasaki, launching that deadly and deforming energy against human beings for the first time in history. And the Allies—following a heinous Holocaust and Germany's occupation of most of Europe—had succeeded in defeating fascism on that continent. We thought that defeat was forever, that such terror could never bare its fangs again. All too soon, history would prove us wrong.

After the war, Allied emotions remained high for a very long time. Suspicion of anything German or Japanese, especially, would linger in sustained prejudice against the ordinary people of both countries. As someone of Jewish origin, I had come of age with an almost visceral aversion to anything German and foolishly said I would never

set foot in Germany. And I can remember during my U.S. childhood the name of a tree, the Japanese maple, being changed to red maple in the common vernacular.[1] Yet here was an extended family composed of a Japanese American husband, a Dutch wife, their mixed-race daughters, Giotta, who was eight at the time, and Ryu, who was six, and two studio assistants, German Karl Kleimann and Japanese Isamu Kanamori.

In addition to their startling family composition, they were all artists. Shinkichi was already a well-known sculptor. His wife, Ferdi Jansen, also a sculptor, wasn't bound by the gender strictures Elaine de Kooning had to navigate. Ferdi was a feminist before the term had entered our vocabulary. She was just coming into her unique voice and would soon free herself of the suffocating strictures placed on women in all fields. The two little girls were actively encouraged in all their artistic endeavors. I remember them making and binding tiny books of their own stories and drawings. And studio assistants Karl and Isamu, if not pursuing individual artistic ambitions, lived and worked in a passionate art-centered milieu.

Most families I knew at the time might tolerate a single member who hoped to become an artist. Even then, it was likely they would be warned to have something to fall back on. Art simply wasn't something one made one's life work. This family, by its very nature, seemed to be saying, What else could one possibly become? And indeed, as I would discover many decades later, Giotta and Ryu, as well as Giotta's daughter and son, all chose careers in the arts.[2]

I lived in Mexico City from 1961 to 1969. For most of that time, I was married to Mexican poet Sergio Mondragón. I had brought my ten-month-old son, Gregory, with me after several years living among the Abstract Expressionist painters, Beat poets, and other avant-garde artists in New York; and Sergio and I soon had two daughters: Sarah, born in 1963, and Ximena, born in 1964. Shinkichi and his family

showed up the following year. I think it was our close friend Mexican artist Felipe Ehrenberg who introduced us.

In profoundly moving ways, the travelers epitomized the best a changing world had to offer. Residents of Holland, where they lived in a broken-down castle they were slowly renovating outside the small southern town of Baarlo, they had spent the previous academic year in Minneapolis, where Shinkichi had a visiting professorship at that city's Institute of Art. His tenure over, the family headed south in their specially renovated Volkswagen bus to continue exploring the world. In Mexico, they found delight and inspiration.

I remember the family's arrival as one of those magical moments in which one meets other people and instantly knows there is a connection. Sergio and I were poets. In 1962, we had founded a bilingual journal, *El Corno Emplumado / The Plumed Horn.* The magazine would grow over an eight-year period to become one of the most relevant and exciting literary projects of the era. It died in 1969 as a result of the repression unleashed by the Mexican government following that country's student movement of 1968.

Sergio and I lived and breathed *El Corno,* as enthusiasts called the magazine. Our goal was to publish a broad range of poetry and other genres in both Spanish and English, cultivate good translation as an art form in and of itself, and connect artists and writers throughout the world. We aimed to break through the limiting divisions caused by corrupt politics, dismantle the colonialist barriers to aesthetic power, create bridges instead of walls. In a total of thirty-one issues, each averaging some two hundred pages, we would publish more than seven hundred poets and artists from thirty-five countries. We believed poetry could change the world.

Because we were the editors of *El Corno,* our home attracted visitors from dozens of countries—some already well established, others just beginning their creative journeys. They showed up on our

doorstep and many stayed for days or weeks. Some hitchhiked; others sold possessions or purchased airline tickets through popular fly now, pay later plans. We fancied ourselves a veritable United Nations of creative spirits or, as the Nicaraguan poet Ernesto Cardenal famously wrote, the true Pan-American Union. In a letter from Cardenal in the magazine, he declared, "If you continue the work you are doing, you will galvanize Mexico. You will galvanize all of Latin America as well. We must create a movement that renews. We must do away with complacency, sanctified literature, the rhetoric that has been imposed upon us, the slogans, the conspiracies, the silence. . . ."[3]

One might imagine Shinkichi and Ferdi and their family as just another set of visitors among such a wealth of visionary artists passing through. Yet their composition and aura of everyday art making was different. Recalling them today, more than half a century after we met, they have only grown in stature. When they said they hoped to stay in Mexico City for several months, we convinced a woman who lived on our block to rent them a large rooftop room and small bath. As I remember, they all lived in that single room, sleeping bags spread out around a large mattress on the floor, tools everywhere, cans of Japanese delicacies contributing to communal meals, bits and pieces of everyone's art occupying pride of place.

Shinkichi was clearly the center of it all. His work was gaining recognition, and the times favored a man's career. But Ferdi was in no way simply the dutiful wife. She was a supportive partner and loving parent while fully engaged in creating her own wildly original art: larger-than-life "man-eating" flowers sculpted of wire and cloth. Until the end of her life, Ferdi's work reflected her very personal take on woman's experience: fantastical gardens created of fabric art but also female eroticism. It had an intimacy to it but also a toughness.

I remember the exuberant jewelry Ferdi made: bracelets and pendants and earrings, symmetrically balanced but also fierce, unlike anything I'd seen. These pieces were large and weighty, and contem-

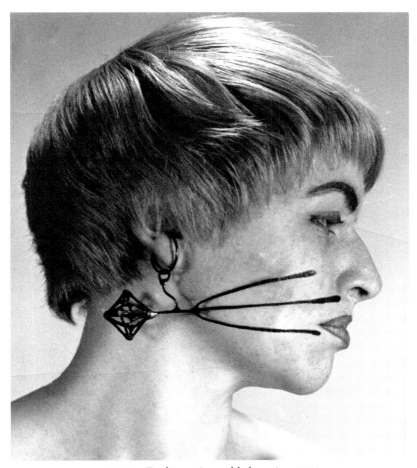

FIG. 2.1. *Ferdi wearing welded earring, 1954.*
Photograph courtesy of Eddy Posthuma de Boer.

porary fashion surely must have suggested they be worn by big-boned women. Ferdi herself was diminutive, pixielike in appearance, yet dynamic. And she wore her own creations elegantly. In 1955, she said of them, "I want my jewelry to be aggressive—not pretty, not charming, but powerful. . . . I want my jewelry to be objects in their own

right, independent of their decorative function."[4] I was the recipient of one of Ferdi's pendants, which I cherished for years. One of my great regrets is that it disappeared in a politically motivated escape from one country to another.

In 1966, immediately following this family's sojourn in Mexico, Ferdi began a new series of constructions. These were larger and more daring than what she had done up to that point: wild gardens with vast foam-filled blooms and magical insects in vivid, clashing colors stretched over welded metal frames and sometimes containing long-haired faux fur. She called these floral and faunal semierotic sculptures "Hortisculptures." Many had finger- or penislike tentacles and pistils. They expressed her unaffected sexuality and have been described as symbols of rapacious life. Ferdi herself said of this culminating work, "I started a new life with the creation of these objects, I have become renewed."[5] Later, her daughters, speaking of their mother's studio at the time, likened it to Alice's Wonderland.

Considering her highly charged erotic art from the viewpoint of how women artists were thought of and how they thought of themselves in the 1960s, Ferdi's ideas were entirely her own: different from either the traditional conception of female creativity or the feminist statements that were beginning to emerge. Her sense of who she was and what she did was different from Elaine de Kooning's feelings about herself or those of any of the other women artists in this book. Ferdi said:

> I want to live with one man, the father of my children; if I uphold the husband and wife plus two children scenario, I am contributing to world peace—that's my responsibility. I lead a triple life: housewife—as quick, good and efficient as possible—my work—and supporting my husband's work, men need backup. . . . I am a woman and perhaps produce what a man would not. There is no such thing as feminine art, only art created by

women. When I welded pieces of jewelry, I wasn't making male art, just because welding isn't exactly women's work.[6]

Before arriving in Mexico, Shinkichi had received a commission to do a sculpture in the city of St. Paul titled *Column for Meditation.* When we spent time with the family, we always saw sketches lying around. These may have been for that commission or for a series of sculptures called *Machines* that he'd planned during his stint in Minneapolis.[7] Around the same time, he'd also cast in metal some oversized phallic and vulvalike pieces and photographed them in combination with a woman's naked body; I always assumed the body in the photos was Ferdi's, although I don't remember asking. I was drawn to the sensual beauty of those images.

El Corno had recently initiated a series of books, mostly poetry collections, and my own *October* was one of these.[8] I can't remember whether it was Shinkichi or I who suggested those photographs would enhance the poems in my book and my poems complement the images. We were proponents of various genres of expression functioning side by side, rejecting the idea of one illustrating another. This was an avant-garde concept at the time.

So it was that a centerfold of those images became part of *October.* It was a compelling collaboration. But the owner of the small print shop where we produced our journal and books was incensed when he realized what we were asking him to reproduce. The images shocked his conservative Christian sensibility. I vividly remember the day he tossed the entire unfolded signature into the street and refused to continue working on the job. We rushed to find another printer, less conventional or simply more in need of the money the job would bring, and the book was published. I have often felt *October* was my first poetry collection of which I can be proud, the first in which the work had begun to reflect my authentic voice, rather than my derivative earlier efforts.

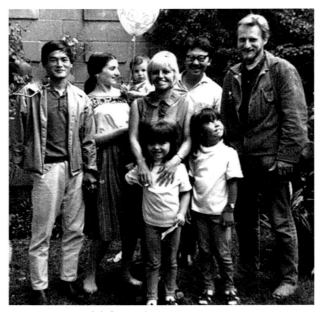

FIG. **2.2.** *Back left to right: Isamu Kanamori, Margaret, Ximena, Ferdi Tajiri-Jansen, Shinkichi Tajiri, Karl Kleimann; front: Ryu and Giotta Tajiri, 1965. Photo from family archive.*

Giotta and Ryu were physically gorgeous as well as intellectually advanced for their ages. Their slightly olive skin, straight dark hair with bangs, and almond eyes reminded me of the Navajo children I had known growing up in New Mexico. They were curious about everything and learned rudimentary Spanish the way young people do, from playing with other children. For the length of their stay in our neighborhood, three of those children were Gregory, Sarah, and Ximena. The freedom Giotta and Ryu exuded also made them extremely attractive; they were helpful and well-mannered while at the same time serious and disciplined about the art they imagined and made.

The sisters have written that their father "would let us draw the Christmas and New Year's greeting cards and would pull them away from us when he thought they were done."[9] My own children were five,

two, and one at the time. Sergio and I also encouraged their creative curiosity, heaping praise on the drawings and poems they produced. It wasn't until many years later that I realized my prideful expressions of enthusiasm for my children's art may have been counterproductive. They didn't like being shown off, and at least one of them—my youngest daughter, Ana—stopped writing her wonderful poems when she tired of her parents bragging to others about them.[10]

Shinkichi and Ferdi shared stories of their early lives. I learned that he was the fifth of seven siblings. His parents had emigrated from Japan to the West Coast of the United States at the beginning of the twentieth century, his father first and then his mother, who was a picture bride. She married a man she had never met.[11] They settled in Los Angeles and, both descendants from Samurai clans and intellectuals, were forced to work in other fields, as they faced racial prejudice and finally all-out wartime rejection in their chosen land. Shinkichi wrote about his parents, describing his father, who died when he was a teenager, as hardworking but remote, rarely talking at all. He and his siblings were *Nisei* in that precise cultural hierarchy Japanese immigrants and their sons and daughters inhabit.[12]

The future sculptor lived in a family rich in Japanese culture but acquired a high degree of assimilation through his schooling in the United States, a stint in the U.S. Army, and—something that marked him for the rest of his life—his family's loss of home and property and their relegation to one of the internment camps to which tens of thousands of Japanese Americans were sent during the early years of World War II. As a child and young man, he was called George, but later Shinkichi (his first name), perhaps to reclaim a heritage for which he suffered so much.

Shinkichi turned eighteen on Pearl Harbor day in 1941.[13] He literally came of age on the day President Franklin Roosevelt declared would "live in infamy" and that would define U.S.-Japan relations for years to come.[14] When the United States decided to send its citizens of

Japanese origin to internment camps, the Tajiri family was first taken to an "assembly center" at the Santa Anita racetrack, east of Los Angeles. After five months, they were transferred to a camp in Arizona called Poston III. There, interestingly, Shinkichi began working under the direction of the great Isamu Noguchi.[15] This seems to have been indicative of his resilience, the ability to find gifts even in the midst of negative experience.

Shinkichi wrote:

> Someone once wrote that we were guilty by heritage. Never accused or tried individually of any crime, we were simply rounded up and dumped into "Assembly Centers" and "Internment Camps." We were allowed to take only what we could carry into the camps. We burned a lot of our belongings, and the rest, the valuables, along with our furniture, clothing, books, etc. we locked in one room of a house my mother had just bought. We rented the house to a young couple from the Midwest who had moved to California to work in the war industries. They looked honest and they promised to take care of our things. We had no choice. We were being evacuated in the next few days. I'm sure the room was quickly broken into. Later, in the camp, we heard that our house was stolen.[16]

Eventually, the U.S. government realized its error in confining citizens of Japanese origin who were certainly as patriotic as anyone else. Inmates were given loyalty questionnaires. All members of the Tajiri family answered these questionnaires to the government's satisfaction. The experience, however, had robbed them of everything: home, possessions, and their faith in the American way. Shinkichi decided to join the all-Nisei 442nd Regimental Combat Team and participate during the last years of the war in defense of the country that had taken several years of his freedom. He actually remained incarcerated until he went to Camp Shelby for his army training. He

is quoted as having admitted that he "wasn't a gung-ho patriot but wanted to get out of the damn camp."[17]

Shinkichi wrote:

> The first twenty-four years of my life, except for one year in an American-style concentration camp and three years in the U.S. army—twenty months in Europe during World War II—I spent in the United States as a free person. My parents were living in the U.S. at the time of my birth, so according to the laws of the country, I was an American citizen and entitled to full civil rights. This did not prevent my imprisonment along with 120,000 other Japanese and Japanese-Americans of all ages. . . .[18]

Following basic training, Shinkichi shipped out to Italy, where he took part in the battle of Anzio. In July 1944, he was wounded in the leg at Hill 140, near Castellina, and spent the next six months in an army hospital.[19] After his recovery, he was reassigned to Special Services, where he did drawings of displaced persons, a task he later described as harrowing.

After the war, Tajiri returned to his family, then living in Chicago. But embittered by the U.S. government's prejudicial treatment and distressed by the anti-Japanese racism he continued to encounter, he decided to leave the United States permanently. Taking advantage of the G.I. Bill, which would pay for art school tuition and provide a stipend as well, he went to Paris, where he was able to study with Ossip Zadkine and Fernand Léger.[20]

Many years later, in the 1970s and 1980s, the Redress movement emerged, grew, and consolidated. This was an effort on the part of the survivors to get reparations for how their lives had been disrupted. President Ronald Reagan eventually rescinded President Franklin Roosevelt's 1942 Executive Order number 9066 and proclaimed the Civil Liberties Act of 1988. This act included an official apology and twenty thousand dollars to be paid to each of those who had been

imprisoned, although the checks weren't issued until George H. W. Bush's administration. Giotta remembers that in the 1990s her aunt Yoshiko, Shinkichi's older sister, mentioned having received her check. She asked her father if he had gotten one, too. He said he had received a typewritten letter, which he'd tossed out because of its impersonal nature. Luckily, he still had the envelope and discovered he, too, had been sent a reparation payment.[21]

Shinkichi Tajiri is internationally known as an important sculptor, with major pieces in public spaces and museums around the world. His themes reflect his take on life: large friendship knots in several mediums and of various sizes; and particularly his long-term work inspired by the Berlin Wall. In the immediate aftermath of Ferdi's death, he drove to Berlin to see if he wanted to accept a job at a university there and became fascinated by the Wall. A result was the photographic essay called *Recording the Berlin Wall (1969–1970)*. One has to imagine the grief that infused it. For that essay, the sculptor photographed every part of the Wall. He was intrigued with its construction, which, he said, "was the most fascinating piece of architecture in the city and drew me like a magnet."[22] Shinkichi wrote:

> A week before Ferdi died, I had received a letter from Berlin offering me a professorship. . . . Arriving in the city's center I began to feel a low throbbing vibration, like a transformer which, plugged into the mains but having no machine to drive, stands immobile and hums. Driving toward the school, I suddenly found myself in front of the Brandenburg Gate. It occurred to me, as I walked along the Wall, that the vibration I felt earlier was, perhaps, energy that had been trapped within the city of the past eight years. In other major cities, numerous broad avenues and highways allow a constant flow of energy to enter and exit. Berlin, an island in the DDR with a few congested highways connecting it to the West, seemed to contain a high count of trapped and pulsating energy. The air felt electric.[23]

Perhaps here is where I should speak about the works by Shin-kichi and Ferdi that have most moved me. I will say up front that I have seen them only in photographs, and at my age it is unlikely I will have the privilege of standing in their presence. But even in reproductions they exert a powerful influence on my psyche. Shinkichi's is a freestanding metal sculpture called *Made in USA*. It is a piece he created in 1965 while in Minneapolis, just before the Mexican trip. The forward-thrusting two-legged humanoid figure is just under six feet tall. It leans slightly forward on its bent-knee insectlike extremities. Unmistakably predatory in gesture, it wields some imagined combination of penis and machine gun. A crestlike headdress embossed with American flags completes the image of an invader in any era. What makes this piece so powerful is that it doesn't depict a man so much as an idea, a system.

Writing about the sculpture in 2020, I am reminded of George Floyd's murder in the same city where Tajiri made it more than half a century earlier. That so little has changed for African Americans and their plight is still inspiring rage and art. I love Shinkichi's *Knots,* with their evocations of peace, unity, and tranquility. But *Made in USA* is undoubtedly one of the most profound sculptural statements about my country's aggressive history that I have seen.

The piece of Ferdi's that grabs and holds me more than any other is called *Wombtomb.* It is a seven-and-a-half-foot-long encasement she created in 1968, a human-size faux-fur bedecked chest in the shape of a sarcophagus with a vulvalike slit in the cover that invites entrance, even immersion on the viewer's part. I feel that I could slip into the piece and rest within it, warm and protected forever. If I did so, though, I have the sense I would be chancing some sort of unimaginable transformation. It lures even as it warns that fully embracing one's erotic identity always implies risk. *Wombtomb*'s outer embellishments and colors speak Ferdi's very personal palette. A tan background evokes the skin tone of most of the world's peoples. Pale green and exploding

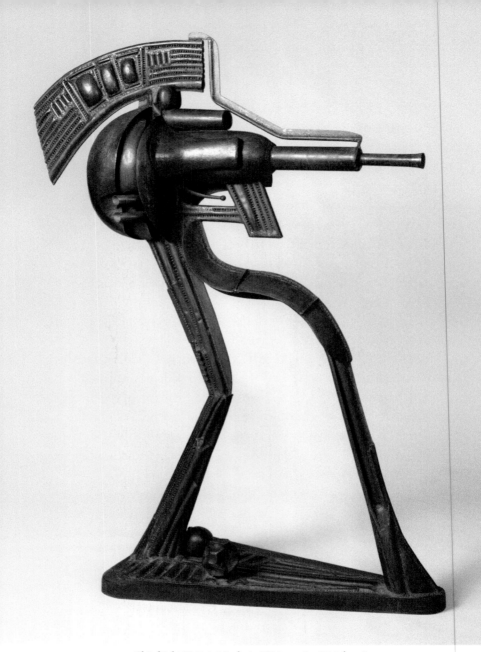

FIG. 2.3. *Shinkichi Tajiri, Made in USA, 1965. Height 180 cm, width 135 cm. Collection 20th Century Art, Rijksmuseum, Amsterdam. Photograph courtesy of Rijksmuseum.*

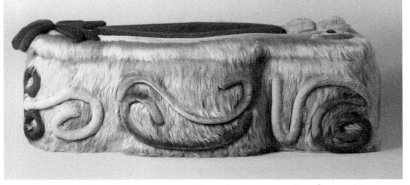

FIG. 2.4. Ferdi Tajiri-Jansen, *Wombtomb*, 1968. Faux fur, foam rubber; height 75 cm, width 225 cm, depth 100 cm. Collection 20th Century Art, Rijksmuseum, Amsterdam. Photograph courtesy of Rijksmuseum.

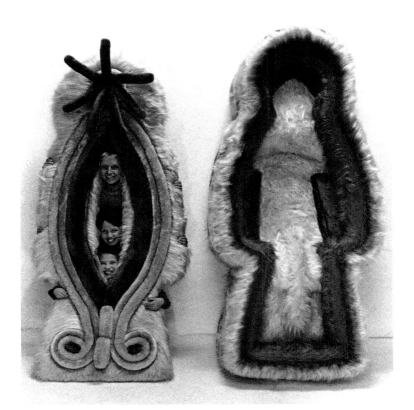

FIG. 2.5. Ferdi's *Wombtomb* open, with Ferdi, Giotta, and Ryu inside, 1968. Photograph courtesy of Ad Petersen.

pink scream life demanding to be seen, heard, felt, acknowledged. The addition of decorative appliqués suggests a spider at the foot and two eyes at the head of this coffin-womb.[24]

Ferdi expressed her sexuality in her art in direct and deeply personal ways. While Elaine de Kooning built her portraits of the male figure with their sexuality front and center, she never painted women in that way. She also refused to consider herself a woman artist. In contrast, Ferdi's work is powerfully feminist. She lived at a time and in a world that allowed her the freedom to assume that consciousness, even if she had to move outside the box to do so. Considering the differences of time, place, and personality, I believe each woman transgressed traditional boundaries in her own way.

Ferdi was born and grew up in Holland, one of the countries that suffered most acutely under Nazi occupation. She spoke of growing vegetables during the war and knitting sweaters that could be traded for food. World War II affected both Shinkichi and Ferdi directly and dramatically. Theirs were not the memories I had, those of ration books, air-raid drills, and Bundles for Britain, but the life-changing experiences that shape one's future in indelible ways. Yet their chosen family included a German man, a Dutch woman, a Japanese man, and an American of Japanese origin, and they interacted on a daily basis in a harmony that defied convention. What they all had in common was the centrality of their art and their knowledge that race needn't divide, that citizenship is not humanity. Giotta and Ryu were born to and for a different world, one embodied in their parents' example.

When we all met, I was twenty-nine and Sergio just a year older. Shinkichi was two decades older, and Ferdi four years younger than her husband. Despite these age differences, in important ways we were of the same generation. We all walked the outer boundary of artistic vision in our respective genres. Art was at the center of all our lives. And our children were contemporaries. But I must also mention an important difference. Shinkichi and Ferdi were mature artists,

while I was still searching for my creative voice. This was something I often experienced as I began my artistic journey. It was certainly true of my relationship with Elaine de Kooning and others of the New York painters. Younger than those artists to whom I was attracted, I was invariably more disciple than equal. Although I don't think I realized it at the time, both Shinkichi and Ferdi—like Elaine—were gifting me ideas and work habits I would come to understand only much later.

By one of those fortuitous series of events that sometimes bring people back together long after they first met, Giotta and I recently reconnected. She is sixty-three now; I am eighty-four. Reminiscing with one another, I have learned a bit about how she experienced the world back then. She spoke of how, as children, she and her sister went to the Catholic school in the tiny conservative village of Baarlo. "We were two little heathens," she said, "at a school of children raised religiously. And our parents weren't like our schoolmates' parents. Our father, with his Japanese features, didn't look like the other fathers. And our mother didn't look like the other mothers; she was Dutch but dressed unconventionally for the time and projected an independence most women didn't have back then."[25] The sisters say that when asked to disclose race on official forms, they always checked "Other." Giotta reiterates what we all know, no matter what our background, which is that when young, all children see their families as normal, just the way people are. It isn't until they begin to interact with the wider world that they may realize they are different and what that difference means.

Although their parents provided that magical world, and encouraged their children's individuality, the sisters don't romanticize their parents or the way they were raised:

Our dad could be very serious when it came to [our approach to our own art]. We were kids after all, but that was no excuse as

far as he was concerned. He treated us as "little people" and expected the same dedication, although this [attitude] sometimes caused irritation on both sides. He once said that he considered his daughters his best work. Well, that set the standard![26]

They add:

We learned at an early age that we had to contain our emotions as they were [considered] private and one should not make a spectacle of oneself; something we later understood was part of his Japanese upbringing as well.

He told us that he and his father rarely spoke, perhaps not ever. His father, Ryukichi, remained a mystery to him and passed away when he was fifteen. Shinkichi was a lot closer to his mother Fuyo, and they had their own secret language unknown to the other siblings. Our father was a rather private person, although in company he could be very outgoing and a great storyteller with a tremendous sense of humor. He was generous in sharing information when it came to technical stuff, contacts and bringing people together. When it came to feelings on an emotional level, he was rather introverted.

Ferdi was a wonderful, loving mother. She was spontaneous and loved to play and engage in all kinds of activities with us. A fine artist in her own right, she was enormously driven and in that way much like Shinkichi. She did everything with intensity, willpower and perfection, whether it be her art, sewing clothes or anything else she set her mind to.[27]

In my reconnection with Giotta I have learned about her children, Tanéa and Shakuru Tajiri. When I asked their mother why they carry her family surname rather than their father's, she responded:

The reason our kids have the name Tajiri is multilayered. Our family is very small. Terry, my husband, is my first cousin. He

is the son of Shinkichi's older sister Yoshiko. Yoshiko raised her four kids by herself. [Terry's] father left after the fourth child was born. I believe the name should be passed on by the mother; you know who your mother is. Your father could be anybody. Terry had no problem with that, and he is a fantastic father.[28]

I cannot help but imagine that the family's younger generation also wishes to honor a grandfather who gave so much extraordinary art to the world. But I also hear Ferdi's outlook in Giotta's words. Ferdi's feminism was not simply metaphorical; she bequeathed it to her daughters and willed it to the grandchildren she would not live to see, all of whom as adults continue to express strong values of gender equality in their lives.

Ferdi and Shinkichi are both dead. She died before her forty-second birthday, just as she was gaining recognition as an artist of note.[29] She'd suffered polio in her childhood and had been having trouble with one hip. This led to the need for an operation at a hospital in Switzerland, followed by a period of recuperation back home in Baarlo. There is a moving photograph from that period in which Ferdi is in her studio, teaching herself to walk again. Late one night, she took a bath. On heavy pain medication, she may have dozed off in the tub and, as the water cooled, suffered hypothermia. Shinkichi was asleep in a different part of the castle because he had the flu; he was always afraid of giving or catching a bug. The next morning, it was Giotta, age eleven, who discovered her mother's body. It was a trauma that affects her to this day.

Messages of grief and admiration for Ferdi flooded in from all over the world. Shinkichi created a beautiful book with chronologies of her life and work, many photos, documents, and notes from friends in Dutch, German, French, and English. All attest to the gift of her life. She was described as someone who defied description, who lived between speed and stillness.

Soon after Ferdi's death, Shinkichi asked Suzanne van der Capellen to join the family, and they married in 1976. He had suffered Ferdi's loss profoundly and said his new wife brought stability back into their chaotic lives. Giotta and Ryu remember Suzanne, who was in their lives for forty-nine years, until her death, as warm and stabilizing. She was ever respectful of their mother's legacy.[30] Whenever anyone refers to Suzanne as Giotta's and Ryu's stepmother, they say, "No, she was our second mother."[31]

Shinkichi died of pancreatic cancer in 2009. Both his daughters nursed him during his final months. Isamu returned to Japan many years ago and the girls have lost contact with him. Karl continued to live at the castle until his own death, also of cancer, a few years back. Giotta and Ryu cared for him as well until the end. Now the sisters are working on their parents' artistic legacy: archiving materials, collecting testimonies, and producing relevant publications. Giotta suggested I write this text, and I jumped at the opportunity.[32]

Giotta's and my reconnection took place against the frightening backdrop of U.S. political turmoil in the fall of 2020. A neofascist sociopath somehow won the U.S. presidency in 2016, and the next four years would see every sort of assault on our national well-being. More than anything, Donald Trump succeeded in creating an atmosphere of officially sanctioned hate, in which those who are racist, misogynist, homophobic, or xenophobic had permission to externalize their basest instincts. And all this as a vicious pandemic raged across the world, to the time of my writing having sickened more than 17 million and killed more than 350,000 in the United States alone. Trump refused to deal with the COVID-19 virus, calling it a hoax or claiming it would disappear in a month or so. His daily example favored the strong against the vulnerable. He tried to make us believe that showing weakness of any kind was unpatriotic.

Concerned Americans rallied and organized. Our 2020 presidential election gave victory to a decent and compassionate opponent,

opening the possibility of a saner time. But Trump refused to recognize Joe Biden's win. The consummate bully, he cried foul, demanded recounts, launched dozens of baseless judicial cases, claiming he had been fraudulently denied a second term, and did everything within his power to prevent a peaceful transition.

Against this terrifying backdrop, I am reminded of a family that half a century ago broke through the fear and hypocrisy embedded in the fabric of the Cold War era. As vast majorities were learning to hate and fear those deemed different, evil, or expendable, Shinkichi, Ferdi, Karl, Isamu, Giotta, and Ryu modeled racial harmony and were living fulfilling lives of insatiable curiosity and vibrant creativity. Their very existence provided a living, breathing example of what family can be and the place art can have in it.

FIG. 3.1. *Frida's satin heart. Frida Kahlo Museum, Mexico City. Photograph by Margaret Randall.*

Frida Kahlo's Bathroom:
A Contested Space

Frida Kahlo (1907–1954) was one of Mexico's most innovative and original artists. She not only painted, sketched, wrote agonizingly frank journals, and entertained at exquisite meals. She also made of her home and person a public statement of indigenous tradition, female identity, Surrealist vision, and unwavering leftist politics. Her presence was like no other. In 1938, André Breton described her art as "a ribbon wrapped around a bomb."[1]

All this was part of a lifelong struggle against the confines of women's social place and her own physical misfortune. At six, she was stricken with polio. She may have been born with spina bifida. Neither disease was understood then as well as it is today, and a withered leg and twisted spine plagued her for as long as she lived. Her condition was further complicated by an accident she suffered as a teenager, when a bus on which she was riding collided with a trolley. An iron handrail pierced her abdomen and uterus, and she endured fractures of two lumbar vertebrae, a shattered collarbone, cracked ribs, a crushed pelvis, a dislocated right foot and shoulder, and eleven fractures of her right leg. She never completely recovered from the

problems or chronic pain these injuries caused. She could not bear children, and her lifelong custom of wearing the flowing indigenous skirts that became her trademark was undoubtedly an effort to hide the deformities.[2]

The Mexican Revolution exploded when Frida was three, and she often gave her birth year as 1910—perhaps to seem younger than she was or perhaps because she wanted her birth to be seen as coinciding with the birth of modern Mexico.[3] She was Mexican to the core.

Frida knew early on who she wanted to be and what she wanted to do. She possessed an inner certainty that the relegation of women could not destroy, even the wildly vivacious version of that relegation that existed in the flamboyant atmosphere of Mexico's 1930s art scene. She intended to study medicine but soon turned to painting, incorporating her fascination with the human body into many of her canvases. The first time she saw the great Mexican artist Diego Rivera up on a scaffold, working on one of his murals (twenty-one years older and already a painter of note), she knew she wanted to show him her own incipient work. She also knew she wanted to marry him. He encouraged her art, and they did eventually marry, sustaining a volatile off-again, on-again relationship until her death. He later said that the day she died was the most tragic of his life, that he realized too late that the most wonderful part of that life was his love for her.

Frida Kahlo was called a Surrealist, but her paintings are more personal than those of most adherents of that school. They combine Surrealism, magical realism, and what she said was simply her life: "I never painted dreams," she claimed. "I paint my own reality."[4] She went from doing early figurative still lifes to portraits of others and fiercely introspective self-portraits. Sometimes her work, with its strange floating figures, allusions to domestic violence, and bodily organs laid bare, verged on the naïve. Yet her subject matter was often distressing. In one famous canvas she depicted her own bloodied body undergoing an abortion as the result of a failed pregnancy.

One knew how Frida was by what she painted. While her husband and the other muralists were putting Mexico's history on vast walls, Frida's pictures were easel-size, although no less immense in their impact. It might seem foolish to say that her work could only have been made by a woman, but I believe this to be true: She noticed what women notice, made the connections women make. There were lots of mirrors in her house; one above her bed allowed her to paint herself during her long recoveries. She was queer in our contemporary definition of that term—that is, she worked in the fluid nonbinary in-betweens of race, sex, and gender. Her subject matter was feminist long before that term was used. Frida's time, life circumstances, pain, and passion for the deeply embedded culture she embodied and explored rendered her an artist like no other.

Because of their times and places, Elaine de Kooning, Ferdi Tajiri-Jansen, and Frida Kahlo assumed their womanhood differently. Elaine, voluptuous and flirtatious, used feminine wiles as well as an acute intelligence to help make her way in the world. She vehemently rejected being thought of as a woman artist, and we can't know how she might have responded to the second wave of feminism had it emerged before she attained a measure of fame. Her relationship with her famous husband both helped and hurt her. Ferdi's husband, Shinkichi, was much more supportive of her art than Willem de Kooning was of Elaine's. Ferdi and Shinkichi also had a healthy and productive partnership and children who completed a loving family. Ferdi had the home life Elaine never had; her art was female in a spirited yet provocative way. Frida's life, like Ferdi's, was deeply affected by illness, and both lives ended much too soon as a result. Yet neither allowed physical disability to limit her creative energy. Diego Rivera publicly stated that his wife was the greatest Mexican artist, although the statement probably didn't reflect day-to-day support. His infidelities caused her a great deal of personal pain, and we have only glimpses of how they affected her as an artist. Shinkichi was proud of his wife's success. Willem de Kooning

taught and encouraged his student turned wife, but clearly his own career came first. He expected her to be content with the fallout.

Although Frida traveled widely—showing her work and gaining admiration in Europe and the United States—she was born, lived, and died in the Blue House in Coyoacán, a beautiful colonial suburb now incorporated into the vastness that is Mexico City. That house would become as much shrine as museum, attracting people from around the world to observe the extraordinary creativity she wove into every facet of her existence. Her collection of *retablos* (small unschooled paintings on tin depicting miracles asked for or received), the Judases (giant papier-mâché figures meant to be strung with fireworks and set off just before Easter), the very Mexican style of her kitchen, her four-poster bed with its butterfly collection on the underside of its high canopy, her painting easel and paints, and many of her oils and drawings all give a sense of who this remarkable woman was. Her ashes are kept in a pre-Hispanic urn shrouded in a richly embroidered Mexican *rebozo* nestled against her pillow.

Frida Kahlo and Diego Rivera were members of the Mexican Communist Party and remained true to their leftist ideals, supporting Leon Trotsky when he was being persecuted by Joseph Stalin and forced to flee the Soviet Union. Upon his arrival in Mexico, they took Trotsky and his wife in for several months but eventually broke with Trotskyism and became supporters of Stalin in 1939. While Rivera expressed his political ideology in his work, Frida's art was more personal, intimate, mystical.

During their marriage, Frida and Diego both had affairs with others. She was bisexual, and we know of important relationships with André Breton's wife, Jacqueline Lamba; Isamu Noguchi; Josephine Baker; Tina Modotti; and Leon Trotsky, among others. Diego's affair with her sister Cristina was a blow from which Frida may never have recovered. The couple sometimes lived apart or in adjoining spaces, divorced in 1939, remarried in 1940, and were together again at the

time of her death. In this, Frida was like Elaine de Kooning: leaving her husband when the relationship became intolerable but returning to it later because, turbulent as it was, it was the romantic passion of her life.

Toward the end, Frida's physical ills became more severe and she was often immobilized and in great pain. Her right leg had to be amputated at the knee. Frida's last public acts, in 1954, were attending a large exhibition of her work at a Mexico City gallery (she had to be carried there in her bed) and, in her wheelchair, leading a demonstration in support of Guatemala, which had just been invaded by U.S. troops intent upon overthrowing the democratically elected government of Jacobo Arbenz.

A few days before her death, at the age of forty-seven, Frida wrote in her diary, "I joyfully await the exit—and hope never to return."[5] Her death certificate stated that she died of a pulmonary embolism, but no autopsy was performed. She may have taken an overdose of painkillers, which may or may not have been intentional. She was cremated, as she wished, and as her body moved toward the crematorium's flames, the intense heat caused it to jackknife and sit upright, her unbraided hair swirling out from her face. Frida's life ended. Her enduring legend was born.

Much as in the case of Che Guevara, Frida's mythology is reinforced today by a vast array of items of popular culture—T-shirts, posters, cheap jewelry, and reproductions of her work on everything from stained glass to tattoos. I once had a pair of earrings on which her image was painted on the insides of bottle caps. These commercial items are probably as numerous as for any artist, man or woman. I would guess they outnumber those generated by the interest in Pablo Picasso. Frida's impact even beyond the world of art has been such that it has drawn an almost religious following. I know someone who says she owns a sliver of one of Frida's bones, retrieved from her ashes— by what means and by whom, she doesn't know. Someone gave it to

FIG. 3.2. *Frida's bed. Frida Kahlo Museum, Mexico City. Photograph by Margaret Randall.*

someone who then gave it to her. She carefully took it from a small satin-lined box and showed it to me almost reverently. I cannot swear the yellowing shard is what my friend says it is, but the claim speaks to the frenzied emotion Frida evokes so many years after her death.

What would Frida have made of this cult to her life and work? I don't think she would have minded. She might have been amused by some tributes, moved by others. But I don't believe she would have been overly concerned with any of it. Frida made of her physical body a daily work of art: the way she dressed, moved, spoke, conducted herself. She covered her deformed leg with the flowing beauty of ankle-length indigenous skirts, carefully braided and sculpted her long black hair, decked herself in her culture's jewels, and refused to tweeze the signature eyebrows that met in an unbroken line above her penetrating eyes. Had she lived to see the devotion of generations, I think she would have taken it all in stride, delighting in the attention.

The Blue House in Coyoacán is a magical place. I've been there at least a dozen times over the years, often with my daughter Ximena, for whom Frida is iconic. On a 2017 visit, I had a particular desire. I wanted to enter the contested space of Frida's bathroom adjacent to her bedroom, the door of which had long been locked. Here's the story: When Frida died, Diego ordered Dolores Olmedo (a family friend who would assume the museum's first directorship) to keep this bathroom closed for ten years. Olmedo took the directive so to heart that she followed it until her own death—fifty years later. When the new museum director took over, one of the first things she did was open that door.

What was inside? Mexican novelist, essayist, and political activist Elena Poniatowska was present at the opening and wrote an important article describing the event for *La Jornada de Mexico.* In 2008, two galleries joined two publishing houses to bring out the evocative little book called *The Bathroom of Frida Kahlo* if you open it from one side and *Demerol with Expiration Date* from the other. The first title

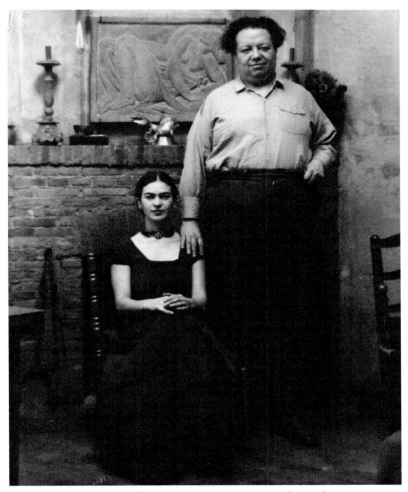

FIG. 3.3. *Frida Kahlo and Diego Rivera, 1931. Gelatin silver print. Photograph by Paul Juley and Peter A. Juley.*

relates to a series of photographs by the powerful Mexican photographer Graciela Iturbide, the second to an essay by Mario Bellatín. In combination, these expressions in different genres give one the feeling of having explored that contested space at the time of its revelation to the world.

Which is a good thing. Because as it turned out, and although on my visit to the Blue House I was accorded every courtesy, I was not, in fact, able to enter that bathroom myself. It was a Thursday, and the museum was crowded with visitors. Had it been a Monday, when the house is closed to the public, my hosts assured me, they would have opened the clouded glass door and allowed me a glimpse inside. They said I wouldn't have been able to see much in any case because the bathroom was then being used as a storage area, stacked high with boxes.

To make up for the impossibility of entering that space, the keepers of Frida's legacy were kind enough to allow me access to what they had removed from it. In a room off-limits to the public, more than one hundred acid-free boxes contained many of the artist's elaborate *huipiles,* her cotton stockings, and a tattered blue-green bathing suit that looked as if it would fit a ten-year-old. These relics were being evaluated to determine which should be restored. Some of the garments were museum pieces. Several heavy corsets showed Frida's own handiwork (or the handiwork of someone close to her), with a fabric lining added to make them less uncomfortable.

In a temporary exhibition hall adjacent to the main house, there was an array of some of the most beautiful dresses, barbaric corsets, and other contents taken from that room. One prosthetic leg was on display, complete with a high-buttoned red shoe painted on it by an artist friend. Feathers and glittering beads adorned the eveningwear. Frida created art even from her own afflicted body.

The contents of the bathroom, as seen in Iturbide's stark black-and-white images, are almost hallucinatory. The bathtub is filled with body braces reminiscent of a scene from the Marquis de Sade, several different types of crutches, and a large poster of Stalin, his hand raised in a salute or wave. Three white enamel enema cans are lined up on a wall shelf, their dark tubes hanging tangled. A hospital gown-type smock looks to be stained with blood or body fluids—or is it

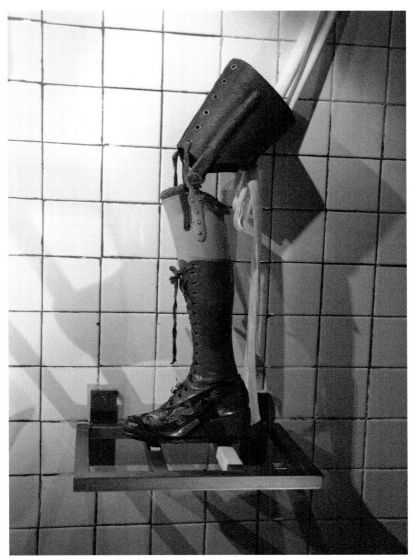

FIG. 3.4. *One of Frida's prosthetic legs. Frida Kahlo Museum, Mexico City. Photograph by Margaret Randall.*

paint? The black-and-white photographs don't tell us. In one image, the empty tub holds only a large tortoise. It is unclear whether it is a work of taxidermy or an extremely lifelike art piece. A large box bears a label for Demerol, which Frida must have had to ingest regularly. One of her prosthetic legs can also be seen in a picture that makes it the only object in the frame. There are several of these legs in the bathroom. And in one posed image, Iturbide photographed her own bare feet (or those of a model) pressed against the end of the tub. The feet are bruised, their toes stubby and curled. The frame includes a view of two simple faucets, a spigot, and a drain stopper with its chain.

In exploring Frida's life, we not only find the accouterments of pain: body braces, prosthetic legs, Demerol bottles, the bed in which she was forced to lie motionless for months at a time. We find the artist's take on her pain in a number of self-portraits that are as poignant as they are tortured. In one of these, *The Broken Column,* she placed herself against a barren landscape, treeless earth scarred with deep crevices extending to an empty horizon, a darkening, almost featureless sky. The painting shows her naked from the waist up, a white cloth that might be a hospital sheet or mortuary shroud covering her lower torso. She is wearing one of those rigid orthopedic corsets, through which voluptuous breasts display erect brown nipples: desire yearning to escape a prison of immobility. Her hair is unbraided, white tears fall from tired eyes, and her body is punctured all over with nails; the viewer feels each of the many places they pierce her skin. But this painting's message comes through most powerfully when we notice that from just below Frida's chin to her pubis, her entire body is rent apart, showing a Greek column shattered and about to topple. Where the spinal column should be, broken architecture stands in its place. The painting itself is testament to the fact that Frida was forced to replace physical wholeness with will. In so many of her self-portraits, she showed us what it was like for such a fierce creative spirit to live inside such a damaged body.

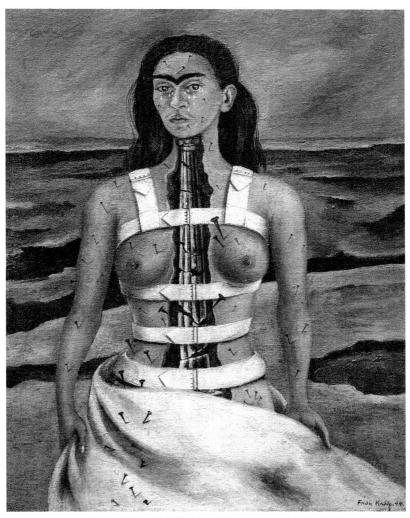

FIG. 3.5. *Frida Kahlo,* The Broken Column, *1944. Oil on Masonite.*
Courtesy of Museo Dolores Olmedo Patiño, Mexico City.
Photograph by Leonard de Selva/Bridgeman Images.

FIG. 3.6. *Papier-Mâché Judas in patio of Frida Kahlo Museum, Mexico City.*
Photograph by Margaret Randall.

What is the importance of contested space? Why did I harbor such a desire to enter that place Diego decided should be closed for ten years following Frida's death? The space of a room stands in for that of a body. The dictum was rather like that often issued by writers, declaring that their archived letters or other papers not be opened to the public for a certain number of years. But that generally concerns people they have mentioned, who may still be alive and be upset by the revelations contained in such material. In Frida's case, she was already gone. Perhaps Diego wanted to respect a certain intimacy or, in his grief, hold on to some vestige of his beloved for a while.

Contested space holds memory, voice, even residual energy fields, such as those of pain or shame. Privacy and public display may or may not be oppositional. On our visit to the Blue House, my wife, Barbara, expressed discomfort that so much of the artist's intimate life was on display, laid bare to the eyes of strangers. I have come to respect Barbara's sensibility about such issues and thought about this for a while. Somehow, though, having seen Frida's brutally personal self-portraits and read her agonizingly honest diary, I don't believe she would have been troubled by this exhibition of the room's contents. Her fascination with the macabre may even have made it appropriate to her.

I am interested in how artists navigate the time and space they inhabit. Not until very recently has it been socially acceptable for a woman to project herself and her work in such a transparent way, and only now in certain societies and situations. From the time she was a child, Frida Kahlo was different. Slight of stature, she was immense in creativity—and remains so in death. The famous bathroom is but one area of revelation, made more interesting perhaps because it was off-limits for so long.

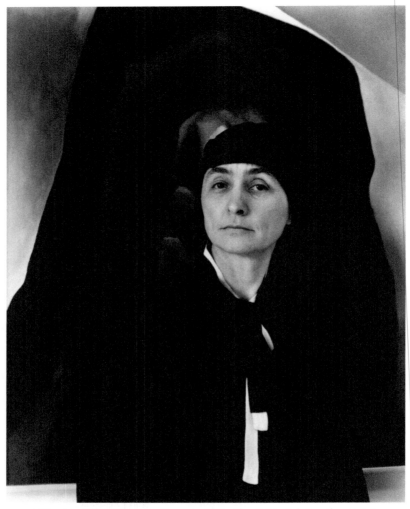

FIG. 4.1. *Alfred Stieglitz*, Georgia O'Keeffe, 1930. *Gelatin silver print.*
Agefotostock / Alamy Stock Photo.

CHAPTER 4

Georgia O'Keeffe:
The Painter Who Made New Mexico Hers

New Mexico, late in achieving statehood (1912) but ancient in its cultures and traditions, has attracted tens of thousands of residents from other places. The Spanish conquest proved catastrophic to indigenous people here, who resisted, survived, and today contribute to life alongside more recent arrivals. Hispanics and Genízaros, Crypto-Jews, artists, writers, and the commune dwellers of the 1970s, cutting-edge scientists and architects, gurus and their followers—all these and more have imbued the state with their ideas and talents, contributing to its splendid diversity.[1]

Some transplanted individuals also stand out for the uniqueness of their contributions or histories: Billy the Kid, Geronimo, D. H. Lawrence, Robert Oppenheimer, Mabel Dodge Luhan, Mary Elizabeth Jane Colter, Agnes Martin, Eliot Porter, Elaine de Kooning, Hassan Fathy, Maria Varela—the list is long. Among these, perhaps none was more interesting, or took more from and gave more to New Mexico, than the painter Georgia O'Keeffe (1887–1986).

O'Keeffe's presence permeates the northern part of the state to the extent that some of us call the area where she lived—the Chama River

Valley, encompassing Ghost Ranch and the village of Abiquiu—"the Georgia O'Keeffe country." If you are familiar with her art and drive through this part of New Mexico, you will recognize the origins of specific paintings as you round a bend in the road or contemplate a view in the spectacular near distance. The multicolor cliffs, Indian and Hispanic cultures, and objects such as sun-bleached animal skulls, low wooden doors, softly contoured adobe walls, and the ladders that rise from one rooftop level to another inhabited her work and remain unchanged from when they inspired her. She didn't paint the *ristras* of dried chile pods or aspen trees turning golden in the fall. She dug deeper, giving us an entirely new way of seeing.

O'Keeffe was born in Sun Prairie, Wisconsin, migrated to the eastern part of the country, and arrived in New York City and the mecca that was its art world in the second decade of the twentieth century. At the age of ten, she knew she wanted to be an artist and, like her contemporary Frida Kahlo, set out to make that happen. She married the groundbreaking photographer Alfred Stieglitz (1864–1946), who both encouraged her work and by his dominant nature sometimes stood in the way of her creative needs. His photographs of her over thirty years are a fine record; he captured her seductive youth, mature grace, and aging dignity but turned out to be better at recording her in images than in being a lifelong companion in a way she could accept.

Stieglitz was twenty-three years older than O'Keeffe. A similar age difference existed between Frida Kahlo and Diego Rivera, slightly less between Elaine and Willem de Kooning. Stieglitz recognized O'Keeffe's genius and promoted her paintings at his gallery, known as 291. He urged, nudged, and interpreted, imposing his own views and managing her early shows and sales. Judging from their correspondence, they were passionately in love. Over a period of thirty years, they exchanged more than 25,000 pages of letters, sometimes writing to each other several times a day. And their letters were intimate and graphic. At 8:35 on the morning of May 16, 1922, O'Keeffe wrote:

Dearest — my body is simply crazy with wanting you — If you
don't come tomorrow — I don't see how I can wait for you — I
wonder if your body wants mine the way mine wants yours —
the kisses — the hotness — the wetness — all melting together
— the being held so tight that it hurts — the strangle and the
struggle . . . [2]

The paragraph would simply be an outpouring of desire were it not
for the word *strangle.* As is true of so many women creatives who
are also passionate about their art, O'Keeffe was eventually forced to
choose between a relationship with her husband and making the life
she needed without him. She eventually broke away and, except for
the summers she spent with Stieglitz at Lake George, remained year-
round in the American Southwest, where she took full possession
of her art. O'Keeffe, like Kahlo, was bisexual, although her affairs
with women seem incidental to how she organized her life. She and
Kahlo also knew and spent time with each other. Whether they were
intimately involved doesn't concern me; the way their feminism is re-
flected in their work does, whether undeclared, denied, or simply not
discussed. I am interested in how gender speaks through creativity.

New Mexico gave O'Keeffe the landscape she needed. She painted
its vast skies with fields of puffed, evenly spaced clouds, its mesas that
were red, orange, purple, tan, or cream as the light changed and shad-
ows descended upon them, its adobe architecture, and the bleached
animal bones she found as she walked the land. She often enlarged a
single shape—a detail of bone, for instance—letting it fill the entire
picture plane. Her oversize flowers took the art world by surprise. To
many viewers, they evoked images of female genitalia, but the artist
denied they embodied any such symbolism. She claimed to hate flow-
ers but said they were cheaper to paint than models and didn't move.
During her early studies at the Art Institute of Chicago, O'Keeffe re-
members her life class as "a suffering,"[3] and one of the interesting

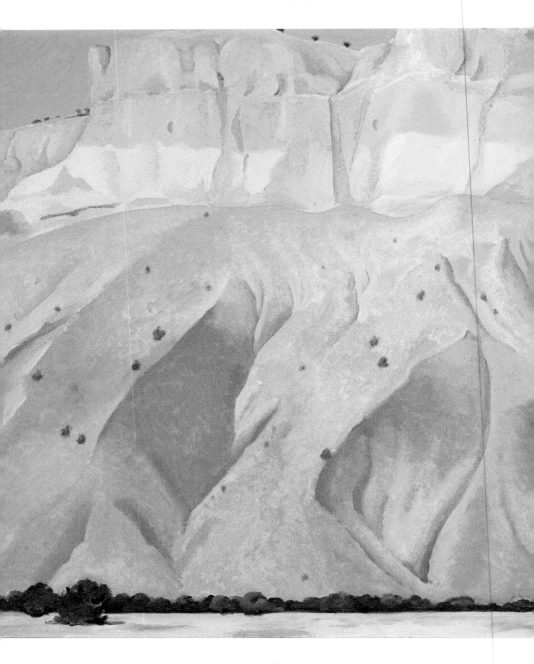

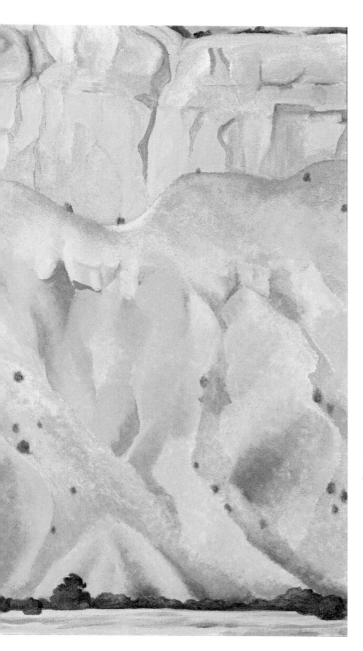

FIG. 4.2. *Georgia O'Keeffe*, Untitled (Red and Yellow Cliffs), *1940. Oil on canvas, 24 by 36 inches. Courtesy of Georgia O'Keeffe Museum, Santa Fe, New Mexico. Photograph by Malcolm Varon.*

things about her mature body of work is that there are no humans or, really, anything animate. She chose to paint landscapes—pure form, large color fields, and minutia magnified to where it claimed its own singularity—and did so as no one else.

O'Keeffe dismissed a feminist ideology. Although much of her work exuded a gendered sensibility, she did not acknowledge it as such. Her contribution to twentieth-century art lay in her ability to enter her subject matter, see inside a landscape or flower or cityscape to communicate what made it what it was. O'Keeffe's adult life strad-dled both world wars. She was surely aware of their horrors and took refuge in a place far from cities and centers of urban busyness and discontent. Like Ferdi Tajiri-Jansen and Frida Kahlo, she developed her own strikingly androgynous look, almost always dressing in black and white, with a simplicity verging on severity.

The relationship between women artists and their artist husbands is invariably complicated. Until fairly recently, it was common for women living with creative men to clean their homes, care for their children, satisfy their sexual needs, and sustain them in every way possible, denying their own creativity in the process. Many worked full-time jobs to support husbands and children. When I lived in New York during the late 1950s and early 1960s, this was the norm and caused no end of conflict. The wives stayed home while the men par-tied, drank at a favorite bar, and slept with the young women who were always available, many of them aspiring artists themselves. Those wives who were artists had to grab odd hours in which to make the time to do their own work, often after their energy was depleted by the tasks of home and family. The same was true of those women who wrote or danced or acted.

Where children were involved, the choices could be especially painful. Elaine de Kooning solved the problem by distancing herself from her husband for long periods and by not giving birth. Ferdi

Tajiri-Jansen was a rare example of a woman who was able to have it all: a happy marriage, loving motherhood, and her art. Her determination, the egalitarian nature of her relationship with Shinkichi, and his obvious support of her work made that possible. Frida Kahlo had a fraught marriage and no children. Her fierce artistic passion tells me it could not have been otherwise and, indeed, she, too, opted to live physically separate from her husband at times. Although she wanted children and Stieglitz didn't, Georgia O'Keeffe never became a mother, and throughout their relationship, she was generally the one who provoked their separations.

O'Keeffe didn't want a husband in the conventional sense. On the other hand, she always counted on ranch hands, studio assistants, and others—women as well as men—who helped her manage the demands of daily living. After all, of the four women mentioned above, she inhabited the most remote landscape, far from the comforts and conveniences of modern life and at a time when driving to a city or even to the nearest town meant a lengthy and possibly risky trip.

Georgia O'Keeffe visited New Mexico in 1929, traveling by train to Santa Fe with her friend Rebecca Strand. Art patron Mabel Dodge Luhan soon moved both women to her community in Taos and gave them studios. Strong women were important to O'Keeffe throughout her life, among them Strand, Dodge Luhan, and Maria Chabot. O'Keeffe lived for a while at the Lawrence Ranch, then at Ghost Ranch, and eventually built a permanent home in the tiny community of Abiquiu, high on a bluff above what was then a dirt road and is now U.S. Highway 84.

The landscape of the Chama River Valley immediately intrigued and inspired her; she never tired of painting its mysteries. The year she arrived, she purchased and taught herself to drive a Model A Ford, in which she roamed every part of that landscape accessible to early automobile travel. Like Frida Kahlo, O'Keeffe was plagued by illness:

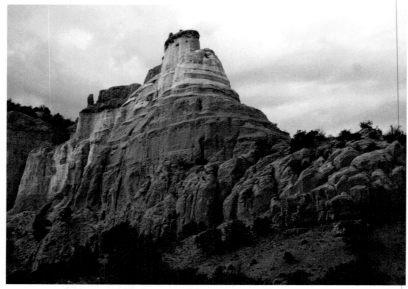

FIG. 4.3. *Echo Canyon, Chama River Valley, New Mexico. Photograph by Margaret Randall.*

bouts of depression, leading to a nervous breakdown, for which she was briefly hospitalized in 1933, and macular degeneration, which in 1972 left her with only peripheral vision.

O'Keeffe often spoke of her relationship to northern New Mexico: the area around Ghost Ranch, a spot she called the "Black Place" (about 150 miles west of the ranch), and the mesas surrounding the home she built at Abiquiu. Among her many expressions of identification with this land was her description, in 1943, of it as a beautiful, untouched, lonely-feeling place, such a fine part of what she called the "Faraway." She said it was a place she wanted to reproduce again and again. In 1977, she wrote, "The cliffs over there are almost painted for you—you think—until you try to paint them."[4]

Georgia O'Keeffe was a loner. Her relationships with Stieglitz, Strand, Dodge Luhan, Chabot, and others were important, each offering support when she needed what they could provide. She tended to

FIG. 4.4. *Rupert Chambers,* Georgia's Black Place, *2020. Archival digital pigment print, 12 by 18 inches. Courtesy of Rubert Chambers.*

FIG. 4.5. *Multicolor cliffs, Chama River Valley. Photograph by Margaret Randall.*

FIG. 4.6. *Ruin of Santa Rosa de Lima church, Chama River Valley, New Mexico. Photograph by Margaret Randall.*

FIG. 4.7 *Santa Rosa de Lima church (detail). Photograph by Margaret Randall.*

dismiss them summarily when she didn't. Toward the end of her life, she lived with Juan Hamilton, a young sculptor who was her companion, helpmeet, business manager, and friend. An acrimonious court battle after the painter's death, disputing what some called Hamilton's "undue influence" on O'Keeffe, was finally settled, with the majority of her estate going to a foundation and Hamilton being allowed to keep the home at Ghost Ranch and a number of her paintings. Her work can be seen in major museums throughout the world, and in 1997, eleven years after her death, the Georgia O'Keeffe Museum was opened in Santa Fe.

The village of Abiquiu was founded in 1754, twenty-two years before the American Revolution. On its small plaza, the church, which O'Keeffe supported generously, is well kept. It is called Santo Tomás and is a typical example of the adobe parishes that dot northern New Mexico. There are a small library and a few other buildings of interest. O'Keeffe's home is secluded behind a wall and thick screen of old trees. No trespassing. One may enter only on a paid tour.

I knew about Georgia O'Keeffe when I came home from Latin America to New Mexico at the beginning of 1984. I was fascinated by her life and work and, knowing she was still alive, yearned to meet her. I remember driving up to her home in Abiquiu, intending to knock on her door. A recently published book of mine and a bouquet of flowers lay on the seat beside me: gifts of introduction. I sat in my car that afternoon for more than an hour but couldn't bring myself to ring the bell. Perhaps it was O'Keeffe's reputation for seclusion, the sense I had that she preferred her privacy to the visit of an uninvited guest, that dissuaded me. I drove away that day without attempting to make contact. Later, I learned that she had already moved to Santa Fe, where she could receive the care she needed in her nineties. A year or so later, she died at the age of ninety-eight.

Georgia O'Keeffe lived a serious life and didn't easily suffer fools or unnecessary frivolity, although she could have as a good a time

as anyone. The postcards and posters and calendars and cookbooks relating to her lack the garish "made in Taiwan" quality of some of the souvenirs that capitalize on Frida Kahlo's fame; they are more tasteful. But, living in New Mexico and traveling often through the still-lonely landscape where the artist made her home, I am always surprised by the degree to which a profit is being made off her fame. I've often wondered what she would have made of it all. Perhaps she would have smiled silently and taken it as celebration. I suspect she might have turned her back and walked away. I don't think she would have enjoyed it as much as Kahlo.

Years after O'Keeffe's death I would come to know her ranch manager, Maria Chabot. She lived at the same senior citizens facility in Albuquerque as my mother, in what would be their final years for both. Chabot would, in fact, become a good friend of Mother's. I was privy to stories about her life with O'Keeffe during the mid-twentieth century. From the tales she told and from a book of their letters, I gained some insight into the relationship between these two women.[5] Chabot was O'Keeffe's ranch manager at Ghost Ranch for four seasons, beginning in 1941. From their correspondence, it is clear that she was in love with O'Keeffe and put aside her own aspirations as a writer to be close to the object of her devotion. O'Keeffe treated Chabot as an employee and friend; their letters don't disclose the sort of relationship the younger woman clearly wanted.

The famous photograph of O'Keeffe hitching a ride on the back of a motorcycle, her head turned toward the person with the camera, was taken by Chabot. I look at that image, long since made into a popular poster, and feel that what Chabot captured in that instant of snapping the shutter tells us something about O'Keeffe's coyote spirit that Stieglitz's studied portraits couldn't probe. Perhaps she was enjoying the life she had not been able to share with her husband. In this image, she is wearing pants and a shirt, has pushed a pair of goggles above her forehead, and is turned toward the camera with a

FIG. 4.8. *Maria Chabot,* Hitching a Ride to Abiquiu, *1944.*
Courtesy of Georgia O'Keeffe Museum, Santa Fe, New Mexico.

mix of anticipation and satisfaction. The man she is seated behind is incidental.

Following their years together, Chabot had many adventures on her own. When I knew her, she was an old butch lesbian who had come up at a time when she couldn't have externalized her sexual identity, and thus lived with a certain bitterness as a result. She is known because of her connection to the artist, a sad footnote, like the collateral damage so many great figures leave in their wake. Georgia O'Keeffe was a unique painter who gained her place in American cultural history by her powerful art and by simply denying the patriarchal limitations of her time.

Mary Elizabeth Jane Colter's
Grand Canyon

Mary Elizabeth Jane Colter (1869–1958) was one of the country's great architects at a time when most professional builders looked to Europe for inspiration and almost no U.S. architect was a woman. To the great delight of those of us who live in our country's Southwest and care about such bounty, many of Colter's beautiful buildings are here. She built them to serve the Atchison, Topeka and Santa Fe Railway and the Fred Harvey Company, responsible for its hotels and adjacent establishments. Today they serve the world. Much of Colter's work was demolished in the 1970s, when train travel gave way to planes. A number of her most original structures remain on the south rim of the Grand Canyon. They perfectly fulfill the seemingly conflicting goal of blending in with one of the world's most spectacular environments while simultaneously standing out as meaningful landmarks.

I live in Albuquerque, and every time I pass its downtown train and bus depot, I mourn the fact that the Alvarado Hotel, which once stood on the site and which I remember from my youth, was torn down in 1970—a shortsighted decision the city would live to regret.

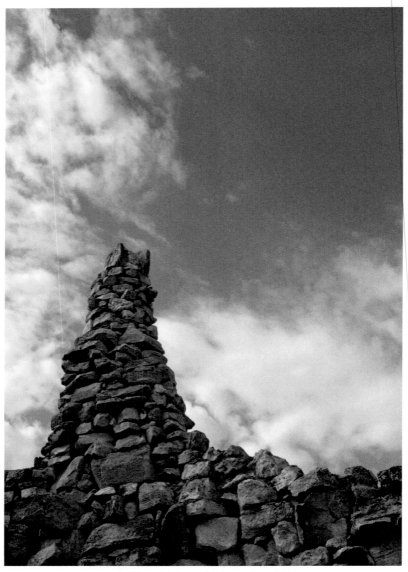

FIG. 5.1. *Hermit's Rest chimney, Grand Canyon.*
Photograph by Margaret Randall.

Albuquerque was not alone in this travesty. As train travel gave way to planes, many of the old railroad hotels met a similar fate. The country is fortunate that examples of Colter's work remain elsewhere.

When Mary Colter was young, there was a single school of architecture in the country, in Oklahoma. She didn't study there. Most builders were self-taught at the time or had degrees in other disciplines, such as art or design. The 1890 census lists only twelve women architects, and by the turn of the century there were little more than one hundred. Being a woman in a profession dominated by men and having to get men to sign off on her blueprints and ask male workmen to follow her orders were obstacles Colter had to deal with throughout her career. And the way she was forced to navigate those challenges did little in the way of gaining her goodwill or recognition while she lived. Colter herself always seemed more comfortable with men than with women. She was forced, after all, to work in milieus in which she was often the only woman in the room. In this, she adopted some of the strategies Elaine de Kooning would develop several decades later: the astuteness, not the flirtatious guile. Through it all, Colter remained an enigma to many, resented by others, a loner traveling extensively and diligently working to understand the land upon which she built and created gem after gem.

Colter graduated from high school at the age of fourteen, demonstrating what would be a lifelong eagerness to learn. She was born into a working-class family in Pittsburgh and grew up in St. Paul, Minnesota. Her father wanted her to study something practical that would make it possible for her to earn a living and care for an older sister who suffered from poor health. It was his early death that allowed her to expand her horizons. Her mother recognized her passion and gave in to her plea to attend the California School of Design (now the San Francisco Art Institute). And her extraordinary success eventually did enable her to support her family, including the ailing sister.

After leaving San Francisco, Colter returned to St. Paul, where she got a job at the Mechanic Arts High School. Meanwhile, she continued studying on her own, reading avidly in archaeology, world history, design, and architecture. In 1899, she joined the New Century Club, composed of women who met to discuss the social, political, and artistic topics current at the time. This was a liberal group; in 1901, it came out in favor of Black women's organizations being admitted to the state and national Federation of Women's Clubs. Given these interests, I have the sense that Colter was progressive, or at least that she was conscious of racial prejudice. She would surely become aware of the way gender discrimination played out in her career.

When I mentioned my admiration for Colter to an employee at the small History Room off the lobby at Grand Canyon's Bright Angel Lodge, the vehemence of his dismissal shocked me: I hear she was a ballbreaker, he said, I wouldn't have worked for her. What was probably just the need for the discipline required to get her projects done the way she wanted may well, in the early twentieth century, have been considered insolence on a woman's lips. Yet I was taken aback that at one of the very venues she created, such resentment could survive and be expressed so emphatically so many years after her death.

It is true that Colter was a hard taskmaster; her refusal to accept anything less than what her vision demanded was what made her work so exciting. Male architects sometimes had to sign off on her plans and workmen often resented the exacting labor demanded by a woman boss. At Bright Angel Lodge (where I had this startling conversation), for example, she asked that boulders for one of her great fireplaces be hauled all the way up from the canyon's various layers of rock strata and placed in just their natural order.

Mary Colter's big break came when she was in her early thirties. She was invited to apprentice one summer to Fred Harvey, whose company was just then establishing its series of railroad hotels as the dawn of train travel began bringing tourists west. It is probable that Harvey's

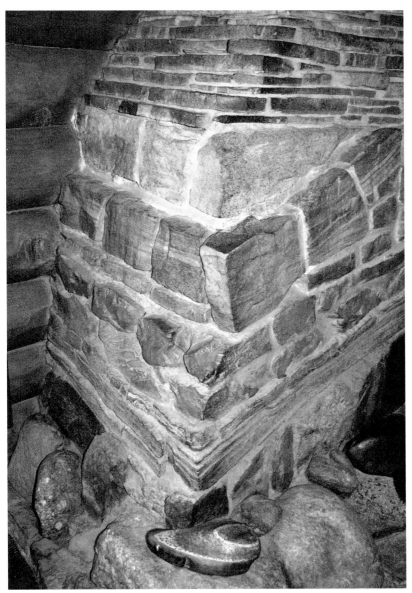

FIG. 5.2. *Detail of rock strata in fireplace, Bright Angel Lodge, Grand Canyon. Photograph by Margaret Randall.*

wife Barbara introduced them and convinced her husband of Colter's potential. Harvey was immediately impressed by Colter's vision and ability. He hired her to design the extraordinary Hopi House at the Grand Canyon, which would remain one of her signature buildings. In 1910, he gave her a permanent position as his chief architect and designer, and the rest is history, a history told only fairly recently in *Mary Colter: Architect of the Southwest,* by Arnold Berke.[1] Before this book, there was one rather thin biography, *Mary Colter: Builder Upon the Red Earth,* by Virginia L. Grattan. Although the latter must be given credit for being the first publication to showcase Colter, it provides only a semblance of the woman's life and is sparse on her architectural achievements. It wasn't until Berke's scholarship that we have been able to appreciate Colter in her considerable complexity and depth.

Mary Colter was a contemporary of Frank Lloyd Wright and, like Wright, was concerned with situating her buildings eloquently and graciously within their natural environments. Wright is credited with developing the Prairie Style. She worked in the Arts and Crafts tradition, molding it to her sensibility and pushing it to new expressions. Wright received accolades of all kinds, Colter almost none during her lifetime.

Speaking of Colter's most unique creation, the Watchtower, Berke points out that "[t]he similarity to Frank Lloyd Wright's Guggenheim Museum, in both design and use, is striking."[2] I have long wondered who influenced whom, especially with regard to employing local materials in order to blend buildings with their natural settings. The Watchtower was built in the 1930s, the Guggenheim in the 1950s. Many of Colter's building preceded Wright's, but as far as I know, he never acknowledged her influence, and the spotlight has always been on him. It's obvious that gender discrimination played a role in how these two architects were perceived. It wasn't until the 1980s, long after some of Colter's railroad hotels had been torn down and she herself was gone, that she began to receive her due.

As tourism in the West increased in the 1930s, every important railroad stop acquired its hotel. Colter designed many of them, adapting each to its surroundings by using local materials, southwestern cultural values, and her far-reaching imagination. She often left wooden beams and pillars in their original rough and crooked condition; indeed, this became a trademark. She got to know and admire some of the great Native American artists and invited them to contribute their work to her interior design. In this, she was ahead of her time, although the ways in which indigenous artists were used at Harvey hotels and shops was not free of exploitation. A company brochure called *The Great Southwest Along the Santa Fe* stated, "The Hopi cling tenaciously to their crude way of living."[3] And in 1929, Grand Canyon National Park superintendent Miner Tillotson described the park region as "one of the very few areas in the United States where the 'red' man still lives in his native state, primitive but happy, contented, unchanged by the white man's civilization."[4] Colter may not have been entirely immune to the racist presumptions of her times (and ours), but in her relationships with Native artists and her use of their work, she is remembered as having been respectful and genuinely supportive.

The station stops established by the Harvey Company established a recognizable atmosphere. Local artists and artisans sold their wares on the train platform. The hotel restaurants became adept at serving delicious full-course meals in the half hour or so the train would be at the station and were known for their generous portions—a quarter pie was one portion! The famous Harvey Girls waited tables in their long black dresses, overlaid by starched white aprons. The aura that surrounded these women resembled that which would envelop the first airline stewardesses twenty or thirty years later; both jobs were romanticized, highly sought after, and paid in line with women's inferior wage scale. They required youth, good looks, a certain code of behavior, and unmarried status. Many young women from the

East competed for the job. Mary Colter's contribution to this culture of western hospitality heightened its authenticity and cannot be overstated.

One of Colter's hotels, La Posada, in Winslow, was saved from demolition when it became the northern Arizona office building for the Atchison, Topeka and Santa Fe Railway. Its once-spacious guest rooms were divided into work cubicles, where the state's waning railroad business was carried out. Later, the building was reimagined and reopened as a hotel. It is popular today with travelers driving I-40 between Albuquerque and the Grand Canyon.[5] La Posada is said to have been Colter's favorite among the lodgings she designed. She was able to choose everything from the landscaping (including a hedge maze) to the furnishings, maids' uniforms, and table china. The result was a classic masterpiece that re-creates a singular moment in American history.

Mary Colter worked for Fred Harvey for forty-six years, beginning as an intern in 1902 and achieving chief architect status eight years later. She did projects throughout New Mexico, Arizona, Seattle, and as far east as Kansas. But by far the most varied and innovative were those she created at the Grand Canyon's south rim from 1905 through the early 1930s. Because of the canyon's popularity with visitors the world over, those creations were also able to survive the terrible demolitions of the 1970s. Long after railway travel faded, the natural wonder itself ensured a steady stream of visitors. Colter built and decorated Hopi House, Lookout Studio, Hermit's Rest, the Watchtower, Bright Angel Lodge and Cabins, and Phantom Ranch, the latter nestled a mile down on the canyon floor as a destination for those descending the chasm on muleback. Over the years, she returned to the canyon to update and refurbish buildings at the site.

Hopi House was Colter's first building on the Canyon's south rim. The three-story red rock structure was designed so that indigenous artists from nearby reservations could live on the upper floor and

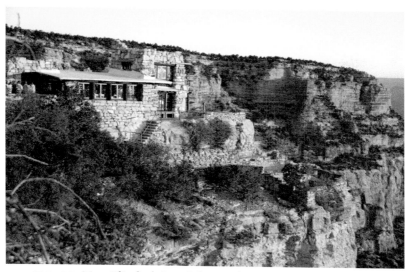

FIG. 5.3. *Mary Elizabeth Jane Colter, Lookout Studio, Grand Canyon.*
Photograph by Margaret Randall.

FIG. 5.4. *Mary Elizabeth Jane Colter, Hopi House, Grand Canyon.*
Photograph by Margaret Randall.

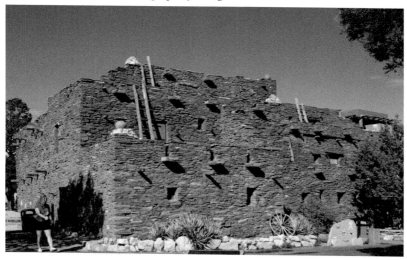

fashion their treasures before the eyes of those who purchased them. It is still a shop today, without the live-in artists. Hermit's Rest, at the far end of the West Rim Drive, is considered by some to be Colter's most original structure. A perfectly conceived off-center rough stone chimney rises from the building to carry off the smoke from one of her vast open-hearth fireplaces—those hearths that invite visitors to gather close in the cold months and are one of Colter's recognizable architectural elements. Lookout Studio, the shop that is literally suspended out over the canyon's rim, almost seems to be carved from the rock strata, blending seamlessly with the canyon walls.

Colter was more than an architect. She was a master theatrical director. Her buildings told stories. She created dramatic stage sets where human and natural history came together in legends she drew upon and reimagined for the benefit of those who would visit. Sometimes she embellished a real history, such as that of a solitary old man who once made camp near where she created Hermit's Rest at the west end of Grand Canyon Village. She structured that building half embedded in the berm of a hillside as an elaboration of the sort of place the hermit would have lived, expanding her vision to include features such as the great fireplace that embraces the lobby and the broad windows that look out on the canyon itself. In other buildings, she told indigenous creation stories or based her design on a Spanish hacienda, with all its attendant romance.

Without doubt, Colter's most spectacular building in the canyon environs—or anywhere—is the Watchtower at Desert View. Neither a hotel or a restaurant, or even primarily a gift shop, it stands simply and proudly as a unique testament to her love of the land, knowledge of and respect for indigenous cultures, capacity for in-depth research, and recognition of some of the great Indian artists, such as Fred Kabotie, a Hopi whose haunting work she brought to national prominence.[6] Today, the Watchtower's ground-floor area functions as one of the canyon's souvenir concessions, and its upper floors are places where

visitors can have a unique viewing experience. Colter finished the tower in 1932 and, although it is located at a considerable distance from Grand Canyon Village, it is a destination well worth the miles.

The Watchtower's base is intentionally rough, built on a natural stone outcropping. There is a sense of its being firmly planted in the earth, not imposition, but growth and continuation. Colter incorporated cracks patterned from ruins she had seen, and stones with petroglyphs brought from nearby Ash Fork. Each exterior stone was selected and placed to achieve exactly the look she wanted. At one point, she had to leave for a day, and the laborers continued to work in her absence, completing two layers. When she returned, she wasn't satisfied with one of the stones and made the men remove and redo their entire day's work.

The tower rises seventy feet above the rim. It is the only building that can be seen from the canyon floor a mile below. Colter flew over the Four Corners region and observed the Ancestral Puebloan ruins of the small native watchtowers still visible there; she had also seen the towers at Canyon de Chelly, Hovenweep, and other indigenous sites, all rising off foundations provided by natural rock boulders. Although she didn't model the Watchtower specifically on any of these, they undoubtedly inspired it.

With the Watchtower, Colter was, again, telling stories—using material, form, content, location, and time as her language. I often think of Colter, an aloof and demanding woman, who walked through life alone and whose curiosity kept her traveling the land she honored and transformed as she built a unique vision out of her sense of time, place, and those who inhabited that place. And she didn't believe that her work ended when a structure was complete, but had precise ideas about how it should be presented to the public. She intended her buildings to be performed. *The Manual for Drivers and Guides Descriptive of the Indian Watchtower at Desert View and its Relation, Architecturally, to the Prehistoric Ruins of the Southwest* was a detailed

pamphlet Colter wrote with instructions for those taking early visitors through the building.

Inside, it's the tower's upper levels that are most captivating. By way of a narrow staircase, gripping banisters still wrapped in the original rawhide, you ascend from one floor to the next. There are many stories embedded in the paintings and artwork on the walls. On the first landing is Fred Kabotie's art, which pays homage to Hopi cultural history. The circular ceiling is the Watchtower's crown jewel: a sort of southwestern Sistine Chapel. It was painted by Fred Geary[7] and re-creates images from the Abó rock shelter, now part of Salinas National Monument, in New Mexico. One can look up from a lower floor through a circular central opening at the rich tapestry of iconography directly above.

On an intermediate floor, a terrace opens to sweeping canyon views. Colter undoubtedly chose this spot with these views in mind. From here, you look downriver, the multihued buttes spreading out on either side. But Colter wasn't content to simply offer the overall vista. She placed small windows—some of them square and others irregularly shaped—in strategic spots along the tower walls. On the terrace, makeshift devices called reflectoscopes—wooden boxes with mirrors inside—turn what is seen through them upside down, framing singular views she must have considered at length.

Sometimes we get to admire an edifice whose reason for being is to bestow wonder, some combination of building, monument, and sculptural experience. The Eifel Tower and the Taj Mahal come to mind. The Watchtower is one of these. It enhances a natural land feature one might think could not possibly be made more stunning. It embraces the ancient as well as exuding a profound sense of timelessness. It simply is. And within it, you can feel the ways in which Colter was connected to this land, this history, this unequaled place on Earth.

Desert View Watchtower was designated a United States National Historic Landmark as part of the Mary Elizabeth Jane Colter Buildings

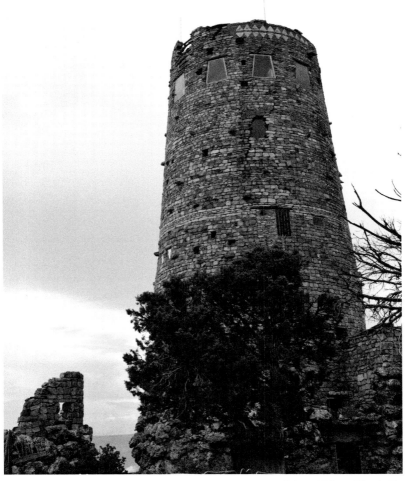

FIG. 5.5. (above) Mary Elizabeth Jane Colter, the Watchtower, Grand Canyon. Photograph by Margaret Randall.

FIG. 5.6. (left) The Watchtower with gargoyle. Photograph by Margaret Randall.

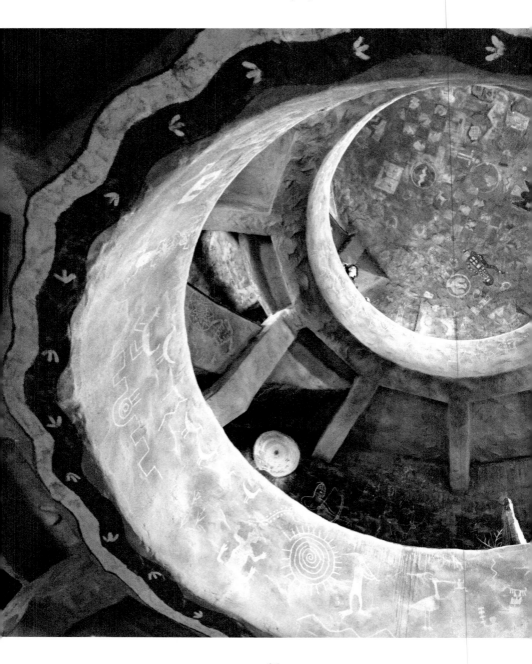

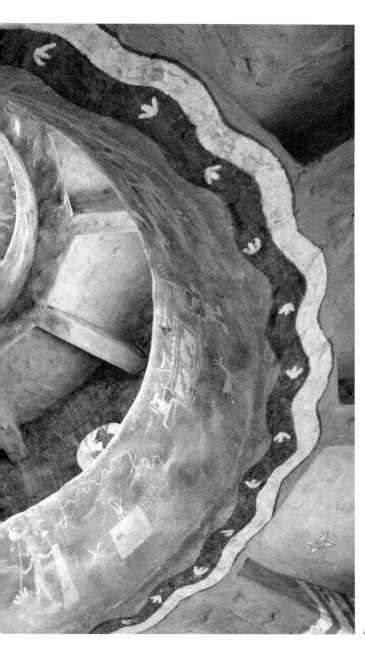

FIG. 5.7.
*Looking up at
the Watchtower
ceiling.
Photograph by
Margaret Randall.*

collective nomination on May 28, 1987, comprising the Watchtower, Hopi House, Lookout Studio, and Hermit's Rest. The tower is also part of a National Register of Historic Places, the Desert View Watchtower Historic District, designated on January 3, 1995.

A powerful corporation gave Mary Colter, a young untrained woman, free reign to imprint her vision on the design and decoration of buildings that became national treasures. She could be a rude task-master, wasn't always liked by those who worked under her, and never married. Her attitude toward children was that of many geniuses; she didn't really pay much attention to them until they were old enough to carry on an intelligent conversation. She recognized the talent in indigenous art at a time when many still believed American Indians to be savages, certainly not creators of anything beyond handicraft. These are some of the qualities that come through in the scant writing about her life. Going beyond the biography to discover the human takes imagination, conjecture.

Colter not only created and decorated on the grand building scale; she designed the harmony and beauty of more intimate objects, as well. An elegant example is the iconic tableware she produced for the dining car of the Santa Fe Chief, using stylized Mimbres Indian bird and animal images to anchor each piece. Fine replicas of those unparalleled dishes grace many tables today, including mine.

I saw some of Colter's buildings as a ten-year-old, when I first visited the Grand Canyon with my parents in 1947. When older, I began to notice and appreciate their special features, how they seemed to grow from the land, the ways in which they made use of materials that one saw in the rough around them. This caused me to want to know more about the woman who created those buildings. I found that little had been written about her, and what there was seemed superficial. It was as if it had been enough that she'd been permitted to do such prominent work; we didn't need to know about her life and challenges.

And then we met. No, not in person; Colter died in 1958, long before my admiration sent me searching for her. We met in a dream in January 1986. My wife, Barbara, and I had fallen in love a few weeks prior. One day, we shyly admitted to each other that we wanted rings. That night, Mary Colter visited me in my sleep. She told me we would find our rings at Hopi House, on the south rim of the Grand Canyon, a landmark I knew well from many previous visits. A few days later, we made the seven-hour drive.

The next morning, braving the high-altitude winter cold, we were waiting at the shop door when it opened. But perusing its selection of rings, we didn't see anything we liked. We tried another of the canyon's souvenir shops, where we found a ring with a single bear claw incised in a medallionlike circle. We were drawn to the symbol but were looking for commitment bands, not something that looked like a class ring. We returned to Hopi House then and, as if they had been waiting, discovered two silver bands we hadn't spotted earlier. They bore the same bear claw design. One was in Barbara's size, the other in mine. Mary Colter's vision has earned a central place in our lives.

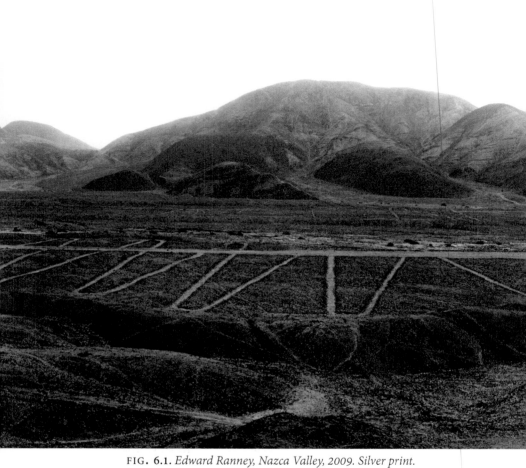

FIG. 6.1. *Edward Ranney, Nazca Valley, 2009. Silver print.
Courtesy of the photographer.*

Edward Ranney, Lucy Lippard, *and the Ancients Who Made the Nazca Lines*

... the behavior, culture, language, and social
organization of rocks. — *The Onion,* November 13, 2014

Every so often, I come across a book that is more than just a book.
I know I won't just read it once and then relegate it to my personal
library, where it will remain until I seek it out again at some point.
Its contents announce themselves as engaging in a way that tells me I
will consult it often for wisdom, inspiration, or connection. *The Lines,*
by Edward Ranney, is such a book.[1]

What do we expect or want from books about ancient archaeo-
logical sites? Simply a coffee-table edition for a bibliophile to pet and
show off? Art publishers often produce publications of an elegance
that far outweighs content. Perhaps an exquisite collection of *National
Geographic*–type photographs that entices us to make travel plans
of our own? I am searching for beautiful reproductions, and today's
print possibilities certainly make that possible. But I also yearn for
information, and what I often find is either superficial tourist propa-
ganda or something so complex that I would have to be a specialist

to crack the code. I knew I should have taken more science, I mutter to myself as I grapple with passages for the fifth or sixth time.

The Lines is none of these. This ten-by-eleven-and-a-half-inch eighty-eight-page hardcover volume might not immediately grab the attention of someone browsing through a bookstore. This is because it is understated, immensely subtle, its front and back covers pale grayscale images of a place most commonly and dramatically photographed from the air but rendered here at ground level. None of the enhancements. Just an extraordinary landscape the way one would see it walking across its sandy pampa, reproduced exquisitely.

The famous lines and other land features of southern Peruvian valleys, created by the Nazca culture some two thousand years ago, although only discovered by outsiders in the 1920s, and similar large geographical features on Chile's Atacama Desert to the south have fascinated anthropologists and others for a century. They are most often referred to as geoglyphs, created by removing the top layer of reddish brown iron oxide–coated pebbles to reveal a yellow-gray subsoil. The width of the lines varies, but most are about a foot wide. Individual figures measure between two-tenths and seven-tenths of a mile in circumference. Their combined length is over eight hundred miles. Aerial photography, with its intense contrast and larger-than-life aura, represents the Nazca Lines as if they had been made by supernatural beings on a canvas too vast for humans to take in. Indeed, some believe they were made to be seen by deities in the sky. Edward Ranney's photographs in *The Lines* reveal a more intimate Nazca. In her accompanying essay, Lucy Lippard tells us:

> [T]he lines are not invisible from the ground, (though . . . if you pass twenty feet to the side, they can vanish), but local residents who knew them may initially have been reluctant to advertise their presence. Their own oral histories would suffice within the culture, and "discovery" by outsiders was not necessarily desir-

able (though the modern economy has flourished with tourism and an astounding level of grave robbing).

Ranney and Lippard understand and transmit the tensions between remnants of ancient cultures and the ways in which those cultures are perceived, used, or abused by those who try to access their legacies. *The Lines* also includes a selected reading list of in-depth studies for those interested in exploring the subject from diverse disciplines.

This land art, for lack of a better descriptive term (applying our modern definition of art may be our first mistake), is about rocks and geometry. It is also about social organization, which is why I begin this text with a quote from *The Onion,* which, for those who may not be familiar with it, is a satirical paper that spoofs the news, often obliquely pointing up the absurdities in much of what passes for information today. This particular quote ascribes behavior, culture, language, and social organization to rocks, an assertion that may seem ludicrous to some. The Nazca Lines and this book that explores them in such evocative photography point to the fact that despite its satirical intention, *The Onion* may be onto something.

The land on which the mysterious designs are embossed is usually referred to as desert: the Peruvian desert, the Atacama Desert of northern Chile. Ranney uses the word the natives use, *pampa,* the Spanish term for a high grassy plateau. The word much better describes the locale. Sandy areas are covered in places by the stubble of tenacious grass. Rocks are everywhere. This is dry, hardscrabble land, the sort from which it is hard to eke a living. Ranney's photographs, made on the ground or from the elevations of surrounding hills and ridges, see the lines and biomorphs (symbolic, animal, and hominid images) as those who created them saw them. Perspective is everything.

Sometimes the photographer is looking up a valley, sometimes across. Many shots appear to have been made almost at ground level. In one image, the photographer positioned his lens from around

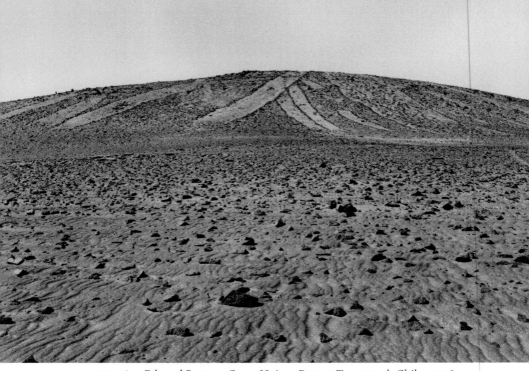

FIG. **6.2.** *Edward Ranney,* Cerro Unitas, Pampa Tamarugal, Chile, *2006. Silver print. Courtesy of the photographer.*

the corner of a prominent foreground rock. Ranney's meticulous large-format detail is rendered in many tones of gray rather than the high-contrast black and white obtained through digital or darkroom manipulation. One doesn't feel the need to view these images in color. In this and other aspects (frame of reference, angle, feel), they more accurately simulate the high-altitude landscape with its thinness of air and light. I can imagine gazing breathless at the places Ranney gives us.

Ranney has been photographing in Peru's Ica Valley and Rio Grande de Nazca drainage for thirty years and, more recently, on Chile's ten-thousand-foot-high Atacama Desert. In his brief but deeply resonant introductory text, he says that one of his interests has been "to explore how geoglyphs in different areas of the coastal desert occupy and alter space on ground level." He sees the lines as "a form

of mapping, marking reference points and connections within the landscape, thereby transforming a harsh natural environment into an understandable, even intimate cultural space." Not everyone has the ability to go beneath the surface of maps, unearthing or even hinting at their secrets. Ranney has that kind of eye.

The forty-four photographs float unidentified, except by a number that corresponds to a list at the end of the book, each on a white field slightly wider than it is high. These are all horizontal vistas, as landscape tends to be when viewed by humans. Almost all the images are on right-hand pages, with the corresponding left-hand page left blank. The exceptions are six pairs, printed facing one another. At first glance, some of these pairs might appear to be panorama shots split by the book's spine. A moment's assessment reveals they are not. This thoughtful placement is clearly part of the experience Ranney wants the reader to have, requiring close attention to the layers of meaning in the configuration of the rocks, lines, and figures themselves. He is inviting us to observe this landscape as we would if we were walking across it, free from explicative signage or contemporary analysis.

We study one image and note a low pile of dark rocks ceding to another and another along a line that moves away from the eye, unmarked by anything but themselves as they go up a gentle hill and over its crest. We see parallel "roads" converging at distant points. We take in a hillside crisscrossed by lines that appear to be as narrow as wild animal tracks; some rise straight up over mountainous terrain, as if they had been drawn there with white chalk. We observe concentric circles over a vast plain with a ridge of trees and mountains beyond. And we trace curved as well as straight lines, delineating immense figures in communal movement. There are fields of complex mazes, like labyrinths to be walked by giant beings. These are commanding figures, their intricate designs produced by a clearing of topsoil and preserved through the centuries in a region where it rarely rains and there are few trees.

FIG. 6.3. *Edward Ranney,* Palpa Valley, *2004. Silver print.*
Courtesy of the photographer.

Isolation and a dry, windless climate have favored the lines' pres-
ervation. The great natural canvas has enemies, though: thoughtless
human destruction, pollution, deforestation that causes soil erosion,
and an influx of squatters looking for places to call home. In 1994, the
Nazca Lines were designated a UNESCO World Heritage Site, which
should help protect them. As maps, they have something to tell us we
need to hear.

Lippard begins her essay observing, "The ancient world continues
to throw up surprises for today's purportedly advanced civilizations,
in the process exposing the limitations of our own Eurocentric views
and expanding the potential of nature as mentor." Nature as mentor.
This sets the tone of a text in which Lippard makes her case with that
combination of cultural sensibility and complex political insight we
have come to expect in her work. Early on, she assuages our curiosity

as to how this land alteration was made: "[T]hey were created primarily by a subtractive method, scraping away the black rocks covering the pampas' pinkish 'desert pavement.' (Some earlier glyphs were formed additively, outlined with stones, and a few combine the two methods.)" Materiality draws us into meaning.

Lucy Lippard is one of the great creative minds of my generation. She has given her research and introspection to a number of arts books but has also written many volumes of her own cultural criticism, several of which I taught to ever grateful students when I worked at a series of U.S. universities in the 1980s and 1990s.[2] I recommend Lippard's books to anyone eager to understand the connections between art, ideology, and public policy. Or simply to those who appreciate brilliance.

The Nazca Lines and neighboring forms have their origins from around two hundred years before the Christian era to approximately five hundred years into it. They were conceived of and executed by an agricultural people who, despite considerable study since the 1920s, are not thoroughly understood. We know they developed a sophisticated system of underground aqueducts to deal with the paucity of water. We know they produced beautiful ceramics, and weavings reminiscent of their Paracan ancestors. The Spanish decimated the Nazca culture in 1532, as it did so many thriving societies. The Nazca left no written language as we define that, although the lines, the older Paracas textiles, the *ceque* system (what Bernabé Cobo called "a tactile form of language"), and the *quipu* way of recording events via series of knots on cords may all be considered communication and related in one way or another.

Lippard's essay in Ranney's book is titled "Above and Beyond the Straight and Narrow," and here, as in all her work, she asks important questions; explores answers, using a wealth of scholarship considered in terms of possibility rather than certainty; and goes beyond the topic at hand to offer thoughtful extrapolations of our current concerns:

FIG. 6.4. *Edward Ranney,* Viscas River Valley, *2001. Silver print. Courtesy of the photographer.*

ownership of time and place, how we inhabit space and how we define its limits, human creativity as expressed in the modification of landscape, climate change, environmental degradation, commercialization and marketing, how we might return to practices that safeguard our habitat, and the ways in which communities draw on cultural capital to find their way out of economic and social distress. What values are expressed in the Nazca Lines?

Lippard asks, "Why straight lines?" and explains that "straight and crooked pathways render very different experiences of place." As I read this essay—and this happens to me more often than not when reading Lippard—I felt like she was always one step ahead of my own thinking and I was running to catch up. Her discussion of straight lines that do not snake or switchback up mountainous terrain, but

climb straight over geographical impediments, made me think of the Chaco roads of the U.S. American Southwest. A sentence or two later, Lippard was making the connection. I wondered about a possible link between the phenomenon depicted in this book and rock art that served as terrestrial or celestial landmarks in other cultures. A paragraph further along, Lippard addresses this subject in her consideration of the Peruvian creations by referencing the pictographs and petroglyphs found at Ancestral Puebloan sites and others. I began thinking of twentieth-century land art by such artists as Richard Long, Ana Mendieta, Walter De Maria, Andy Goldsworthy, Charles Ross, and Jon Foreman. Immediately, Lippard brought this present-day making of art on the land into her conversation with the reader.

English land artist Richard Long created *A Line Made by Walking* in 1967. Long walked back and forth in grass, leaving a track that he then photographed in black and white. His work balances on the fine edge between performance art and sculpture. About this piece, he has written that walking—as art—provided a simple way for him to explore relationships between time, distance, geography and measurement. Ana Mendieta placed her own body on the earth, leaving an impression that was an artistic statement. These pieces might have been inspired by the lines and figures engineered by the Nazca people in ancient Peru. Or perhaps they were compelled by some modern-day version of a similar need.

The most important distinction between the Nazca Lines' alteration of landscape and those alterations produced by twentieth-century artists is that the former worked in and for their community, while the latter make individual, albeit often beautiful statements. Sometimes, as with Mendieta and Goldsworthy, the artist intends a natural dissolution of the artwork: Time and weather will destroy the piece, which then remains only in photographic memory. Foreman's elegant arrangements of varicolored rocks on sand are stunning and

also not erected with any permanence in mind. But sometimes, as in the case of De Maria, the artist alters the landscape in a more permanent way. In his *Lightning Field* in western New Mexico, a large grid of stainless-steel poles irrevocably changes the landscape of a small valley; De Maria imposes his notably phallic ownership upon the land.

The Nazca Lines could not be more different from these and other examples of contemporary land art. Their construction obviously required group cooperation, but it is likely that their creators worked together on equal terms rather than in the rarified air of art hierarchy (with the help of paid or unpaid assistants) or people who were indentured or enslaved, as was true of those laboring to build Egypt's great pyramids or Europe's Gothic cathedrals. Although we cannot presume to understand what motivated the Nazca people's creative effort, we can see that it responded to a worldview unlike that which dominates today's consumer culture.

As Lippard points out, "The deliberate loneliness and isolation of contemporary land art appropriate the forms of ancient cultures while simultaneously disregarding their values and belief systems. The ancient models were actively communal. . . ." She quotes artist Robert Morris, "writing firsthand about the Nazca lines and Minimal art in 1975, [as defending] his contemporaries' lack of interest in communication, [and] describing the then-new art as explorations of 'the space of the self.'" What could be a more self-involved use of landscape?

Lippard explains that Nazca wasn't a state society, and "centralized leadership and a labor pool were not required to make the drawings." She refers to John Reinhard's speculation that "they may have been constructed by small groups during slack periods in the agricultural cycle." Yet their vast size and reach, the profound ways in which they altered the landscape for their creators and continue to alter it for us today, speak to a vision of immense proportions. Many of the Nazca Lines go to the horizon, and the photographs in this book make us

FIG. **6.5.** *Edward Ranney,* Lower Ica Valley, *1994. Silver print.*
Courtesy of the photographer.

FIG. **6.6.** *Edward Ranney,* Nazca Pampa, *1985. Silver print.*
Courtesy of the photographer.

feel that they continue beyond it. This was community communication, a way of conversing with place and preserving memory for those who would come later.

Ranney's photographs are deceptively matter-of-fact yet haunting. They breathe quietly but deeply on the page. Lippard draws on the observations of chroniclers, anthropologists, ethnographers, astronomers, historians, artists, and poets for clues to the nature of these lines and glyphs, the why of their conception, the possible meaning in the communal activity required for their construction, and their significance for the people who made them part of their landscape as well as for those today who believe they have something to say to us. She explores directionality, seasons, kinship, and collective memory. She gets us pondering ritual, signage, and identity. Together, photographs and essay open a window onto human alteration of landscape that is both majestic and relevant.

In this chapter, I link the work of photographer Edward Ranney, cultural critic Lucy Lippard, and an ancient people who created mysterious lines and figures across vast areas of South American desert two thousand years ago. I hear them in conversation with one another. The two contemporary voices made the link themselves by collaborating on this book. They have the advantage of looking at the work of their interlocutor of so long ago from their modern sensibilities. But those who made the lines have the advantage of having been first, concretizing intention without concerning themselves about what would be said of their gesture. It is precisely because we cannot know why they created those impressive images that they will forever be asking us questions.

CHAPTER 7

Leandro Katz:
The Catherwood Project

Land, its purpose and ownership. The buildings it inspires and em-
braces. Those who inhabit the land, how they manage, shape, protect,
and build upon it. Who names these people and their places, who
draws the maps, and whose interests do they defend? What cultures
grow, are denigrated or usurped, and eventually destroyed, only to rise
resistant once more, whispering their secrets to future generations?

Human movement leaves its footprint. Migrations across vast
areas deposit traces before moving on. At ancient sites, we discover
bygone technologies and ponder the meanings of features we call
art but which may reflect attitudes we are still trying to decipher. In
the previous chapter, I looked at the Nazca Lines, immense images
"drawn" by people two thousand years ago, photographed by a con-
temporary lens and analyzed by a cultural critic who has done a great
deal of thinking about such phenomenon.

Leandro Katz is a poet, visual artist (often of large constructions),
photographer, filmmaker, and translator. One of the things I love about
his art is that he tends to take a subject and explore it for years, build-
ing upon the kernel of an idea to create a many-layered offering that is

extraordinarily rich in texture and meaning. Creative research is part of his process, and he travels where and as often as he must in order to absorb context and meaning. Katz brings his interest in memory, symbols, iconography, semiotics, image, and history to bear on all he creates. This is true of his alphabet of moon phases, which startles the viewer on the keys of an old-fashioned typewriter or on one whole wall at New York's Museum of Modern Art[1]; his project on Che Guevara (which resulted in a film and book as well as a photographic essay)[2]; and *The Catherwood Project,* which is what concerns me here.

In *The Catherwood Project,* Katz employs political curiosity and photographic gaze to replicate and speak about the drawings of Maya monuments made by Frederick Catherwood (1799–1854) more than a century before. In this, Katz worked like Edward Ranney over a period of many years, attempting to inhabit the mind-set of those earlier architects and attending to particular angles to achieve his desired results. Aesthetically, however, the two men's work is quite different. While Ranney gives us a hazy high-altitude view of the Nazca Lines, achieved by looking through dry heat, Katz's project is as wet and fecund as the lowland jungles in which the Maya built their majestic architectural marvels. In one of the images, in which Katz holds an engraving by Catherwood up against his own photograph of Casa de las Palomas at Uxmal, the background photograph exudes a feeling of wetness that evokes waiting until the last possible moment to lift a darkroom print from the developer, just as it has attained its point of saturation. Including the artist's hand in the image functions like a bridge from one century to another.

Katz describes *The Catherwood Project* as a work about time. There is the obvious juxtaposition of Katz's time upon that inhabited by Frederick Catherwood and John Lloyd Stephens (1805–1852) when they explored the Maya ruins in the nineteenth century, as well as Catherwood and Stephens's time in relation to the era in which the Maya built

FIG. 7.1. *Leandro Katz, Uxmal—*Casa de las Palomas, *1993. Gelatin silver print, 16 by 20 inches. Courtesy of the photographer.*

their cities. But time is not linear in any of these periods, nor in the whole. It moves backward and forward or perhaps on a spiral journey through disparate stages of history, influencing our perception of that history embodied in the art.

I don't know Ranney. I saw his images in a book and felt instant communication. I had seen the Nazca Lines only in reproductions, all of them dramatic aerial views, until I came across his ground-level images, which spoke to me in ways others didn't. Katz and I have a long friendship, one I value beyond measure. We were young poets together in the heady Mexico City art scene of the 1960s. We both suffered deep personal loss as a result of the Dirty Wars that ravaged the southern cone of South America in the 1970s and 1980s. We hold on to the pride of our social justice struggles while acknowledging their painful failures.

Katz and I have also had occasion to talk about *The Catherwood Project.* And I have visited the Maya sites that drew Catherwood, Stephens, and him. I have stood long hours at Uxmal and Tulúm, looking at some of the same buildings from the very same angles; Uxmal, with its air of mystery almost intact, and Tulúm by the sea, its small beach backdrop to original inhabitants, smugglers, and modern-day bathers. I have explored Labná on the Ruta Puuc. Most meaningful, for someone like myself, who shares with Katz a generation's profound defeats and search for elusive justice, this work looks at issues linked to that search and those defeats with complexity and nuance. Much of Katz's work, rather than proclaiming only the glory of our struggles, attempts to understand their shortcomings.

And I have viewed pieces of *The Catherwood Project* not only in a book but mounted on perfectly lit walls at SITE Santa Fe's 2014 biennale and in an equally well-designed exhibition of the artist's work at the Museum of Science and Art (MUCA) at the University of Mexico four years later. It is a work that has been exhibited in its entirety or (more often) partially in museums around the world. My relationship to these two projects is necessarily different.

Here's the history behind *The Catherwood Project.* Travel writer John Lloyd Stephens and artist Frederick Catherwood met in Europe in 1836 and read Juan Galindo's account of the Maya ruins at Copán, Honduras.[3] They decided to visit Central America themselves, with an eye to producing a more detailed and better-illustrated account. Their expedition came together in 1839 and continued through the following year. They visited and documented dozens of ruins, cataloging many for the first time. Stephens wrote about what they saw, while Catherwood made drawings using the camera lucida technique. He later rendered those visual records as steel engravings. They were so accurate that even after photography was routinely being used to record the Maya world, they continued to be consulted for cartographic

perfection. Catherwood's attention to detail and his insight allowed him to produce a sensitive record that continues to speak to us.

Stephens and Catherwood were inspired by such explorers as Galindo and Alexander von Humboldt. They, in turn, influenced Edgar Allan Poe. Thus, the long chain of artistic giving and receiving that is so fascinating when we begin to explore how one generation's engagement leads to another's. Stephens and Catherwood were involved in the practice of seeing that Katz continues in our time. They were credited with "rediscovering" the Maya civilization. Their work resulted in several publications, including the iconic *Incidents of Travel in Central America, Chiapas, and Yucatan* (1841). They returned for more exploration in 1843. Their relationship was clearly magical and extremely productive. I imagine them as lovers at a time when gay identity had to remain unspoken.[4] Sadly, both men died young.

So many years later, Katz has used one of the products of this generative relationship as the basis of his own artistic inquiry. "During the summer of 1984," he writes, "I had the opportunity to work in the Yucatan area, photographing the Maya sites drawn by Catherwood." Much as in such projects as *Grand Canyon, a Century of Change: Rephotography of the 1889–1890 Stanton Expedition,*[5] Katz sought identical positions and angles:

> In this way, I started to compile the elements of a work-in-progress called The Catherwood Project, a visual reconstruction of Stephens and Catherwood's expeditions. I continued this project into the summers of 1985 and 1986, covering other sites in the Yucatan and Chiapas region in Mexico. During December and January of 1987/88, I completed the itineraries of the two expeditions, photographing at Quiriguá in Guatemala and Copán in Honduras.[6]

I am drawn to this extreme "time-lapse" photography, the practice of returning to a place that has been documented many years before

and recording it from the same angles, often even at the same season of year and time of day, to show how it has changed or not. But while the Grand Canyon project was commissioned to determine the viability of building a railroad through the canyon, thus documenting nature and science in an effort to understand if such a project would be commercially profitable or detrimental to the environment, Katz is less concerned with which giant barrel cactus remained standing one hundred years later or how erosion might have changed a river's course, and more with the changes wrought upon an archaeological site by conquest and time. It is emotional, political, and makes connections that can only be evocatively made in art.

Katz has explained that his "intention when starting The Catherwood Project, which resulted in nearly 4,000 black and white photographs and 1,800 in color, was not only to re-appropriate these images from the colonial period, but also to visually verify the results of archaeological restorations, the passage of time, and the changes in environment," all elements acquiring an added significance—indeed an urgency—as humans finally begin to recognize our environmental and sociopolitical impact on the Earth. As Katz says, "In this 'truth effect' process, issues having to do with colonialist/neocolonialist representation become more central . . ."

Katz writes that in the process of covering the itinerary of the Stephens and Catherwood expeditions, he became aware of Catherwood's struggle to depart from his Eurocentric style: "[P]revious explorers could only manage to document the sites by merely reproducing the style and the vision of the Romantic period. The line in their drawings was wrong, their final results a fiction. . . . [Catherwood] managed to enter the mind of the Maya architects, challenging his own Western hegemony."

In a wonderfully revealing interview with filmmaker Jesse Lerner, Katz has said he believes "we tend to judge ancient cultures in the American continent with a Eurocentric eye, forgetting the medieval

morals that ruled the old world." And he asks, "Aren't we still strug-
gling over our origins, the universe, the planet? I think that we are
still living in the Middle Ages."[7]

Being able to enter the minds of those who inhabited an earlier
and entirely different cultural and sociopolitical period requires the
ability to extract oneself from the limitations imposed by centuries of
conditioning. It means being able to leave behind all modern-day pre-
conceptions. It is not easy and rarely accomplished to any significant
degree. Leandro Katz does this in *The Catherwood Project,* not only
by transporting himself back in time but by engaging a sensibility that
enables him to peel away layers of meaning and also to superimpose
the distortions of those layers.

Katz describes his approaches to producing the works in this proj-
ect. First, he attempted to adopt as closely as possible the same points
of view used by Catherwood, "which at times included lower or ele-
vated perspectives, often," as described above, "incorporating a view
of his own hand holding Catherwood's published engraving in front of
the documented monument, making the comparison the subject of a
single photograph. The third approach . . . follows Catherwood's vision
of the site directly and without visual quotation. At this stage, although
the original structure is still being followed, the conceptual rigor of the
project becomes more abstract."

We grasp what Catherwood did 170 years ago, how Katz appro-
priated the earlier artist's struggle, imbuing it with his own passion
and concerns, and what places, such as Uxmal, Tulúm, Chichén Itzá,
Palenque, Tikal, and Labná, tell us about our contemporary world.
A colored photograph leaves Catherwood behind. In it we see a ruin
cleared of underbrush and made accessible to today's steady stream
of visitors, overrun by brightly and sometimes scantily dressed tour-
ists who trod its delicate walls without thought for the destruction
they may be causing. The image is Katz's final statement; he need say
no more.

FIG. 7.2. Leandro Katz, House of the Nuns, after Catherwood (Uxmal). *Gelatin silver print, 16 by 20 inches. Courtesy of photographer.*

Mexican art critic, curator, and historian Cuauhtémoc Medina makes the issue more explicit:

> The virgin gaze is a utopia. Engraving, photography, film and television have colonized the world to such an extent that seeing is almost always a comparative process dependent upon a previous image. Tourism, far from being a search for the extraordinary, is fed in large part by this iconic accessibility or familiarity. Before boarding a plane or getting into a car, we carry with us the often very precise vision of the place we're going to visit and its things. And so, we frequently travel simply in order to verify what we have already seen, to make a souvenir of that which we remember. . . . [In *The Catherwood Project*] Katz places before

FIG. 7.3. *Leandro Katz,* Templo de Dios Descendiendo, Tulúm, *1985. Chromogenic print, 20 by 24 inches. Courtesy of photographer.*

us precisely the accumulation of those levels of historic memory and the tensions between tourism and the romanticized images that feed it.[8]

At many archaeological sites, sound and light shows are staged to seduce and entertain the tourist trade. They necessarily romanticize the society about which they speak. The ancient monuments are accentuated in ever changing colors and sound track, a disembodied voice offering a narrative that may or may not have anything to do with the reality or culture on display. Such shows do a grave injustice to these sites, interpreting ancient cultures through a consumerist lens that is intended to make it more enticing to the contemporary viewer. It is through renderings such as *The Catherwood Project* that we may travel a more authentic road to the possible meanings of such sites.

I am interested in the sociocultural aspects of how images affect the way we see where we live and visit. I want us to contemplate

FIG. 7.4. *Leandro Katz, Labná*—Estudio para la Noche del Tiempo
Transfigurado, *1993. Chromogenic print, 20 by 24 inches.*
Courtesy of photographer.

mapping in all its definitions. I know that art, when it works, alters
our perceptions of our own reality. I am fascinated by Leandro Katz's
ability to move backward and forward within the art he creates, pro-
voking us to follow similar journeys as we immerse ourselves in *The
Catherwood Project* and other examples of his work. I am grateful for
his vision and how it feeds my own.

The Great Gallery and
Our History Is No Mystery:
Two Murals Across Time[1]

I.

In tiny Hanksville, Utah—little more than a crossroads with a gas station, a convenience store, a couple of shabby motels, and a few houses—we visited the local Bureau of Land Management office for instructions to Horseshoe Canyon. The man behind the desk seemed surprised to see us. He roused himself from a book and pointed out the thirty-mile drive on a tired map, said we would come upon an old barrel by the side of the road and it would be our indication to turn. From there, it would be several more miles of dirt track to the trail-head, which had a pit toilet, he said. We'd probably see a few other cars.

It was a brilliant early-spring day—fierce blue sky and desert light glancing off canyon walls—and it was hot. We felt a mounting anticipation as we followed the directions we'd been given. Once at the small parking area, we made sure we had enough water, laced our hiking boots, locked up the car, and set out. The first part of the seven-mile trail descends six hundred feet over switchback slickrock, our way occasionally signaled by a cairn. Soon we were on the canyon floor, trudging through the thick sand of a dry riverbed. A couple of

plump chukars strutted out from behind some brush. Horseshoe is a detached part of Canyonlands, its much better known and more frequently visited "other half," far to the east. Few hikers, perhaps only somewhere between a dozen and twenty a day, drive to Hanksville to explore this remote canyon and its extraordinary pictographs.

Horseshoe, or Barrier Canyon, as it is sometimes called, has its history. Fossilized dinosaur tracks can be seen in the slickrock near an old water tank. Outlaws like Butch Cassidy made use of Horseshoe in the late 1880s, hiding out in the circuitous warren of adjacent canyons. Later, in the early 1900s, ranchers built several stock trails into the canyon so cows and sheep could reach water and feed at the bottom. Eventually, the ranchers constructed a pumping station to fill water tanks on the canyon rim. Many of these modifications are still visible, although in shambles now. Prospectors explored the area in the mid-1900s, improving some of the trails to accommodate vehicles and drill rigs. Although they searched the rock layers for oil and other minerals, no successful wells or mines were ever established. After being added to Canyonlands National Park in 1971, grazing and mineral exploration were discontinued.

We were interested in a history generally referred to as "prehistory," many thousands of years before the written record. Exactly how many years is still up for discussion. In the 1970s, the rock art expert Polly Schaafsma dated the pictographs we had come to see to between 500 B.C. and A.D. 500, or roughly two thousand years ago. Others make a narrower reference, to the Late Archaic period, from 200 B.C. to A.D. 500. Still others say they are much older, and subsequent discovery seems to push them back in time. Artifacts recovered from sites in this area date as early as 9000–7000 B.C., when Paleoindians hunted megafauna like mastodons and mammoths across the Southwest.

These pictographs were painted by nomadic pre-Fremont people, who passed through but left no evidence of having settled at or near the mural sites. They thus appear as works of public art rather than

interior decoration. Archaic clay figurines that closely resemble the pictographs in style have been found about nine miles away. Since these have been positively dated to around 4700 B.C., it is possible that the Great Gallery was painted seven thousand or even ten thousand years ago.

So, two thousand years, seven thousand years, ten thousand years? We don't know. In truth, what we can imagine about the people who left these images is greater than what we can back up with conclusive evidence. There are so many conflicting studies, revisions based on new findings obtained from one discipline or another, and we must always be wary of our preconceived cultural notions.

This we do know: The artists worked hard to acquire and prepare the mineral dust and binder they used to apply color to the rock. They abraded the surfaces that would receive the paintings. The larger-than-life-size figures show vivid artistry and creative voice. These people clearly needed to draw these abstract, hominid, and animal figures. They had a purpose in depicting hunting scenes and otherworldly beings—perhaps ancestors, perhaps spirits. Their art has been called "shamanic," and it may have had a ceremonial or ritual meaning. Beyond question is the fact that they wanted to communicate and chose what we call art as their medium.

We felt alone in the canyon. We knew a few others had preceded us, as we had seen their cars at the trailhead and their footprints in the sand. But silence was our welcome companion as we made our way along one side of the dry riverbed, then the other. After about an hour, we spotted a high panel of figures to our left, then a lower panel across the way. Each warranted rest stops to examine stylized figures of hominids, birds, and other animals. We continued, easily imagining time had collapsed about our shoulders and that we, too, inhabited a dimension in which this landscape was an active painting studio. It is in such places, and at moments like these, where I find it perfectly plausible that time exists as a simultaneous pattern of events

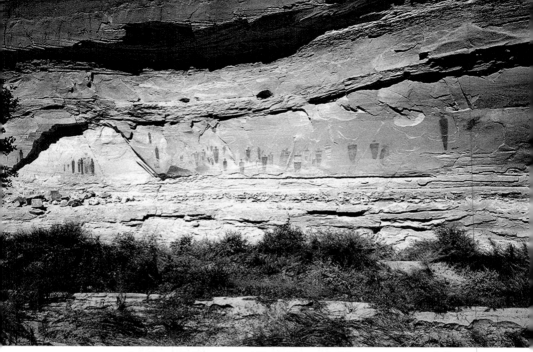

FIG. 8.1. *Great Gallery, central Utah. Photograph by Margaret Randall*

and that only human consciousness on our unique planet imbues it with sequence.

After hiking some three miles, as we approached the Great Gallery—Horseshoe Canyon's magnificent two-hundred-foot-long panel —an intense energy seemed to thicken the air. The figures, familiar from photographs, became visible, and the full impact of the mural hit me. A few other visitors sat quietly on rocks, contemplating the paintings. A troop of some ten or twelve Boy Scouts shared the space; even they seemed to be in awe.

The Great Gallery includes a couple dozen hominid figures, often referred to as anthropomorphic, many of them life-size and one seven feet tall. Armless, their bodies taper from broad shoulders to narrower lower extremities. Several have skull-like faces; the heads of others are crowned with ornate headdresses. Several of them contain wavy designs, rows of white dots, parallel lines, snakes, or other images within their torsos. One, referred to in our overly culturally

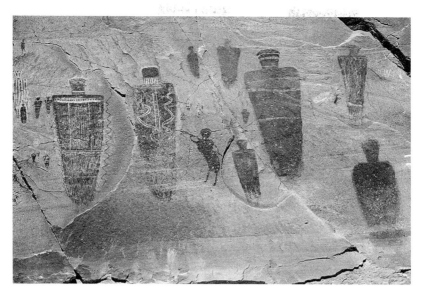

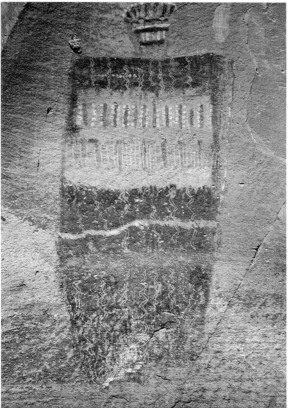

FIG. **8.2.** *Great Gallery panel, including "Holy Ghost figure." Photograph by Margaret Randall.*

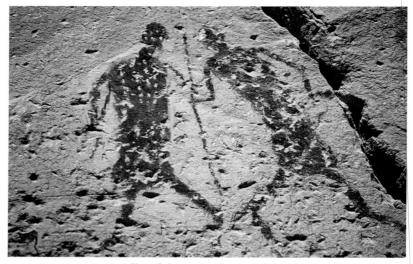

FIG. 8.3. *Great Gallery fight scene. Photograph by Margaret Randall.*

determined literature as "the Holy Ghost figure," was painted with a
spatter technique, giving it an aura of movement or perhaps meant
to depict a fur or feather cloak. Some of the large beings have small
mummylike figures inside them, and there are other mummylike
forms on the wall. Some paint was applied with the artist's fingers in
thicker and thinner layers, and in places the interplay of paint and
stonecutting produces a textural feel.

Other images are just as interesting: Two human characters en-
gage in a spear fight, an even smaller single being bears a weapon of
some kind, a delicately painted triangle of mountain sheep run in dif-
ferent directions, and what looks like a large dog seems to be chasing
them. At the lowest level on the wall, an open mouth or vagina spews
a long line of little marks—humans, or events? This last image and
the larger figures contain elements of abstraction, or even perhaps
record keeping, contrasting with the medium-size figures that display
a sophistication of gesture and movement unusual in much prehistoric
painting.

What struck me, as I remember standing before those two hundred feet of Archaic images, is that I was looking at a mural. The wall, a fairly shallow and exposed alcove, had been smoothed in preparation to receive the paint. The people—men, women, perhaps even children—created some of the smaller images, and a variety of styles indicates more than one participant. Those who painted this wall were creating a magna collective work of art and/or communication. The word *art,* because of its contemporary implications, can take us down a slippery slope. We say *art* to convey something transformative, powerful, gripping, with a presence beyond the mundane. At the same time, we want to avoid falsely circumscribing the Great Gallery by employing contemporary nomenclature.

II.

Flash forward thousands of years, but back a few in my life. I am in San Francisco, mid 1980s. I have come to the corner of Hayes Street and Masonic Avenue, to the 320-foot-long retaining wall of John Adams Community College. I have taken San Francisco's subway system, BART, and transferred to a city bus. I am west of downtown, near Golden Gate Park. I am here, as I have come periodically over the years, to visit an extraordinary mural painted by close friends. In this era in which artists sign their work, Jane Norling, Miranda Bergman, and Arch Williams are responsible. I have no idea if the ancients who painted the Great Gallery affixed their signatures to what they painted, or if they spoke anonymously for the group. Perhaps vision and style were enough. Since the specialists haven't deciphered anything resembling an identifying mark, I assume the latter.

The San Francisco mural is called *Our History Is No Mystery.* The events and people depicted are meant to give a sense of people's history from the time the city was founded. I wonder how this explicit representation distances it from, or brings it closer to, the Great Gallery. In both cases, I ponder the artists vis-à-vis their contemporaries.

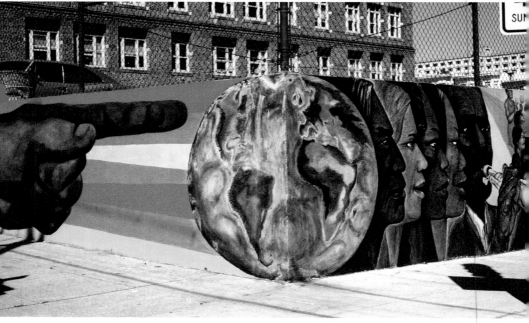

FIG. 8.4. *Corner view of* Our History Is No Mystery.
Photograph by Tim Drescher. Courtesy of photographer.

While Archaic people painted in Horseshoe Canyon, did others in their community or passersby stop to watch, comment, encourage, berate, or perhaps even participate? Did the large figures frighten or comfort those who saw them? Were onlookers challenged, or did they take the paintings in stride? Could there have been discussion or disagreement about painting the site?

One of the muralists involved in creating *Our History Is No Mystery* says that now, in this era of performance art, she realizes that the act of painting a mural is, in fact, performance. She tells me that she and her colleagues always had an audience and, as they worked, were flooded with comments, visitors, offers to pose.

Many people of color can be seen on the John Adams wall, reflecting the roles they played in the city's development. As the mu-

ralists worked, Anglos often drove by and shouted, "Where are the whites?" If they didn't see themselves in the majority, they couldn't see themselves at all. Their sense of themselves as the center of everything—the norm—blinded them to reality and to their place within it. A great deal of research went into planning and designing *Our History Is No Mystery,* and photographs of community activists were often the models for the faces in the mural.

Our History Is No Mystery is divided by the street corner that splits it in two. On one side, a long arm points to the other half, where the action is. This long pointing arm reminds me of the line of dots or small marks that emerge from the mouth or vulva painted at Horseshoe. Both indicate a way in or out: direction, a pathway, a map.

The San Francisco mural has faded over the years, and it has also been vandalized by one or several people who scrawled the word *ugly* in white paint over some of the figures, not once but twice. Just as with ancient rock art, there are people intent on defacing or destroying *Our History Is No Mystery*—perhaps precisely because they want truth to remain hidden and a more self-serving version to replace it. As the centuries unfolded, and other indigenous peoples—and finally non-Indians—came upon the rock art panels, some of them also defaced what was there. Sometimes they have ruined a drawing by chipping away the stone. In recent times, gun-crazy intruders have used the pictographs for target practice. In some cases, defacement may have had a ritual meaning. In most, it has been nothing but thoughtless vandalism.

Routine restoration has also been necessary from time to time. The artists who painted *Our History Is No Mystery* used Politec, a new paint back then, developed in Mexico. They power-washed the rust-streaked wall, primed it with white house paint, laboriously gridded the mural sketch onto the large surface, and then applied the final paint coats in washes, using water as the medium. Later muralists tend to employ paint at full density to eliminate fading.

Thousands of years ago, in Horseshoe Canyon, the muralists, if we may call them that, had to mix their colors from mineral deposits and plants. They would grind each color to a powder: hematite for red, limonite for yellow, malachite for green, and azurite for blue. Clays stained with other minerals produced various pastel shades. Silica, gypsum, chalk, and calcium carbonate were used for white, charcoal for black. The vehicle and binding agent were combined into a single layer, to which the ground pigment was added. The binder has disappeared with age, though, so scholars have never been sure precisely what it was. No Politec in ancient times, no specialized products available at art stores. Each color was a laborious discovery.

A mural speaks to us. By its size alone, it engulfs, drawing us into its landscape and meaning. We may come away feeling we have participated in its narrative, indeed as if we embody the identities of one or more of its central figures. Painted thousands of years apart, Horseshoe Canyon's Great Gallery and San Francisco's *Our History Is No Mystery* both put us in touch with the primal forces of an era. A thousand years from now, multihued faces on a twentieth-century wall may seem as enigmatic as the elongated figures in the rock alcove in Utah.

The people who created the Nazca Lines drew by adding or subtracting rocks in geometric patterns on the ground. They extended the shapes across valleys and over hills, as if nothing could get in their way; or perhaps they used the shape of the land to give form to what they were creating: a picture plane stretching farther than the eye can see in a language we cannot fully know.

The Maya architects who built their temples in the jungles of the Yucatán and Chiapas were erecting monuments for the centuries. The glyphs that adorn them speak a code we have just begun to crack, a

FIG. 8.5. *(Facing page) Close-up of panel of* Our History Is No Mystery. *Photograph by Tim Drescher. Courtesy of the photographer.*

language rich in sculptural complexity. The pre-Fremont people who painted the Great Gallery left no written language, only strangely otherworldly figures filled with a symbolism we attempt to explain but do not really understand. The muralists who painted *Our History Is No Mystery* were able to consult archival documents, speak with some of the principal actors or those who knew them, and use photographs to achieve facial likenesses.

Frederick Catherwood and John Stephens couldn't look to previous scholarship. They were the first. But they understood that what they were documenting in the Maya world was important, worth recording with precision. Edward Ranney and Leandro Katz used today's advanced technologies to add their voices to cultural histories millennia old. And the muralists who labored to put San Francisco's multiracial history on two sides of a long city block added their voices in this generational chorus that keeps on giving us memory in spite of every effort to erase it. It is this constantly renewed cartography that moves me beyond the discrete power of each separate cultural manifestation.

If we extend our imaginations, we may find profound connections between the Great Gallery and *Our History Is No Mystery.* Monumental works of art are able to speak not only to but also for the people for whom they are created. Think of the Sphinx at Giza, China's terra-cotta warriors, Picasso's *Guernica,* and Maya Lin's Vietnam Veterans Memorial in Washington, D.C., to name only a few. When art speaks for us, it allows us to understand who we are. It glorifies and empowers, comforts and explains and inspires. By imagining what such creativity meant to the people who made and lived with it, we are able to begin, just begin, to walk the maps of their worlds.

Gay Block
Looks at People and Shows Us Who They Are

My wife Barbara's and my first visit to Gay Block's Santa Fe home is vivid in my memory. At the time, she and her then partner, Malka Drucker, lived on a sprawling adobe estate on the outskirts of the city. I recall an imposing gate, beautiful old trees, and a small chapel on the grounds that served as Malka's writing studio. The walls of the main house were covered with original photographs by some of the great visual artists, painters as well as photographers. I remember what I felt standing before a Dorothea Lange and realizing that my friend owned an authentic print by the extraordinary Depression-era photographer. And there were other originals, as well. I gazed at them all in astonishment.

I had brought homemade bread with us that day, a contribution to our lunch. Gay and Malka had two little miniature schnauzers, and when we returned to the living room after a tour of the house, the dogs had devoured the loaf, which I'd foolishly left on a low coffee table. Only crumbs and a few scraps of aluminum foil remained. We laughed, which helped break through the awe Barbara and I felt in such surroundings: warm and inviting but obviously the consequence

of wealth. Then Gay looked straight at me and asked, "What does it make you feel to know that I live in a place like this?"

I can't remember what I answered. I think I mumbled something about feeling fine about it. Gay had taken me by surprise, and I didn't yet know her well enough to appreciate that she was asking because she really wanted to know and hoped for a response that might help her navigate her own feelings about coming from money. I didn't judge Gay at the time, nor have I since. She has used her resources to finance important photographic projects and has been generous to many. These days with Billie Parker, her partner since 2011 and wife since 2014, she lives in a much more modest but equally welcoming space. I sense that she has come into herself after a long and courageous journey.

I no longer remember when or how Gay and I met, but she lives in Santa Fe and I just an hour south in Albuquerque so, once we did, visits were periodic and easy. I will say up front that she is a brilliant photographer and lovely human being; encouraging and supportive of my own photography when I needed that. Although I have always known that making pictures is secondary to writing in my life, I've appreciated Gay's help and, above all, the powerful example of her work. Her pictures move me deeply.

Gay was born into an affluent Jewish family in Houston, Texas, where her parents had moved in 1938 from their birthplace in Monroe, Louisiana. Her father worked first at a family-run wholesale liquor distributorship. In 1950, he and his two Monroe business partners bought a controlling interest in the Houston National Bank, then the city's third largest, and he became chairman of the board there, a position he held until his retirement, in 1968. Gay speaks of how her father went into banking to make it possible for Jews to get loans, begin businesses, become successful and accepted. He died in 1971, at the age of sixty-six.[1] Gay's mother, the Bertha Alyce of some of her most poignant images, considered philanthropy her life's work.

Gay was given a Brownie box camera when she was ten years old and immediately began to take pictures of family and friends. That was the beginning of her life in photography, although her perceptive eye as well as the make and model of her cameras changed over time. When she started doing portraits in 1975, she used a four by five. But two years later, when she met and studied briefly with Aaron Siskind, he suggested she use a medium format in order to achieve a quicker response, so from then on, she has worked with a Pentax six by seven. She says she always uses a tripod, preferring a long exposure, which she feels encourages her subjects to be particularly aware of having their picture taken, and she includes them in the making of the images. Such a long exposure also obviates the need for lights. I imagine this, too, is important to Gay, as it imbues her portraiture with a natural quality. I believe that this effort to involve her subjects in the process of their portraits is indicative of the relaxed relationship Gay establishes with them.[2]

Gay worked exclusively in black and white from 1975 to 1982, when she went to Miami's South Beach, where, she says, everything she saw was color. Portraits have always been her focus, her passion. I will go so far as to say that I don't know another photographer, either today or throughout the genre's rich history, who captures the nature of human complexity better than she does. As well, perhaps. Differently, of course. But not better.

Gay's major work unfolds in breathtaking series, and I use the adjective literally: Looking at Gay's images takes my breath away. Several sequences, such as the searing portraits of her mother, *Camp Girls,* and her take on Houston's affluent Jewish society, come from the loving yet critical attention she's paid to the people with whom she grew up. To produce others, like *Rescuers,* she has drawn on her deep desire to understand what makes people do what they do—in that case, risk their lives to save others during a terrifyingly catastrophic period in human history.

Underwear is a series of close-up color images in which male and female subjects are pictured from mid-torso to just above the knees. Each is clothed only in an ordinary piece of underwear: plain white Jockey shorts, high- or low-cut women's panties, lacy briefs and underpants in camouflage print, among others. By depicting these very average-looking bodies—all are white, none are excruciatingly thin, voluptuously buxom, or disfigured—Gay takes us to a place where we are required to search for difference in sameness. No faces are visible. The very ordinariness of these images is revealing.

White Fire includes separate color portraits of women, diverse in terms of their culture, race, and style, some with a female partner or a pet. I asked about the title of this series and Gay told me that the Talmud says that the Torah is written with black fire on white fire. I still don't understand the connection. Without pondering the title, what distinguishes the series are the strength and power that comes through in every face. In another sequence, called *American Politics,* class is what Gay is projecting: her take on difference through portraits of people who are all white but visibly diverse in terms of work, income level, and demeanor. One can ponder the titles Gay gives these series, and in most cases, they function as codes, containing well-placed clues to what she has on her mind. But the images always astonish.

For *Camp Girls,* her models were women of her Houston generation, in their adolescence and then a quarter century later as adults. She photographed the girls in 1981. Those images are black and white. Twenty-five years later, she rephotographed them, this time in color. The replay is very different from that achieved by the team that rephotographed the Grand Canyon's 1889–1890 Stanton Expedition or what Leandro Katz did in *The Catherwood Project.* At the Grand Canyon, the subject was landscape and how it had changed or not in one hundred years. In Katz's images, the subject is time. For both these works, it was important that the photographer place himself in the same spot and at the same angle as the person who had rendered

the earlier image. Block works with the human body and psyche. She didn't need to photograph her subjects in the same place or from the same angle. She was interested in how their lives had evolved. Her images also speak of the passage of time, but they forefront human emotion rather than an endangered environment or ancient architecture.

In *Camp Girls,* one has a sense of a particular community of youngsters growing into womanhood, still struggling with their physical and psychological relationship to a society that has expectations about the female person that are inhibiting and difficult to live up to. This series includes group pictures—posed as well as spontaneous—pairings, and individual portraits. Some of the women hold children of their own, or dogs. In every one of these images, we can read the conditioned shame, energy, wariness, indecision, studied nonchalance, defiant confidence, and hard-won courage that accompany the female's journey into adulthood. And because of the milieu from which these girls and women come, we understand that even money doesn't solve the dilemma of gender under patriarchy.

In one of my favorites from the black-and-white *Camp Girls* images, an intense adolescent engages the lens to the left and behind another girl, whose face we can't see. The girl to the right is a bit pudgy, hunched, and slightly out of focus, perhaps due to one of Gay's long exposures or perhaps simply because she moved. The contrast between the girl whose face we see and the one whose face is hidden might be the stuff of a novel—or even an opera—so subtle yet explicit is the story it tells. It is the humanity in all Gay's work that connects so profoundly with the viewer.

And there is also Gay's consciousness of the ambiguity and veiled prejudice against being "too Jewish" that ran through the community of her youth. As in many Jewish enclaves in the United States at the time, assimilation seduced those whose parents had survived pogroms, knew what been perpetrated in Europe, and feared being seen as different. I understand this dilemma. I come from a Jewish

FIG. 9.1. *Gay Block,* Jill Weiman, Camp Pinecliffe, Harrison, ME. Camp Girls *series. Silver print, 1981. Courtesy of the photographer.*

family and self-hate festered in my mother. She persuaded my father to change our surname, moved our family west, distancing it from Jewish relatives in the East, lived assimilation, and denied the real reasons for those decisions almost up until the time of her death. I am from a different social class than Gay but recognize things she's shared with me about the prejudices in the community in which she was raised.

In her case, Gay says her family's need to assimilate wasn't rooted in self-hate, but in an understanding that Jews in Houston constituted a drastic minority; when she was growing up, the city's population was about half a million, of which only some eighteen thousand were Jewish. She remembers how the Reform Jews judged their more Conservative and Orthodox counterparts. "They denied their roots," she

told me, "and didn't want to claim their history because of this need to be accepted by the wider Houston community." Gay says this was her main motivation for beginning to make portraits of Jewish people in Houston: "I wasn't comfortable with the fact that the affluent Reform Jewish community seemed to think they were better than the more traditional Conservative and Orthodox Jewish communities. I wanted to interview and photograph [those people] to disabuse them of this."[3]

Gay is adept at photographing her subjects in their environs, alternating between close-ups, in which we may glimpse just a bit of an object that speaks volumes, and longer shots, in which a whole way of life is revealed. Clothes, or lack of same, furnishings, art, gesture, and expression combine to tell us who these people are. As with Elaine de Kooning's painted portraits, Gay reproduces this backdrop instinctively. Many of her images come in pairs, such as those in *Clothed and Nude,* in which the same person—woman or man, photographed in black and white or color—appears dressed in one frame and undressed in the other. In some of these diptychs, the subject assumes the same position in both frames; in others, they don't. These portraits give lie to the popular expression "clothes make the man (or woman)." The fact of their being dressed or undressed is interesting, but the facial expressions in each portrait are what matter. These, like many of Gay's pictures, might be gimmicky if they weren't so rich and complex. She consistently avoids cliché.

I was introduced to Gay's work through *Rescuers*, the series of portraits she made in the late 1980s and early 1990s while traveling for three years through those countries of Europe where the Nazis had terrorized and murdered Jews and other "undesirable" peoples during World War II.[4] This was a joint project: Gay made the photographs and Malka conducted the interviews. It helped that they had the resources to take on a project of this scope. They visited ten European countries, Israel, and Canada in search of their interviewees and spoke with more than one hundred, ultimately focusing on forty-nine

stories that combine visual portraiture with verbal testimony. The resultant body of work, which also includes archival images, documents, and other ephemera, became an exhibition that has traveled to more than fifty museums and galleries around the world. There is also a book and a film.[5]

By the time Gay and Malka met them, these men and women were elderly. When asked why they had risked their lives to help others survive, some mentioned that those they hid were friends, but although all the rescuers are among the more than 27,000 honored by Vad Yashem as Righteous Among the Nations, none thought of himself or herself as a hero. They said they simply knew what they had to do, and it wouldn't have occurred to them not to. As Samantha Baskind observes in her foreword to the new edition of *Rescuers*, "For them there was no moral ambiguity, no ethical dilemma, no liminal space for what was right."[6]

I feel it is also important to point out how prescient this project was. Today, it is safe to say very few of the rescuers are still alive, or if they are, it is unlikely they are any longer capable of giving testimony about what they did three-quarters of a century ago. Gay and Malka rescued these stories just in time, just as those they interviewed and photographed rescued Jews who would have perished without their help. Along with the project's depth and brilliance, we have the fact that without it, we might never have known this important history.

There is so much to be read in Gay's portraits of rescuers: self-knowledge, compassion, and the confident satisfaction of having lived a moral life. We look into their faces and know we are looking at enormous strength of character and a proclivity to risk that is hard to come by in any era. Still, we search for something, perhaps hidden, that might help us understand such heroism. These portraits remind us that, given the circumstances, everyone has the capacity for heroism—just as everyone is capable of ugliness or betrayal. In

these extraordinary portraits, Gay captured precisely that which is extraordinary in the ordinary.

These aren't portraits made quickly. Each was chosen from the several images Gay made during or following an interview that lasted on average two hours. As in her other portrait series, she included elements of the rescuers' surroundings: furniture, a plant, a bit of fabric or a plate of food, old snapshots spread out on a table, the light coming through a window. Adele Defarges has a crumpled handkerchief just visible in her right hand in the bottom left corner of the portrait; we imagine she has used it to staunch the emotions being revived as she told her story. She holds before her an elaborate wooden frame, in which we see three photographs of a younger woman. Is this the woman she hid? No, these are pictures of her at the age she was when she did the hiding. We are privileged to be able to study this woman's face back when she took inestimable risk and as it is today as she grows old with her memories.

Gay tells me that Defarges, from Marseille, decried the fact that she'd only saved one person, a woman who'd come to her for help and whom she hired as a maid to keep her identity hidden. Gay says, "As Malka was finishing the interview, I walked around the apartment to learn more about her and to know where I wanted to make her portrait. I found the framed images of her as a young woman on the wall in her hallway and asked if she'd pose with them. It was a very unusual thing for me to do and I don't think I ever did anything like that again."[7]

The rescuers welcomed Gay and Malka into their homes, served them coffee or tea, helped them carry their heavy photographic and recording equipment, opened themselves to a relationship in which two women from the United States were asking them to speak of a time many had relegated to that psychic space that can wall itself off when one needs to put fear behind. One rescuer, Dutchman Arnold

FIG, **9.2.** *Gay Block,* Adele Defarges. Rescuers *series.*
Silver print, 1988. Courtesy of the photographer.

Douwes, later wrote Gay and Malka a letter in which he said, "I can-
not push aside the thought that two American ladies cannot possibly
have any idea of what happened in the Netherlands between spring
1940 and spring 1945. The time of the Nazi boots. . . ."[8]

It is true that the experience of enduring such terror is impossible for others to really know. Yet with her camera, Gay managed to cross an almost unimaginable bridge. Additionally, when she did this work, World War II was in the distant past; all those interviewed had to make their way through recall no longer as sharp as it once had been. But those weeks and months and years of doing what they felt had to be done had been pivotal for them; once they began the journey back, the memories flowed.

There is an intimate connection between these portraits of rescuers and a series of portraits Block made at a community of retirees in South Miami Beach, Florida, many of whom were Holocaust survivors. Some of the latter might not have survived without the former, and, even if there is no evidence of this in specific cases, an aura of solidarity and gratitude—a connection—is there, somewhere beyond the picture plane.

One of the great strengths of Gay Block's portraiture is the time she invests in these series. She often documents her subjects for years. This is never more evident than in the images, text, and video she made over a thirty-year period of her mother, Bertha Alyce. Theirs was not your typical mother-daughter relationship, certainly not a loving one nor any longer dramatically tumultuous—although traces of mother-daughter discomfort can be seen in some of the images. *Bertha Alyce: Mother exPosed* is the book that resulted from this long project, and it is surely one of the most exquisitely adventurous volumes in the annals of contemporary photography. It required abandon, risk, determination, confidence, and an artist's perfect timing from mother as well as daughter. The daughter conducted the show, although the mother's self-confident improv may have set the tone.

We are introduced to Bertha Alyce as a young debutante. We are shown conventional family portraits of mother, father, older brother, and a plump little Gay at age five or six taking the camera on with decision. These images of affluent family life suddenly give way to

those of Bertha Alyce nude, speaking on the phone and conversing as relaxedly as if she were fully clothed. Gay recorded the moment. Bertha Alyce luxuriates in a bubble bath. Gay framed the image and snapped the shutter again.

Gay tells an interesting backstory to the nudes. It was early in her work as a photographer:

> They were among the very first pictures I took after beginning my first course in photography in 1973. The professor told us to put film in our cameras and take pictures of something we needed to understand, so I did just that. The next morning, I went to my mother's apartment—my father had died almost two years before—and, using my key to enter, I found her nude in her bedroom, talking on the phone as her bathwater was running. I took a couple of pictures, and when she got off the phone, she posed on the bed for three more. I hid those negatives so others wouldn't see them. I made some prints, showed them to her and we laughed about them. . . . Being an exhibitionist, she was never bothered about it and didn't give a damn what her friends or anyone else thought about her.[9]

In another photograph, mother and daughter sit beside each other in ornate chairs, naked from the waist up. Gay is wearing jeans and holds the cable-release bulb that allows her to make the image. Small pictures of their hands and feet appear, continuing a theme of generational, lifestyle, and physical and ideological contrast. In all these series, Gay made critical decisions about print size, using the same format for all the portraits, as she did in *Rescuers, Underwear,* and *Clothed and Nude,* or varying them, as in *Camp Girls* and *Bertha Alyce.* In the latter, smaller images of isolated body parts and the accouterments of her mother's life supplement and enhance the central images. Every aspect of these series is carefully thought out.

FIG. 9.3. *Gay Block*, Bertha Alyce. Bertha Alyce *series.*
Silver print, 1973. Courtesy of the photographer.

Bertha Alyce shows off her youthful figure as she dresses for gala society events or exercises on her bedroom floor. She displays an elegance and sexuality groomed from before she was born for the sole purpose of satisfying male fantasy and eliciting male applause. But she also delights in a femaleness she seems to own, one that is forever impacted by the social values she inherited but that now give her genuine pleasure.

The daughter, who reveals through her own self-portraiture that she struggled with weight and body image for years, photographed the mother in her consciously cultivated performance. And then, beyond any imaginable mother-daughter portraiture we can anticipate, we are shown a close-up of the mother's pubis, its silky hair adorned with a diamond brooch, followed by another of her clitoris, velvety, fresh, and pale pink as newborn skin, circled by a ring. There is no way for me to meet these images with anything but graphic, unsparing prose.

In one image, Bertha Alyce is standing regally beside a china cabinet, on the shelves of which a series of decorative objects rests. In a paired image, between a similar piece of furniture and the wall, Gay sits on the floor in the corner, casually dressed and with her knees drawn up before her. Beneath the surface of all these photographs is the journey daughter and mother traveled together as the daughter claimed her own space, came out as a lesbian, and became a world-renowned photographer, and the mother took refuge in her cultural values while venturing into a new world she embraced but never fully understood.

In this series in which "pose and expose" is the leitmotif, we also see close-ups of Bertha Alyce's features immediately after a surgical face-lift: bruised, bandaged, stoic in pain as she seeks another chance at youth and beauty. After Bertha Alyce's death, Gay photographed matter-of-fact arrangements of her mother's jewels and made a self-portrait hugging one of her fur coats. These end the sequence.

FIG. 9.4. *Gay Block,* Gay and Her Mother. Bertha Alyce *series.*
Silver print, 1977. Courtesy of the photographer.

There is longing, love, and understanding in these pictures. And there is rebellion. Ultimately, there is also the willingness on Bertha Alyce's part to go as far as Gay asks. She revels in the attention, but we also sense that she respects her daughter's art.

The *Bertha Alyce* series is shocking but not voyeuristic. Like visual alchemy, it acknowledges contradictions that surely left their scars along the way, and also a coming together as startling as it is authentic. It tells the story of a wealthy Houston society matron who was also a woman and a mother, and of her daughter, who, through her photographic art, needed to understand the tenderness, pain, and pride in her mother's life. A great deal of what passes for art these days is novel or experimental in an effort to set a trend or break with one. The *Bertha Alyce* series, like *Rescuers,* is interested in going deeper. It gives us a new way of looking at ourselves.

As for so many of us, Gay's personal journey began in a place constructed for her by the society in which she was raised. She married, had children, divorced, assumed her lesbian identity, and eventually found the relationship that enables her to live her fullest life. Professionally, she also had to claim the space she was meant to inhabit, through hard work and against the odds the system throws at women who won't submit to patriarchy's rules. Gay's parents surely would have been proud of the daughter whose photography is in the world's major museums. I asked her how her mother reacted to her lesbianism. She told me her father had died by then, and her mother only remarked, "The world is different now, Gay."[10] She was pragmatic about how she navigated her own path and, ultimately, about how she accepted her daughter's.

I immerse myself in *Bertha Alyce: Mother exPosed* and see a courageous and successful visual narrative of a daughter's relationship with her mother. Because I know Gay, I also understand something else: Completing these images made it possible for the photographer to experience her own nature with joy, free from her mother's expectations and society's demands. Profound artistic work changes the world. It also changes the artist.

Gay changed perceptively, to the extent that when a few years back, after not having seen each other for a while, she came and sat next to me at a Santa Fe art event and it took a few moments before I recognized her. She looked a decade younger, with newly acquired health, and exuded an entirely different energy. Gay told me she had moved from the large estate to a more modest one and that she had found the love of her life, Billie Parker. Barbara, sitting on my other side, leaned across and greeted Gay: "Those are new glasses, aren't they?" she said. "They look great."

Gay Block claims, "My portraits are my truth, not necessarily the truth."[11] Her truth is a truth well worth exploring. It helps us know ourselves.

Sabra Moore:
In the Big Out There

Driving from Albuquerque through central New Mexico, you leave I-25 just as you enter Española, cross the bridge over the Rio Grande, and make your way on U.S. Highway 84 up into what those of us who know the history of the area refer to as "the Georgia O'Keeffe country." This is where the great painter made her home back when none of these roads was paved and the high bluffs and winding Chama tributary must have seemed like the landscape of another world. In many ways, it still does. The tiny village of Abiquiu lies just a few miles farther north, atop an imposing roadside bluff.

This is farm country, rich fields set against an increasingly dramatic backdrop of volcanic necks and multicolor rock: hulks of blue-gray on the horizon and, closer in, hillocks of striated reds and oranges, golds and mauves and creamy beiges undulating beneath a sky that is vast and almost always blue. There is the scent of piñon wood burning in the cold months. The people who inhabit this valley are mostly poor; in the decades we've been making the drive, there hasn't been much building. One old landmark on Highway 84 is the

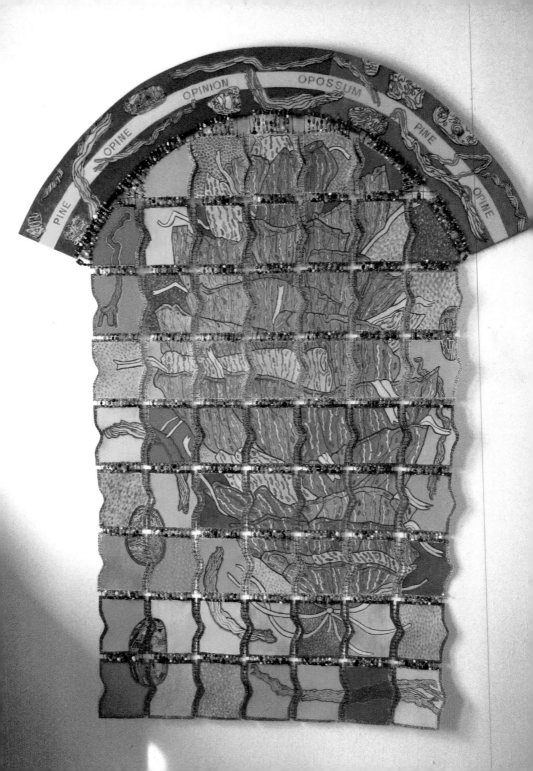

adobe ruin of the church of Santa Rosa de Lima, where the old Span-ish village was located. A few new houses, maybe, not much else.

Just after the road sign for El Rito and before you come to Abiquiu, a run-down pizza place that has been there forever signals the turnoff and climb up onto the mesa. Quickly the road deteriorates to dirt as it begins to ascend past increasingly dramatic views of soft rock molded by centuries of wind and melting snowpack. Occasionally, you pass a house built by someone who, like Sabra Moore and Roger Mignon, came from somewhere else and immediately knew they'd found home. This is the Big Out There. The land is vast and stunning in every sea-son. The county does a pretty good job of keeping the backroad graded until you must turn off again onto a narrower surface that will take you to their place. After a couple of miles, you spot it nestled way down in a hollow to your left.

A driveway that may or may not be passable, depending on the time of year and make of car, careens toward the adobe house and detached straw-bale studio these artists built with their own labor after they bought the land in 1989. They came out each summer to work on it and returned to New York in the winters. They finally immigrated in 1996; and immigrate it was, as if they'd come to a foreign country. From the crowded streets of Brooklyn to the lonely New Mexican north, from artist's loft to a home that had to be constructed from scratch, from the old pipes of a megacity's water system to searching for water by digging a well that now gives barely enough to support the couple's modest lifestyle.

When they first arrived, Sabra and Roger built a wooden shack just big enough so they could lay out their sleeping bags and stay there through the several years it took to make part of the main house hab-itable. Sabra remembers that the building "went on for six summers.

FIG. 10.1. *(Facing page) Sabra Moore,* Pine/Opine/Opinion/Opossum/Pine/Opine, *2020. Mixed media, 85 by 63 inches. Photograph by Sabra Moore and courtesy of the artist. Artist's private collection.*

What I learned about space—the way a house looks at various stages and the way it changed when the roof went on, when it became an enclosed space, the materials themselves. I started working with the vigas as art materials. The way I came here to draw the plans and drew the rooms from the inside looking out. All the special aspects of our relationships with the crew. Joy and work. Being here for the well to be dug. And having land, coming home."[1]

Ten acres of land cost ten thousand dollars. The money to keep the construction going came in bits and pieces. Roger, a painter when he and Sabra met, no longer paints his haunting oils, but he continues to draw and has become a fine woodworker, making custom furniture from time to time and doing carpentry at construction sites. Sabra manages the Española Farmers' Market. She also tutors local young-sters, supervises art projects for area schools, and occasionally sells a piece of her own art. Over the years, she has earned a number of important grants but never enough to make a difference except for the immediate future. Their income is always uneven because they have chosen to prioritize their own creativity, a choice many of us made easily when we were young but one that takes enormous courage as we age.

The place where Sabra and Roger live is isolated. The nearest neighbor is a quarter of a mile away over open country. The earth is hardscrabble, dry and difficult to work; Sabra sometimes plants a few vegetables. Once, I marveled at a patch of amaranth: delicate pink seedpods gently swaying against a cobalt sky. There have been periods when they've had to haul water, and they must chop kindling to feed their wood-burning stoves throughout the winter months. They de-pend on a working vehicle for transportation into Española, which is twenty miles away, or even just down the mesa to Bode's, the nearest general store. I have known several of their vehicles when they were barely working. With Roger now in his mid-eighties and Sabra not that far behind, friends have wondered how long they will be able to

remain in that magical place. But magical it is, and I cannot imagine them leaving.

When you arrive at the house, if you feel safer leaving your car on the road above, you'll walk down, past an old truck and a wire-covered coop where Sabra's happy chickens all have personalities and names to match. The house is always welcoming, never more so than on Thanksgiving, when, for many years, a small group of friends have driven from Albuquerque, Santa Fe, Galisteo, and one or two spots between to share Sabra's turkey and chess pie, made the East Texas way, and various contributions from the rest of us. Except for November 2020, when the COVID-19 pandemic kept us away, the ritual is one of the highlights of everyone's year.

Sabra Moore was born in Texarkana, Texas, in 1943 and grew up in nearby Commerce. Her father was a railroad engineer for the Cotton Belt and an organizer for the Brotherhood of Locomotive Engineers and Trainmen; her mother taught first grade. Many of the women in her family were artists, although not recognized as such; they made beautiful quilts and other textile creations and nurtured a vision Sabra mirrors in her own work, which she defines as a reinterpretation of those inherited traditions. Moore's art is internationalist and sophisticated—she graduated from the University of Texas at Austin, did a two-year stint with the Peace Corps in Guinea, West Africa, studied at the Brooklyn Museum Art School, and spent many years in the New York City art world. At the same time, it is intensely personal, as it draws on the beauty and meaning of her grandmother Gladys's quilting and her own memories. It is profoundly feminist and ecological, concerned with the preservation of the planet and the extinction of species.

Both Sabra's grandmothers were important in her life. She says:

Mother Gladys was always working on quilts, so I consider her an artist, but she wouldn't identify herself that way. And

Caroline, the one I called Grandmother, was also always making art—dolls, stuffed dogs, quirky objects. She also tatted. Her "work" was really her garden. Both these women were focused on making beautiful objects but without a self-conscious identification. I grew up with an assumption that creative work was part of life. Mother Gladys didn't actually teach me as much as teach by example. We would all look at the quilts she was working on and talk about them. We all sewed starting in childhood. It was later, as a working artist, that I went back to that experience and incorporated it into my art practice, realizing that it was my "art language."[2]

Sabra herself is a work of art, in much the same way as Ferdi Tajiri-Jansen and Frida Kahlo were. She is a big woman, not heavy, but tall and imposing. Yet there is also something delicate about her and she has one of the most genuine smiles I've ever seen. When it bursts across her face, it spreads to embrace everyone in her presence. Sabra's features have something of the classic American Indian, but her hair is blond—now white—and hangs loose, with a small braid on one side. Her clothes are always interesting, never pat styles the fashion industry would have us buy each year and discard the next: woven, embroidered, or beaded shirts over jeans or unusual peasant skirts, the kind of clothes we were excited to discover from those who hand-crafted them or at thrift shops when we had the time and energy to surf their racks. One takes in Sabra's self-presentation and understands that she creates her style every day with the same eye for beauty and care she puts into her canvases, constructions, or books.

I want to emphasize the communal aspect of Sabra's work. It has always had deep ties to whatever community she inhabits. She has involved others in projects ranging from collective artist books, to which dozens of participants may contribute, to ceramic murals designed and made by schoolchildren under her tutelage. Although some of

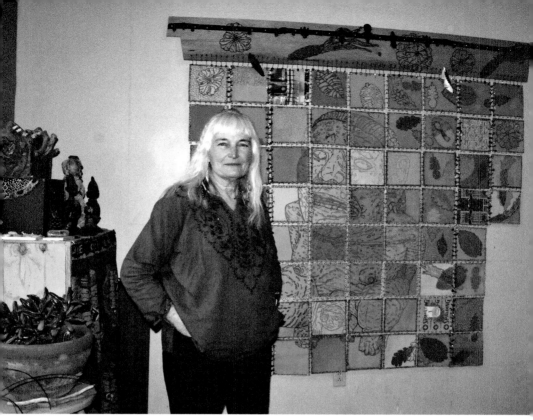

FIG. 10.2. *Sabra in her studio in Abiquiu, 2008.*
Photograph by Margaret Randall.

her major constructions are created in the solitude of her studio and are the result of working alone with memory and her need to make that memory material, many others have been produced with groups of women, the farmers she has come to know at the Española Farmers' Market, or collectives she has joined or created herself around such themes as female consciousness, genealogical history, domestic violence and war, and environmental concerns. Hers is a particularly collaborative process.

Several discreet periods in Sabra's life can be felt again and again in her art, in different ways and with varying degrees of intensity. Her East Texas childhood, of course. The two years she spent in N'Zérékoré,

Guinea, far from other Peace Corps workers and profoundly involved in the local community, where she taught English at Ecole Technique. Her important activism in the New York City of the 1970s, 1980s, and early 1990s, when she and other women protested their exclusion from museums and galleries and brought their rage into the open and their art out of the shadows. Sabra was especially influential in that movement as a driving force at meetings and marching in the street, and as a core member of *Heresies* from 1979 to 1991, an important feminist magazine of the era.[3] And her life in New Mexico, where she continues not only to be a caring friend and neighbor but also an activist who seeks to understand a multicultural community and enrich it. In 2013, for example, she helped organize a scholarly project with the Pueblo de Abiquiu Library to collect the oral histories of Abiquiu residents who knew Georgia O'Keeffe.

Intimate moments that stand out in Sabra's life and resonate in her work include having endured a life-threatening abortion in Guinea— it was legal in that country, but the doctor botched it—subsequently working as an abortion counselor in New York before *Roe v. Wade,* and having suffered ugly abuse at the hands of the man she identifies as "C," whose repeated threats to kill her almost succeeded and from whom she only narrowly escaped. It is significant that abuse informs so much women's art; it is an experience that crosses class and racial lines and is so much more prevalent than many are prone to admit.

Echoes of these assaults emerge, then retreat in Sabra's work. She has taken the fear and pain and turned them into art pieces that speak loud and clear to those who have suffered similar experiences but may not have the consciousness or talent to channel them into such powerful creative catharsis. These moments never vanish completely, but remain as evidence of one of her lifelong convictions: that the personal is political and the political personal. For those of us who lived through the 1970s and 1980s, the connection between intimate and public spheres was both revelation and relief, something we shouted from

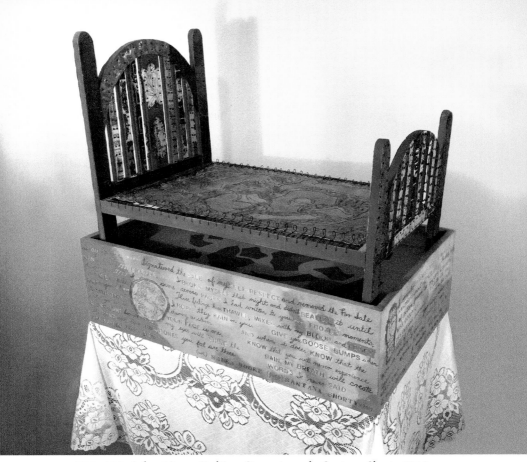

FIG. 10.3. *Sabra Moore,* Bedtime Story, *poem by Santana Shorty, 2012. Mixed media, 34 by 24 by 36 inches. Photograph by Sharon Stewart. Photograph courtesy of the artist and in her private collection.*

the rooftops and incorporated into our daily lives. Sabra imbues her work with this truth.

Bedtime Story is a collaborative piece. Joan Logghe, Santa Fe's poet laureate at the time, paired visual artists with poets and assigned Sabra a poem by Pueblo de Abiquiu Library writer Santana Shorty because she felt she could handle its difficult content. Sabra produced this just under life-size construction of a richly painted bed frame—there is no mattress or box spring, no sheets or blankets, no woman sleeping.

And yet this bed is full—of cellular memory. On the sparse surface linked to the frame with old wire at the edges, dismembered pieces of a human figure are painted, like the separated head, torso, and limbs of a paper doll or disjointed puppet. The subject is tragically familiar; we know what happened here. The bed frame sits on a box, around which the lines of the poem are inscribed, some words emphasized by being rendered in a different typography or color, others given prominence with blotches of red paint. The entire construction is placed atop a table covered with a lacy cloth, evidence of the fact that this sort of abuse takes place beneath the cover of placid family life. Artist and poet didn't know each other before they were paired. Their commonality of experience produced a piece that hits the viewer hard.

Sabra uses textiles and wood, found objects, canvas, metal, paper, inks, thread, wire, paint, and inexpensive reproductive techniques. There is sewing and pasting and tacking. She is constantly creating new forms for her art, such as the "trees," from the branches of which hang cutouts of her friends' palms, each painted in line with the special connection that links her to that person. Sabra asked these friends to send her photocopies of their palm prints, which she then drew on the six viga posts. She calls this piece *Palm Trees*. It is composed of six trees with the handprints of eighty-two friends wood-burned onto six vigas.

Barbara and I own a piece we love that tells the story of two real trees standing thirty feet apart for three hundred years; images of the trees are painted on linked wood panels and the piece includes twigs and a mesh bag holding seeds. Like many of her recent pieces, it is concerned with the relentless destruction of our habitat. Yet Sabra's work is never didactic or rhetorical. It always favors the language of art.

FIG. 10.4. *(Facing page) Sabra Moore,* H/EAR/HER/E, *2017. Mixed media, 47 by 85 inches. Photograph by Sharon Stewart. Artist's private collection. Photograph courtesy of the artist.*

For all the significant struggles in which Sabra has participated, indeed leading many of them, and for all the extraordinary artists and intellectuals she's known (she worked as a freelance photo editor on more than thirty books at several New York publishing houses, including Doubleday, where she was an assistant to Jackie Kennedy Onassis; took a show of women's art to Brazil with Josely Carvalho; and counts Faith Ringgold, Sylvia Sleigh, Ana Mendieta, Lucy Lippard, May Stevens, Nancy Spero, and Miriam Schapiro among her lifelong friends), her deepest relationships are still with her father, who died after being hit by a drunk driver when she was in Guinea; her quilt-making grandmother Mother Gladys, also long gone; and Roger Mignon, her husband and the man with whom she came to New Mexico so many years ago.

Her father's death hit Sabra hard. They had been very close, and she traces her activism to having accompanied him to strikes when she was a child. Once the whole family traveled to New Orleans to take part in a picket line. In her memoir, *Openings,* she writes:

> A plane came to N'Zérékoré every Thursday and landed if the weather was clear. . . . That fall, it happened that my father died on a Thursday. I was at home cooking when a stranger bicycled to my house carrying a letter that had arrived with the plane. It simply said that I had to return immediately to the United States. Four hours . . . later I was in the capital city of Conakry and learned that my father had been killed, but by then I couldn't cry. I was wearing the indigo dress I had bought that summer in Nigeria and carrying a canvas bag with a book, some tangerines, and a black gourd from the rainforest as gifts for my family. Henry Norman, the Peace Corps director who had written the pithy note, was traveling with me. As the plane landed in New York City, I threw up. Most of my luggage was confiscated by customs. My mother was waiting for me in Texas. Daddy had been crushed in the accident, and my family had arranged

with the mortuary for his face to be rebuilt, wanting me to be able to see my father again. When I went with Mother to the funeral home, she hurled herself onto his corpse in the casket and I stood there, only able to recognize his hands. I returned to Guinea two weeks later, feeling like I was taking the bus home. It was five years before I was able to cry—that day I spent listening over and over to Abbey Road and decided to leave C.[4]

Throughout *Openings,* Sabra tells us her dreams from time to time. One of them reflects her anguish over her father's death. She describes the dream and then recounts a ritual she enacted to try to make peace with her loss:

Daddy kept appearing in my dreams as a ghoul. His funeral haunted me; I felt like he was trapped inside that double steel casket and couldn't get back into the earth. I decided to try to free him with a farewell ceremony of my own invention. I cut little strips of colored paper symbolizing different aspects of Daddy's life—his union activism and work on the trains, his childhood on the farm, his sense of adventure, his cowboy outfits, his singing, and the pain of his accident. One Sunday, I set up a little shrine in my Warren Street kitchen next to the white sink where I had burned the letters from C. . . . I set out a sage candle and incense next to Daddy's photo and his paper symbols, and burned the papers in a red bowl, one by one—my sweetest memories of his character and sorrow for his suffering going up in thin smoke. Then, I threw the ashes out the kitchen window, letting them float free onto the garden below. Since this ceremony, he has appeared as himself in my dreams, usually he wears a hat.[5]

Sabra's early life, like that of most women who came up in the prefeminist 1950s and 1960s—and even those of many today—was dictated by patriarchal values. Although she was raised with the examples of strong creative women, East Texas, like everywhere else, put

FIG. 10.5. *Sabra Moore,* We Are All in the Same Boat, *2002. Mixed media, 96 by 24 by 21 inches. Photograph by Roger Mignon. Artist's private collection.*

men first. Women internalized those values, often going in directions or making choices that contradicted our own best interests. Sabra's formal education was interrupted by such twists in the road, but her deep knowledge that she had to follow her passion into art led to alternatives that ultimately enabled her to stay true to her inclinations and needs. Again, in *Openings,* she writes:

> A year after my return from Guinea, I was awarded a Fulbright fellowship to study African art at the Centre for West African

Studies at the University of Birmingham in England. I left my paintings and colored pencil drawings with C for safekeeping. A few months into the fellowship, he demanded I return and threatened to destroy my artworks. I returned. It's hard to think about my truncated education; I have seldom mentioned it. But I think the work in the cooperative gallery and in the women's movement provided me with the university I had abandoned.

Some artists saw the cooperative gallery as a means to move into the dealer system and others saw it as an opportunity to explore ideas and create shows free of commercial imperative. I am in the latter camp.[6]

Living in the latter camp, of course, isn't conducive to earning a dependable living. Even those artists who have galleries may not find it possible to survive just from selling their work; many teach or hold other jobs and make their art in off-hours. The United States is not a country that supports its artists particularly well. Sabra is confident about the choices she has made: "I think we all make work for someone in particular to see. I make art for my grandmothers, for the people I knew in Guinea, and for my peers, who are mostly women. Some members of this mythical audience of my heart might not like my work, and many are dead, but that is not the point. I feel the connections."[7]

Sabra has a special relationship with books. With other artists (each made a single page), she created a large museum-quality codex much like those few that survived the Spanish conquest of the Maya world. During her years at Random House and Doubleday, she illustrated a number of books with her original line drawings. She has made many artist books of her own, some elaborately fashioned, others using the cheapest reproductive methods, all beautiful. And she has written several commercially produced books, a little-known but extremely interesting compendium of indigenous rock art images

FIG. 10.6. *Sabra Moore,* Letter from Sylvia, *2015. Mixed media, 70¾ by 60 inches. Photograph by Sharon Stewart. Artist's private collection. Photograph courtesy of the artist.*

for which she wrote the text as well as copied the elusively complex drawings, *Petroglyphs: Ancient Language / Sacred Art*[8] and, most notably, the memoir that is also the history of many individual artists, collectives, and overlapping movements. *Openings* is one woman's story, and also a comprehensive record and profoundly moving telling of how women artists of the era took on the New York art-world establishment.

Openings puts on display the full range of Sabra's ability to combine memory, storytelling in its deepest sense, the written word, and unique book design to create something that shapes experience in a new way. And New Village Press met her more than halfway by

producing her vision flawlessly. The book is medium format, at 9¼ by 7½ inches, almost as wide as it is tall. In addition to two full-color insets, a continuous strip of small images, also in color, runs along the bottom third of each page; these 950 graphics include paintings and art pieces by the many creatives about whom she writes, archival photographs from the era, magazine covers and interior spreads, placards, and other ephemera. Even her dreams are present, floating to the surface of the page from time to time in a light blue typeface.

In Sabra's art, lettering is frequently an integral part of the piece. She incorporates words and sometimes whole sentences or even longer passages of poems, quotes, or statistical warnings in a way that stands somewhere between the pure design elements in the work of such painters as Braque and Magritte and the verbal screams of Jenny Holzer, Bansky, and today's graffiti artists. Sabra achieves a perfect integration of image, color, and script.

Sabra Moore begins her memoir with this statement: "Here was my dilemma: I didn't like the art world and it didn't like me. I needed to make art, but I didn't know where that art could go. I was the wrong gender and the wrong class."[9] This was not an easy beginning. Yet despite the many struggles along the way, always asking questions and making common cause with other women who were asking the same questions, taking risks, shunning conformity, and prioritizing her integrity and creativity, she continues to make art that matters.

CHAPTER 11

Jane Norling:
Between Art and Activism

In 2000, following years of vibrant participation in a number of different pictorial movements, San Francisco Bay Area artist Jane Norling (1947) leaped into new territory. She began to make paintings that invited us to experience an ease with subject and materials in service to themselves, and thus in service to the only artistic reality there is: the sole objective of all good art being its rendering as art.

Pablo Picasso famously said, "We all know that art is not truth. Art is a lie that makes us realize truth, at least the truth that is given us to understand."[1] A more accurate reference to Jane's work might be that successful art erases the fictitious barriers between what momentary art-world or political fashion coerces us into perceiving as cutting-edge and what we would be able to see and feel if we could free ourselves from those coercions. Jane takes us to planes between planes, interstitial rifts where reality cannot be twisted, the unexpected happens, and pasts and futures are remembered in, or superimposed upon, the present. These are like the great continental rifts in the Earth's surface. Think the East African Rift Valley, the tectonic clash beneath the Pacific Ocean, or our own Rio Grande fault line.

A major planetary shift has taken place and changed everything. We view Jane's paintings and understanding comes with the all-of-a-piece experience great art gives.

Writers and art historians write about art because artists can't or don't want to. This is particularly true of painters. Muralists and installation artists seem to be more expressive and verbally adventurous. But for most visual artists, the painting itself is the statement. Why overexplain or limit a painting by speaking about it when the piece, if it works, speaks for itself? Jane Norling's canvases are powerful statements on their own and she is also unusually articulate about her art. I have looked at her paintings for half a century now, have more on the walls of my home than those by any other artist, and have long felt the desire to explore them in words.

Perhaps this desire comes most forcefully from conversations Jane and I have had about her art over the decades in which I have witnessed its development. Whether experimenting with poster techniques in Cuba, where we met in 1972, working on some of the great Bay Area murals throughout the 1970s and 1980s, focusing on portraiture, or moving back into abstraction and finally out into her more recent and breathtaking landscapes, she has periodically felt nudged by questions about intention and effect. These are a citizen's questions; the work itself resists such concerns.

Jane studied art at Bennington College in the 1960s, a time when Abstract Expressionism was the most original contribution U.S. artists were making to world art. She graduated in 1968, having majored in painting and printmaking. Early the following year, she began training in book design at Random House. But she felt stifled by her family of origin's upper-middle-class culture. She describes having grown up in "a new subdivision, Hollin Hills, south of Alexandria, Virginia across the river from DC. The architecture was post-war prefab as well as floor-to-ceiling glass window modernism, populated by white people who hired Black women as housekeepers and, for the many women

who had careers, to look after their small children as well. My mother was a newspaper reporter with a concern for civil rights. But it was from our caregiver that I learned to cook, heard the music of the day on Black radio, and absorbed aspects of Black culture. She was the adult in my family with whom I could be myself."[2]

Despite a promising career in New York, Jane moved to San Francisco in 1970 to apply her love of graphic design and typography to the justice movements of the day. In San Francisco, Jane's visual arts interests shifted from abstraction to representational imagery, supporting community efforts to bring about social change. Although abstraction remained a foundation for her perceptual design, she applied her observational, drawing, painting, and typographic skills to serving the people. She joined activists working to end the war in Vietnam and build collective, art-centered communities.

In 1971, among a small group of activists, Jane formed the publishing/print collective Peoples Press, where she operated a small offset press as well as designed jobs for print. Concurrently, she was active in the nascent Bay Area community mural movement and other local and city arts organizations and ventures, all supported by the rich cultural mix that was then and still is San Francisco. Jane remembers Peoples Press as "a vehicle to voice my fierce desire for justice, particularly women's rights and ending the US war in Vietnam."[3]

It was Peoples Press that sent Jane to Cuba in 1972. Those were the early exhilarating years after the revolution; social change was still new and transparent, and everything seemed possible. She was invited to work at the OSPAAAL design studio. OSPAAAL, the Organization of Solidarity of the People of Asia, Africa, and Latin America, was one of the revolutionary institutions that reached beyond the U.S. blockade to speak to and collaborate with people around the world. It carried a message of equality, justice, and hope. Cuban poster artist Alfredo Rostgaard was the studio's director, and Jane worked under him. She still talks about how he assigned her design projects and

also to go out and see, read, and learn on her own. When September 23, the Day of International Solidarity with the Puerto Rican People's Struggle for Independence, approached, Rostgaard entrusted Jane with designing the poster.[4]

As I say, Jane and I met in Havana, where I'd been living for several years. We became instant friends, and our friendship has continued across borders, as young (sometimes single) mothers, as women working for social change, through dramatic world events, personal and international crises, and many shared projects. Over the years, Jane designed beautiful, impactful covers for several of my books. I remember taking her in 1972 to places where typical Cuban life unfolded, not what tourists saw, but everyday making and doing. I'd sit beside her and sometimes run gentle interference with onlookers who might become annoyingly curious as she got comfortable perched on a curb or beneath a tree, making rapid sketches of people doing what they did. Jane's ability to capture attitude and action in a few quick strokes has been a constant in her work, from the simplest campaign mailer to her full-fledged portraiture.

On her way home from Cuba, Jane stopped in Mexico for several months. I remember her letters from that time, filled with wonderful little drawings and excited descriptions of what she saw and whom she met. I have marveled at Jane's letters through the years. Back when we still wrote by hand, hers could be twenty pages long, illustrated with evocative little sketches in the margins. Her powers of description were extraordinary.

Wherever Jane's gone, she's been avid to explore the place's artistic traditions. As an activist in the community mural movement, where she was the designer and an editor of *Community Murals Magazine* in the 1970s and 1980s, she visited Mexico again in 1975, this time specifically to study murals, especially the great works by Diego Rivera, José Clemente Orozco, and her visual mentor, David Alfaro Siqueiros.[5] Spending time with those monumental wall paintings and mosaics—

examining materials and subject matter—has long influenced Jane's perspective on making art. In time, all these strands and skills came together in the expressive voice that characterizes her mature work.

Some of Jane's abstractions and the more abstract areas in her figurative paintings are still among those works of hers that move me most. And—like painter Elaine de Kooning or photographer Gay Block—she is masterful at portraiture, capturing attitude and gesture in ways that do more than bring her subjects to life; they reveal the person's essence. We not only recognize the subjects instantly; we discover nuances about their physicality and emotional makeup unnoticed before. This is also true of the composite or more representative faces in Jane's murals or on the poster art and brochures she's done for so many social movements: the young African American marching in the street, the elderly Asian American man, the woman enraged at the daily violence she endures, the child of whatever age or race deserving of a better world. Jane often uses photographs from which she copies particular features or expressions. All her portraits project complexity, strength, and energy.

Jane is someone who has never stopped studying the array of techniques available to painters, printmakers, and people who love to draw—from oil paints, acrylics, pastels, resins, waxes, pencils, and graphite to the digital and industrial possibilities that continue to entice contemporary artists. Even as a successful artist, she would surprise me by taking a course or joining a group of other artists interested in a particular art-making practice. Painting and design are Jane's life and, while she kept an active and successful graphic design studio for thirty-five years, her most moving and electrifying creative statements came from hours spent working with paints and drawing in her Oakland studio and those she now spends working in painting and collage at her Berkeley and Chicago studios.

Jane feels injustice deeply, and throughout our friendship she has experienced crises of self-doubt, always expressed in the feeling that

her fine art should somehow reflect our struggles more specifically or directly than it does. (I am using the term *fine art* here to distinguish it from movement work, although I realize there is an overlap.) I tell Jane she needn't worry about her art's making a specific narrative statement. And then, each time the same questions and doubts re-surface in our conversations, I tell her this again.

Painters speak with brushstroke, color, and movement. They project their vision onto a flat surface, most often contained within a rectangular picture plane. Just as a poet uses language, a musician speaks through rhythm and sound, a teacher passes on knowledge and encourages curiosity, a genuine healer looks at the whole person, or a gardener enjoys the intimate satisfaction she may receive by designing a natural environment in peaceful counterpoint to the chaos that surrounds us, a successful visual artist creates a moment of transformation through color and line. Form and content should be inseparable. We do not simply contemplate a picture but are also seduced by its many entrance points, bringing with us our own diverse histories and sensibilities. A great painting meets us more than halfway; it can change us.

As the new century dawned, Jane's work began to focus on land and water in the most profound and overarching ways. She began doing what she has described as "landscape abstraction." Preparation would begin in her own contact with a particular place: familiarity birthing discovery. As she explored, she often used a digital camera to take notes. Or she would make quick sketches, especially of illu-sory movement: the energy of temperature, seasons, growth, and de-struction. Jane's vision is large: the reshaping power of water and wind as they carve canyons through millennia, the fluctuation of tectonic plates, glaciers and ice fields receding before the onslaught of global warming, what is left when fire consumes old-growth trees and Earth's covering must begin again. Implicit in all this work is the artist's con-

sciousness of how human greed and a misguided understanding of progress threaten our habitat.

Jane's painting process builds through a variety of mediums to create luminous, almost translucent surfaces, marked by "leftover" line drawing that reflects her initial commitment in the field: armature and gesture. These sketch lines often remain visible in the finished work, playing with or accentuating the more elaborated areas of paint. Painting follows the gesture of drawing like those who make great journeys follow their internal maps.

In *Patagonia 1 Glacier Spegazzini,* the shapes of a threatened natural world are both literal and abstracted back into themselves, reiterating what might have been preserved and what is undeniably lost. Jane has divided the picture plane in half horizontally: what rises above the water and its reflection below. The narrow line of surf separating the two is intimate, fragile, fighting for its life. The mirroring of land in water moves in interlocking triangular shapes: dark and almost foreboding on the painting's left, brighter on its right. Here Jane's black lines are thin, broken, and scattered, sometimes painted and repainted to produce an intentionally unfinished texture that gives the work exceptional depth. To me, this is one of the most exciting of Jane's many powerful images.

Jane's way of working and reworking the surfaces of her paintings reproduces a sense of familiarity with her subjects. Volume and fracture, luminosity and darkness play off each other as they do in dreams—or when we give up subterfuge and allow ourselves to see.

Coming or Going is one of the artist's later works in this series dealing with water and ice. In it, she asks difficult questions. This large canvas works on myriad levels: as perfect abstraction, figurative exploration, and a third plane created where these elements meet. Green land teeters and disintegrates at the left of the painting as it careens into the sea. Bits and pieces reappear in other areas: floundering,

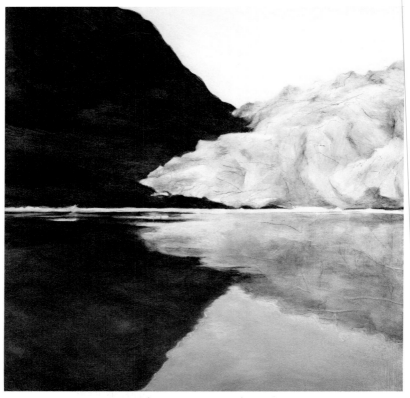

FIG. 11.1. *Jane Norling,* Patagonia 1 Glacier Spegazzini, *2010.*
Oil and graphite on canvas, 18 by 18 inches.
Photograph by Dana Davis Photography. Courtesy of the artist.

lost. The picture plane fragments almost to the extent that it seems a
jigsaw puzzle of separate shapes, yet there is a strong feeling of overall
unity. The result is movement, Earth's power heaving from one place
to another, from a moment in which a turning point is possible to one
that is beyond salvation.

Red Is the Answer to Everything is, for me, a pivotal painting in
this ongoing series about the Earth and its struggle for survival. Al-

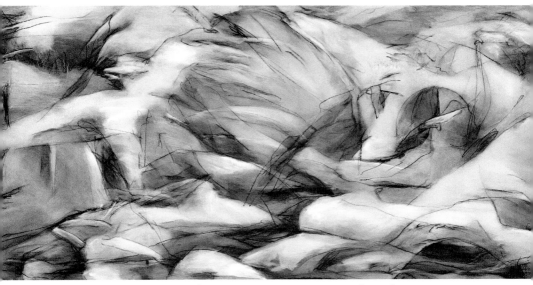

FIG. 11.2. *Jane Norling,* Coming or Going, *2011. Oil, graphite, and resin on canvas, 24 by 48 inches. Photograph by Dana Davis Photography. Courtesy of the artist.*

though this is a small painting, here the color areas are larger, almost aggressive. Figure and abstraction are equally present, imploring us to pay attention. A treelike image to the left bends against the elements. An even larger plant image to the right meets it in a dance—like the branches of old trees come together over streets in cities that value greenery. In the lower part of this work, areas of paint move with a rhythm both vibrant and exhausted. Black lines are here, but there are also white ones where she has scratched paint away to leave a negative space of erasure in motion.

Red Is the Answer to Everything breaks my heart. There is no other way to say it. The depth of feeling and movement in the painting lifts it above even those many others that are so extraordinarily powerful. If Jane continues to wonder, from time to time, what her art has to do

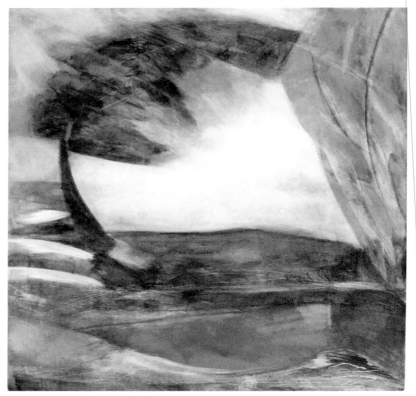

FIG. 11.3. *Jane Norling,* Red Is the Answer to Everything, *2009. Oil and graphite on panel, 12 by 12 inches. Photograph by Dana Davis Photography.*

with how she sees the world and its dilemmas, this work offers the only possible answer: everything.

Burned Earth What Next crackles with the intensity of fire that has come and consumed, its destructive force laced with the haunting beauty of what is left. We can feel the echo of its smoldering among charred remains. Again, those thin black lines create a dance of movement, but here they dissolve into the thicker black of burned tree trunks: stark but not defeated. Many small areas look back at us like a quilt reflecting what we are doing to our environment. In their very

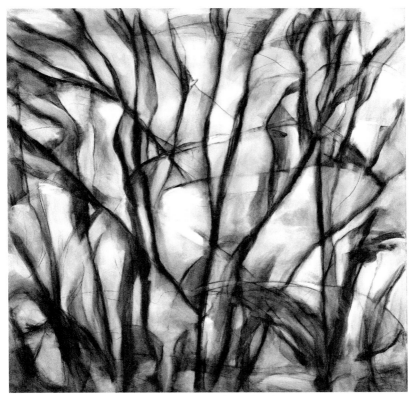

FIG. 11.4. *Jane Norling,* Burned Earth What Next, *2008.*
Oil and graphite on canvas, 35 by 35 inches. Photograph by Dana Davis
Photography. Courtesy of the artist.

different styles, this painting and some of Sabra Moore's quiltlike con-
structions tell the same story, Jane's of our habitat and Sabra's of those
who inhabit it. At the bottom of Jane's canvas whispers of green remind
us of what is still alive and struggling to reestablish itself. Painted and
repainted areas of white function as connective tissue in their ability to
hold the overall image together. In this as in all Jane's paintings, there is
a working and reworking of shape and color that mirrors seasonality,
weather, multiple cycles of birth, aging, death, and the possibility of
rebirth.

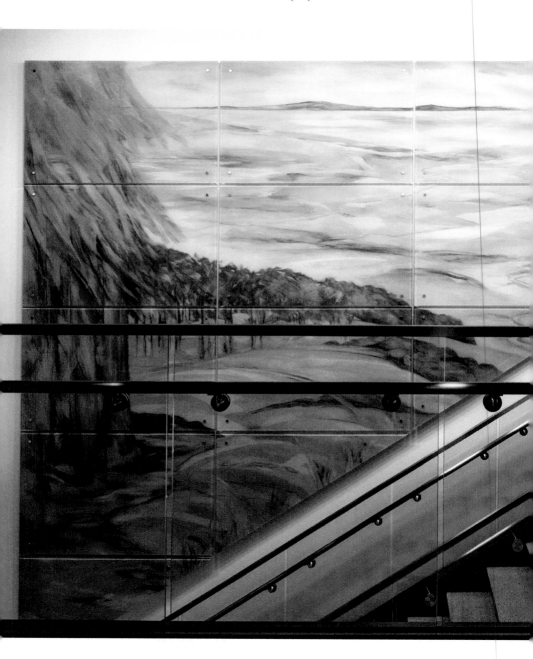

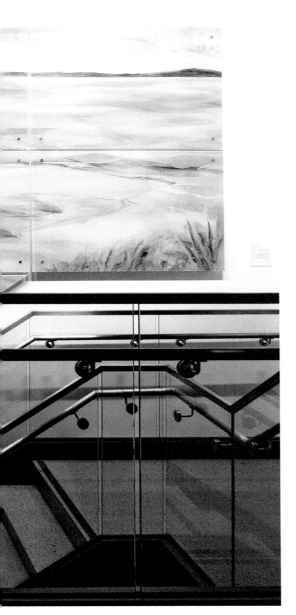

FIG. 11.5. *Jane Norling, Large staircase panel at Alameda County Services Building, 2016. Digital ceramic print on glass, 15 feet deep, 19 feet across. Photograph by Sibila Savage Photography. Courtesy of the artist.*

The largest example from this period is the permanent glass mural in six parts that Jane was commissioned to create by the Alameda County Arts Commission, the Oakland installation of which she oversaw in 2016. These luminous panels began as studio studies before they were digitally printed on glass. Jane had to learn to take into account the idiosyncrasies of this unfamiliar medium. The space between glass and wall gives the panels added depth. This is a building where people come for counseling as well as other services. I remember Jane telling me that they discouraged her from using the color red because it might trigger painful emotions. The panels start large as the first one borders a stairway that goes from the first to second floor, where they split into discreet images that nonetheless go from floor to ceiling. Viewing the whole is a consuming experience.

All these paintings evoke the broadest and deepest forces at work in our world: tectonic movement, Earth's magma breaching its wounded surface, melting ice caps, oceans threatening to devour whole nations, rivers rising above their banks, reduced animal habitats, climate change, harrowing fear and tenuous hope; and how the forces of nature come undone when tampered with, and jeopardize all life. Even in their protracted death throes they manage to embody pure energy. As message, they are definitive. As works of art, they are gorgeous and vivid, seducing us with their originality and power.

Since this series that so moves me, Jane has continued to produce interesting work. After 2011, she journeyed into digital printmaking made partially from abstract paintings. She has also done a great deal of collage and produced new posters for new causes. During the forced isolation of COVID-19, she has made collages created from earlier artwork, some of it decades old.

Jane Norling's art, even when it is most abstract, expresses her concepts of justice—social, environmental, preservation of life on Earth—brought forward from earlier figurative work (murals, posters,

portraits, illustrations) to something deeper and more inclusive. She has found this something deeper and more inclusive via the abstraction in nature and years of looking and studying how to transmit in paint what she has learned to see and thinking deeply about the consequences of the harm we inflict. These paintings are about foundation, the very architecture of life on Earth. Most important, it is art that is not about, but is.

Barbara Byers:
Surviving in Art

Barbara is androgynous in look and dress, her shaved head not a fashion statement, suggestive of an identity as a Buddhist nun, or the result of chemotherapy, but about comfort: Her nervous system, damaged by years of abuse, is intensely sensitive to fabric, temperature, even the itchy stubble of hair growing out. Plus, her parents always wanted her to look like a girl, which meant long, curly blond locks, and it's been a relief for her to get rid of those. Tiny lines gather at the corners of her eyes, a sign of engagement and frequent laughter. And her eyes notice the slightest alteration in her surroundings or need on the part of another. When they smile, it is with the fullness of deep empathy.

It's been a rough road and continues to be. Extreme childhood abuse resulted in lifelong pain and occasional immobility. As with Frida Kahlo, although for very different reasons, these problems are almost always with her. When Barbara's legs go wooden or balance threatens to desert her, she uses hiking sticks or a cane. Because of encroaching neurological impediment, she has had to give up biking, a sport she loved. Still, she manages a good deal of joy. When she is out in the world and notices a young child being ignored or someone

in a wheelchair, she will crouch down to that person's level and exchange a few words. She says she just wants them to feel seen. People are drawn to her attention and kindness.

Barbara Byers was born in 1952. Her story begins almost seven decades ago in a family in which danger stalked her constantly and becoming an artist was not on the list of acceptable options. This chapter may be the most difficult for me to write. I know Barbara better than any of the other artists in this book; she is my wife and we have been together for more than thirty-five marvelous years. The difficulty, however, isn't due to this closeness or any resultant subjectivity. It's because, for most readers, Barbara's story is almost impossible to imagine and extremely disturbing to hear. Telling it risks incredulity on the part of the listener, or the suspicion that she must be lying or on some sick quest for attention. Because of this, until fairly recently, she has hesitated to talk about her past. Now she may do so if she trusts the person to whom she is speaking or intuits that this person, too, may come from a background that alters one's very cells. I tell it here because, as hard as it may be for others to digest, I believe it is the source of much of her sensibility and profound ability to see, both prime ingredients of her art.

Barbara is the eldest of three siblings born to working-class parents in Denver, Colorado, during the twisted and—for women at least—stifling 1950s. World War II had ended, and the United States was experiencing a booming prosperity, but always within the patriarchal, capitalist paradigm. McCarthyism blanketed the country with fear, and most people opted for conservative choices. Barbara's father started out as a lineman at the local telephone company but came up through the ranks, until he eventually held a vice presidential position, lifting the family from hard times to a comfortable middle-class lifestyle. Her mother never worked outside the home. It's clear that her parents, too, suffered childhood abuse—the terrible pattern that tends to repeat itself if not confronted.

Barbara remembers being made to feel guilty when she needed glasses or some other support that most families are able provide their children as a matter of course. Violence was an everyday occurrence in her childhood home; waiting for it was a way of life, keeping her wary and afraid. And she was expected to be strong. Her father, especially, didn't tolerate weakness. Her mother, emotionally subject to her husband's rage and domination, was unable to put a stop to it. She suffered from multiple sclerosis and eventually was confined to a wheelchair, making her husband's control more absolute. Two years after Barbara, a brother was born, and ten years later, a sister.

The family was Baptist. Gradually, though, they left more traditional congregations to join fringe groups shunned even by the conservative Baptist Convention. These churches had a variety of names. Barbara remembers the members of one of them meeting in an old mortuary. Much of her childhood recall is hazy—she now realizes that she was conditioned to forget criminal incidents and whole periods of time, programmed to kill herself if she remembered or revealed them. Through psychotherapy, a fierce will to survive, and years of hard work, she's recovered enough memory to know that she witnessed and was forced to participate in activities as repugnant as they were terrifying. The forced participation was the worst: a burden of shame with which she continues to struggle.

Barbara's effort to retrieve enough of her childhood to have a sense of what she endured has been arduous. Physical, sexual, and psychological abuse was the least of it. Her father routinely punished her with electrical current, resulting in a damaged neurological system, which has been diagnosed as the cause of her chronic pain. It's been a long and sinuous road. She and I have both felt grateful that my experience with Latin American torture victims allows me to recognize the symptoms shared by survivors of political as well as so-called domestic abuse. My validation of her experience and my admiration for her resilience have helped build the deep bond we share.

She remembers being sent door-to-door to proselytize to neighbors and coming home from school one day to find the house empty; not even the dog could be found. She was sure the Rapture had taken place and she'd been left behind.[1] This sort of sudden immobilizing fear was a common feature of her life for years and still echoes in her automatic response to situations that may trigger such fear. As she grew, her natural curiosity, privileged mind, and obvious discomfort weren't lost on teachers, several of whom saw the endangered young person struggling to survive in a hostile environment. Two tried to intervene by inviting her home on weekends, and Barbara remembers those times as welcome intervals—breathers, if you will. Being seen by teachers helped, but their efforts to effect some sort of ongoing solution were useless. What could anyone do against a student's father who was considered a pillar of the community and literally owned his wife and offspring, as was common at the time?

A combination of fundamentalist religious practices and political ties that were far more sinister shaped Barbara's childhood and youth. She has memories of being taken to training camps and being taught to shoot at a very young age. The targets were men on the run, perhaps extracted from the local drunk tank and hunted down. It is clear that Barbara's parents belonged to a secret cult, whose membership undoubtedly included other "upstanding" community members: church deacons, school principals, police officers, the usual untouchables. This made denouncing what was happening to her or seeking help impossible, even dangerous. After many years and much research, she determined that her father and mother were probably members of a group called Posse Comitatus.[2] Whatever the shadowy history, it left scars that she continues to grapple with today.

During the early years of Barbara's and my relationship, we tried to maintain a connection with her family. Our culture tells us one is supposed to be close to one's parents, after all. We would visit them from time to time, but after each of those visits, Barbara would be physi-

cally ill for weeks, even months. Once, out of nowhere, her mother suddenly declared, "I'm sorry we treated you so brutally as a child." She didn't elaborate, and we were too startled to ask for more. This and other chance comments or bits and pieces of stories validate what Barbara now knows of her childhood. In their old age and before their deaths, both parents nurtured a fictitious innocence; the disconnect between what Barbara remembered of her childhood and the way they were living so many decades later seemed disturbingly incongruous.

Cutting ties with her family has made a positive difference to Barbara's well-being. She has never wanted to be defined, or to define herself, by the abuse. Still, memories resurface, and wounds continue to fester. She remembers a childhood family trip on which her father took her and her siblings to visit a prison—presumably to frighten them into socially acceptable behavior. Her brother once broke his arm at the beach and their father refused to take him to a hospital. Barbara, too, was extremely ill at one point in her adolescence and her father wouldn't get her the medical help she needed. Yet, curiously, she vividly recalls his insisting on accompanying her to their family doctor when, as a child, she showed signs of having been sexually abused. He shot several family dogs and a flock of ducks because he was fed up with their barking or quacking; on one such occasion, Barbara says, he calmly got up from the family dinner table, took out his revolver, did the deed, and returned to the meal again as if nothing unusual had taken place. A painting she calls *Daddy Will Spank Self Portrait* stands as evidence of this trauma.

Barbara speaks about a moment, around the age of sixteen, when her father was about to strike her and she stood her ground, looking at him in a way that made him stop. Never again would he abuse her physically. But his psychological control would continue. She was raised in a state of dependency that kept her at home far longer than was healthy. Even as she experienced difficulty living fully on her own, she was eager to stay in college. But after a single year, her father

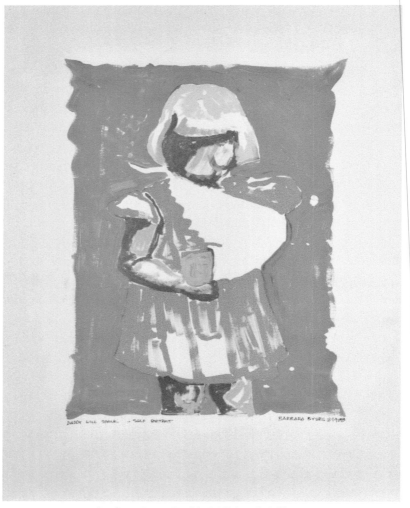

FIG. 12.1. *Barbara Byers*, Daddy Will Spank Self Portrait, *1988.*
Acrylic on paper, 27¾ by 21⅝ inches. Photograph by the
Albuquerque Museum. Courtesy of the Albuquerque Museum.

refused to fill out the financial aid papers, making it impossible for her to keep studying.

And so the journey from family out was piecemeal, convoluted, and difficult. She eventually did escape her parental home, supporting herself with modest, nondescript jobs. She married to gain some like-minded companionship. She and her husband shared a love of hiking and canoeing and a gift for restoring old cars. They joined a Baptist congregation with a social orientation, allowing them to meet other young couples who were interested in creating a more socially conscious community.

A few years later, Barbara left the Baptists altogether and joined an Episcopal church. Here was a religion that permitted questioning and thinking. She even studied for the priesthood, but eventually realized she could no longer in good conscience preach what she didn't believe. Still, she retains an ability to engage with people whom society rejects and to this day has a personal pastoral practice consisting of seeing and listening to those who remain invisible. Her husband turned out to be another lost soul, smart and a lover of the outdoors, but limited by his own early conditioning: racist and narrow-minded. She left the marriage after eight years and assumed her lesbian identity.

Barbara is profoundly creative, and I often imagine what heights of expression she might have achieved had she been encouraged to study when she was young. As it was, she worked at many different jobs, eventually apprenticing to a master sign painter. She entered that trade just as it was about to evolve from the magic of hand lettering to using machines to cut letters out of vinyl and metal. What had been an art form became a far less creative practice.

From an early age, Barbara wanted to make art. No, not really wanted to as much as was compelled to. She drew and painted, but her work was always seen by her family as a hobby, not anything to

be taken seriously. This was also true of her ideas, her growing polit-ical consciousness, and eventually her lesbian identity. None of these was on the list of what was expected, or even tolerated, in her father's world. It was her innate inner strength that enabled her to pursue those activities, ideas, and identity. It was as if she'd been born into the wrong family. The whole person could no longer allow herself to be determined by others.

When we got together, Barbara was working at a sign shop. She had the habit of taking one university course a semester, not toward a degree, but just to keep herself intellectually stimulated. One semes-ter, she took a class from me. It was called Women and Creativity. I was in the midst of my immigration case at the time, harried and tense. One day, she came to my office with a single silver rose in her gym bag. When she took it out and handed it to me, my heart sud-denly relaxed and burst open. After I turned in final grades, we began seeing each other. We started living together a week later.

Experiencing life on her own terms finally enabled Barbara to begin thinking about what she wanted to do with it. She knew she needed to give back to society and decided to finish her university education, this time earning the credentials that would make it pos-sible for her to become a public school teacher. She graduated on her fortieth birthday and taught special education middle school students in an impoverished area of Albuquerque for twenty years before she retired. She brought her considerable gifts to her teaching career and still occasionally runs into ex-students, now adults, who remember her with gratitude.

She began taking her art more seriously. Until she stopped work-ing, she painted when she was able—after exhausting days in the classroom or during summer vacation and other breaks. Those early years in which her need to make art was ridiculed and dismissed had taken their toll. It took a long time for Barbara to consider herself an artist, claim the necessary time and space, and invest in the tools

she needed. Now that she's retired from teaching, it's easier. A high compliment about others is that they "make new things."

But she has never wanted to go the art-world route, seek a gallery, or engage in the sort of self-promotion and politicking that being a professional artist in this country demands. In this, she and Sabra Moore have something in common, although Sabra still has to struggle to make ends meet, while Barbara is fortunate to have a teacher's pension. I've encouraged her to simply make her art. These days, that is what she does. And her work is unique and exciting, moving from one long series of images to another as she explores new directions, materials, and subject matter.

Travel to other parts of the world, but most especially the landscape of the American Southwest, informs Barbara's work. She often says that the Colorado Plateau is her heart home. As with the other artists in this book, she is possessed of an insatiable curiosity and the ability to make connections. She experiences life through her art, and her art allows others to experience it through her way of seeing. Unlike most of those about whom I've written here, she typically works small. It may have been the conditions of her life that prevented her from visualizing a studio where she might produce large canvases. A modest room in our home and lately an even tinier corner of our apartment has been enough. Almost obsessively organized, she creates the perfect venue, each tool in place, each new idea expressing itself in a space ideally designed for its execution. When Barbara gives her studio an organizational overhaul, which happens often, I always know she is about to embark on a new artistic journey.

Like most artists, Barbara works in series: images of old cars; stylized tortoises; underwear flying through the sky, such as in a small acrylic on paper she called *Northern Bra Warning,* which made me laugh out loud when we got together; New Mexico landscapes in which earth and sky may be purple or orange; petroglyph images, which she's studied for years and which appear and reappear in her work; peace

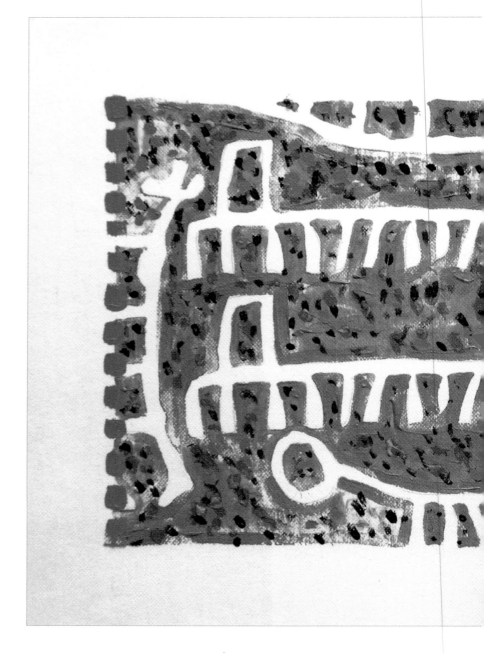

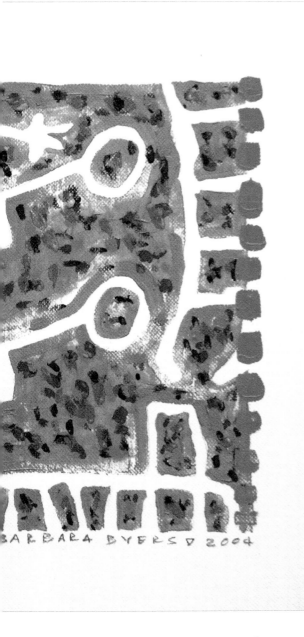

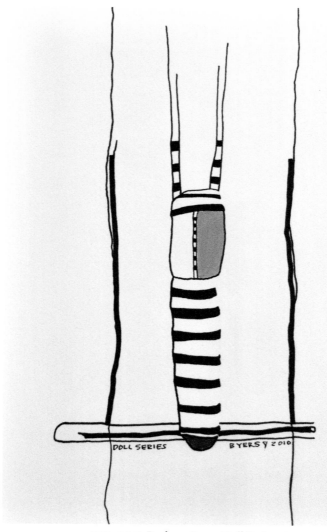

FIG. 12.3. *Barbara Byers,* Doll Series, *2010.*
Ink and watercolor pencil on paper, 9 by 11 inches.
Photograph by Barbara Byers. Courtesy of the artist.

shields; complex abstract maps that use collage and which she calls *Personal Cartography;* drawings rooted in asemic writing, an unintelligible script through which she can express her innermost thoughts without being concerned that anyone can read them[3]; pure abstraction with dominant areas of color that might also include one or more of the foregoing elements. She will work on a series until she feels she has exhausted its possibilities, then move on to something else. But nothing is forgotten: Vestiges of earlier images reappear. Lately, she has been making art on an iPad, teaching herself the secrets of digital painting, and doing extremely close-up black-and-white photography.

In recent years, Barbara has been fascinated with making artist books and doing artisanal printing. She belongs to Libros, an Albuquerque contingent of bookmakers who meet to experiment with a variety of materials, bindings, and styles, and who show their work publicly. Her books tend to be original creations, more about the art than about a complex technique, although she also likes experimenting with new approaches. Sometimes she will make a book that is a one-of-a-kind album created to display a series of small paintings she wants to keep together. But she is just as likely to sell one of its pages if someone is interested.

Barbara has had gallery shows, and examples of her work are in important private collections as well as in a few museums, but she most often exhibits in cafés, bookstores, and other community venues. A few years back, she hung sixteen notebooks in a horizontal line on the wall of an Albuquerque café frequented by street people as well as academics and neighborhood regulars. Viewers were encouraged to touch the spread-out books, turn their pages, explore their contents. I was shocked at first that she would subject her work to that sort of risk. But her trust in the public was rewarded with extraordinary feedback, and the notebooks themselves made it through unscathed. She also loves making two-by-two-inch drawings and giving them away to friends and others. Her business cards are individual handmade works

FIG. **12.4.** *Barbara Byers,* Personal Cartography, *2013.*
Bleach and ink on kraft paper, 4 by 4 inches.
Photography by Barbara Byers. Courtesy of the artist.

FIG. 12.5. *Barbara Byers,* Abstraction, *2020. Digital painting,*
3,000 by 3,000 pixels. Photograph by Barbara Byers.

of art, drawn or produced from silicone pads called Gelli blocks, with
the necessary information on the back. Most recipients don't even
realize they are being given an original drawing or print. When in new
surroundings for a few days or weeks, she may affix unsigned artworks
to the walls, leaving them for people to discover and enjoy—and very
often take.

Barbara works simultaneously in several mediums. She will always
have two or three notebooks going at a time, one for the thoughts and
images that she says "leak from my head," which she destroys when it

FIG. 12.6. *Barbara Byers, black-and-white photograph.*

is full, others for more formal output. She experiments with inks, teas, bleach, special papers, and other materials. She travels with a reduced set of implements—pens, colored pencils, a couple of notebooks—so she can set up a studio of sorts wherever she may be. She loves drawing with our great-grandchildren, Guille and Emma, who are six and three, respectively. Their parents give them the freedom she never had as a child. Barbara's art is like breathing and eating, necessary to her survival.

A renewed interest for Barbara is photography. It has become another way for her to notice things. When we met, she took pictures that, much like for Jane Norling, became notations for drawings or paintings. Now she has developed this medium as a new interest. With her iPhone camera, she often wanders the neighborhood or even the rooms in our home, making pictures of details: the cracks in a sidewalk, old wood and roots, a bit of tree bark, fallen leaves and other detritus she calls "gutter art," the edges of the pages in a book, a fragment of a refrigerator magnet, or a hidden curve on the under-side of a piece of furniture. By shooting items from unusual angles, unexpected landscapes emerge. The micro becomes macro. Textures, shapes, patterns, shadows: often magnified until they are transformed into something else. She renders all these images in black and white and describes them as "photographing light." Then she crops and edits until she has produced what she wants to say. This is but one type of creative expression, which she explores simultaneously with the digital paintings, the collages, asemic writing, and artist books.

Barbara and I have often collaborated on creative projects. She has given me cover art for many of my books. In a few, such as a couple of small chapbooks and a collection of poems about the Grand Can-yon, she contributed drawings throughout.[4] As with other of Barbara's work, these magnified black-and-white photographs have inspired poems. In these collaborations, we don't think of the images illustrat-ing the poems or the poems illustrating the images. They are simply two creative expressions working together, each extending the other's voice. Here is a poem of mine written in response to her black-and-white photographs:

It Looks Like a Dead Leaf

It looks like a dead leaf, dry and cracking
at your feet, but in its broken veins

the Nile, Amazon and Yangtse run, carrying
barges of secrets for centuries to come.

Deep within the willow basket, the hands
that wove it still move back and forth
combing and plaiting
until it can hold every memory.

The edge of the book is like the edge
of reason: brittle but deep,
strong enough to tender any idea
that can take us where we want to go.

At the edge of vision somebody moves.
You look again. She isn't there
but will accompany you always,
her brilliant mind ready to play with yours.

Our home is one in which art is front and center: Barbara's drawing and painting, my writing, the work of others. We respect and support each other's work space, and artistic creativity is central to our relationship. She doesn't worry about her art surviving her. She is lax about keeping photographs of what's she done or recording where her pieces live. Once we were visiting a collector in San Antonio, Texas, and saw one of her paintings on his wall; she'd completely forgotten he'd purchased it several years before. She's often said, "When I die, it will all get kicked to the curb." I know her work has changed lives. It has changed mine and I believe it will outlive her despite her predictions.

Acknowledgments

There are many people to thank for helping to make this book what it is. I am first of all indebted to the artists. In one way or another, whether close friends or gone before I could know them personally, they all changed my life. For the images in the chapter on Elaine de Kooning, I am obliged to Brandon Fortune, Charles Fried, Clay Fried, Guy Fried, Gabrielle Shatan, Dr. Michael and Susan Luyckx, the staff at the Smithsonian Institution's National Portrait Gallery, and the National Museum of Women in the Arts. For the chapter on Shinki-chi Tajiri and Ferdi Tajiri-Jansen, I am profoundly grateful to their daughters, Giotta and Ryu Tajiri, who made all manner of material available and went above and beyond in helping me research their parents' lives and work. Giotta's memory, especially, helped sharpen my own. I thank Edward Ranney, Leandro Katz, Gay Block, Sabra Moore, Jane Norling, and Barbara Byers for responding to innumerable questions about their art and generously providing me with all the images I wanted. I am deeply indebted to Mary Gabriel and Ed McCaughan, who honor this book with their beautiful forewords. V. B. Price, John Randall, Gregory Randall, and Mary Oishi read and

commented on portions of the book, which benefit from their input. Lynne Elizabeth, founding director of New Village Press, is a joy to work with; this is the second book we've done together. I am also indebted to her talented staff. And Barbara Byers, my artist partner of thirty-five years, gave me the support and sensitive critique she's provided on every project during our time together—as well as giving me the constant excitement of her art. Thank you all.

Notes

FOREWORD *by Ed McCaughan*

1. Patti Smith, *Just Kids* (New York: Ecco, 2010); Elena Poniatowska, *Mariana Yampolsky y la buganvilla* (Mexico City: Plaza y Janés, 2001).
2. Stuart Hall, "Cultural Identity and Diaspora," in *Social Theory: Continuity and Confrontation,* ed. Roberta Garner (Peterborough, Ontario: Broadview, 2001), 560.
3. Edward J. McCaughan, "Navigating the Labyrinth of Silence: Feminist Artists in Mexico," *Social Justice* 34, no. 1 (2007): 44–62.
4. Edmund White, *My Lives* (New York: HarperCollins, 2006), 162.
5. Magali Lara quoted in Edward J. McCaughan, *Art and Social Movements: Cultural Politics in Mexico and Aztlán* (Durham, NC: Duke University Press, 2012), 141.
6. Manulani Aluli Meyer, "Hawaiian Hermeneutics and the Triangulation of Meaning: Gross, Subtle, Causal," *Social Justice* 30, no. 4 (2003): 57.

CHAPTER 1. *Elaine de Kooning Paints a Secret*

1. Caryl Chessman (1921–1960) was convicted of robbery, kidnapping, and rape, crimes that took place in the Los Angeles area in 1948. He wrote four books while on death row, including a memoir, *Cell 2455, Death* Row,

claiming his innocence to the end. Following a string of unsuccessful appeals, he was put to death in San Quentin's gas chamber on May 2, 1960.

2. Willem de Kooning (1904–1997) was born in Rotterdam, the Netherlands, and came to the United States in 1926. He would become one of the leading artists of the Abstract Expressionist movement, which took New York and the world by storm in the 1950s.

3. Elaine de Kooning, *The Spirit of Abstract Expressionism, Selected Writings*, with a preface by Marjorie Luyckx and an essay by Rose Slivka (New York: George Braziller, 1994), 151.

4. Ibid., 15.

5. "Elaine de Kooning: Portraits," National Portrait Gallery, Smithsonian Museums, March 2015–January 2016.

6. Elaine was the only woman artist to that point commissioned to paint a presidential likeness. In 1962, she was asked to make a portrait of John F. Kennedy for the Harry S. Truman Library in Independence, Missouri. She traveled to Palm Beach, Florida, and spent three weeks there with her studio assistant, the painter Eddie Johnson, who documented the sittings photographically. Back in New York, Elaine produced her series of extraordinary portraits. When Kennedy was murdered just a few months later, she was deeply affected.

7. Harold Rosenberg, *The Tradition of the New* (New York: Horizon Press, 1959).

8. Living in Mexico and married to a Mexican, I assumed Mexican nationality in 1967, thereby losing my U.S. citizenship. Several relationships and much political turmoil later, when I returned to the United States in 1984, the government invoked the 1952 McCarran-Walter Act and ordered me deported because of opinions expressed in some of my books it deemed "against the good order and happiness of the United States." I won that struggle, and with it my U.S. citizenship was restored in 1989. For a fuller accounting of the case, see my *Walking to the Edge: Essays of Resistance* (Boston: South End Press, 1991).

CHAPTER 2. *Shinkichi Tajiri and Ferdi Tajiri-Jansen: Remembering an Extraordinary Family*

1. Ironically, a few years later, when the Soviet Union had replaced the Axis nations as the United States' number-one enemy, the name of this tree was changed back.

2. Ryu married but didn't have children. Giotta's daughter, Tanéa Ferdi Teruo Tajiri, is an independent creative project coordinator, and her son, Shakuru Shin Tajiri, a music supervisor and specialist in sonic branding.

3. Ernesto Cardenal, letter in *El Corno Emplumado* 3 (July 1962): 134. Translation by MR.

4. See Ferdi Tajiri-Jansen, www.ferdi-tajiri.com.

5. Ibid.

6. Giotta and Ryu Tajiri, eds., *Ferdi: Hortisculpture* (Baarlo, the Netherlands: TASHA BV, 2008), 60–63.

7. This series comprised eight sculptures that Shinkichi started after teaching in Minneapolis. They were mistaken as a glorification of war/killing machines. Shinkichi's intent was to be critical of governments spending lots of money on machines to kill and suppress people rather than on education. He wrote, "I am anxious over the frightening technological developments that aid men in evolving and perfecting the means and machines of executing legalized murder under the name of war." This was during the U.S. war in Vietnam. See www.shinkichi-tajiri.com/machines.

8. Margaret Randall, *October* (Mexico City: El Corno Emplumado Press, 1965).

9. Giotta and Ryu Tajiri, "The Fabric of Our Lives," in *Shinkichi Tajiri: Universal Paradoxes,* ed. Helen Westgeest (Leiden, the Netherlands: Leiden University Press, 2015), 16.

10. Ana's father is Robert Cohen, a man I lived with for a number of years after Sergio and I divorced.

11. Shinkichi Tajiri, *Autobiographical Notations* (Baarlo, the Netherlands: TASHA BV, 2015), 15–21.

12. The Japanese immigrants were *Issei;* their offspring—the first generation to be born in the United States—were *Nisei.*

13. Greg Robinson, "Shinkichi Tajiri and the Paradoxes of Japanese American Identity," 2019; see http://www.discovernikkei.org/en/journal/2019/9/17/shinkichi-tajiri/.

14. President Roosevelt made this statement in his address to Congress on December 8, 1941, when he asked that a state of war be declared between the United States and Japan.

15. Isamu Noguchi (1904–1988) was an important Japanese American sculptor and landscape architect.

16. Tajiri, *Autobiographical Notations,* 28.

17. Greg Robinson, "Shinkichi Tajiri and the Paradox of Japanese Identity," in *Shankichi Tajiri: Universal Paradoxes*, ed. Helen Westgeest, 74.

18. Tajiri, *Autobiographical Notations,* 9.

19. "Twelve Japanese Americans Killed, 25 Hurt in Recent Action in Italy Front," *Pacific Citizen*, 19, no. 5 (August 5, 1944), 1.
20. Ossip Zadkine (1888–1967) was a Russian sculptor. Fernand Léger (1881–1955) was a French painter, sculptor, and filmmaker.
21. Giotta and Ryu Tajiri, "The Fabric of Our Lives," 30.
22. These observations and quotes are from Shinkichi Tajiri, *The Berlin Wall* (Baarlo, the Nethlands: TASHA BV, 2005).
23. Tajiri, *Autobiographical Notations*, 69.
24. *Made in USA* and *Wombtomb* are both in the Collection of 20th Century Art at the Rijksmuseum, Amsterdam.
25. Paraphrase of comments made during a telephone conversation with the author, November 19, 2020.
26. Giotta and Ryu Tajiri, "The Fabric of Our Lives," 16.
27. Ibid., 18–32.
28. Email to author, November 21, 2020.
29. She had just had a major exhibition at Amsterdam's Stedelijk Museum, unusual for a woman artist in 1968.
30. Giotta and Ryu Tajiri, "The Fabric of Our Lives," 26.
31. Email to author, December 4, 2020.
32. This chapter is based on the text I sent to Giotta. It became the first chapter I wrote for this book and the one that provided the impetus for the others.

CHAPTER 3. *Frida Kahlo's Bathroom: A Contested Space*

1. Geoffrey T. Hellman and Harold Ross, "Ribbon Around Bomb," "The Talk of the Town," *The New Yorker*, November 12, 1938. The authors wrote about Kahlo: "She was sitting at one end of the gallery in a brightly colored Tehuantepec costume, looking pretty much like a beribboned bomb herself. She is dark, small, vivacious, and twenty-eight, twenty-four years younger than her husband and two hundred pounds lighter."
2. See https://hyperallergic.com/660471/indigenous-perspective-frida-kahlo/ for an interesting perspective on Frida's indigeneity by Purépecha writer Joanna García Cherán.
3. Frida Kahlo was actually born on July 6, 1907.
4. Anna Haynes, "Frida Kahlo: An Artist 'In Between,'" *eSharp* 6.2 (Spring 2006), an online journal published by the University of Glasgow.
5. Frida Kahlo, *The Diary of Frida Kahlo: An Intimate Portrait* (New York: Abrams, 1995), last page (unnumbered). This is not the translation of this line that appears in the book. Realizing that it is incorrect, I made my own translation.

CHAPTER 4. *Georgia O'Keeffe: The Painter
Who Made New Mexico Hers*

1. Genízaros were detribalized Native Americans in New Mexico and Colorado who in the sixteenth century, through war or payment of ransom, were taken into Hispanic villages as indentured servants, shepherds, or laborers. In 2007, Genízaros were recognized by the New Mexico legislature as indigenous people. Today, they respond to the idea of a distinct heritage. Many Crypto-Jews found their way to the New World, specifically what is now northern New Mexico, following the 1391 massacre of Jews in Spain and their expulsion in 1492. They publicly professed Christianity, keeping their Jewish culture hidden, but continued to practice Jewish religious rituals in secret. Many families still hesitate to publicly claim their Judaism.
2. Sarah Greenough, *My Faraway One: Selected Letters of Georgia O'Keeffe and Alfred Stieglitz,* vol. 1, *1915–1933* (New Haven: Yale University Press, 2011), 334.
3. Sarah Churchwell, "Georgia O'Keeffe's Visions of the Faraway," *Prospect,* July 14, 2016.
4. *Rotating O'Keeffe Exhibit* (Fort Worth, Texas: National Cowgirl Museum and Hall of Fame exhibition catalog, 2010).
5. Barbara Buhler Lynes, ed., *Maria Chabot–Georgia O'Keeffe: Correspondence, 1941–1949* (Albuquerque: University of New Mexico Press, 2003).

CHAPTER 5. *Mary Elizabeth Jane Colter's Grand Canyon*

1. Arnold Berke, *Mary Colter: Architect of the Southwest* (New York: Princeton Architectural Press, 2002).
2. Ibid., 204.
3. Ibid., 68.
4. Ibid.
5. When he learned La Posada was in danger of being torn down for good, Allan Affeldt bought the hotel in 1994. He restored it, and his wife, the painter Tina Mion, added furnishings and interior design touches meant to resemble the hotel's original decor. The hotel opened in 1930, just after the stock market crash of 1929. It stayed open for twenty-seven years before closing in the late 1950s, when all the original fixtures were auctioned off. Restoring it to its former glory has taken years but has been an enormous success. Winslow remains a dusty little town, but the hotel today is almost always full.

6. Fred Kabotie (1900–1986) was a Hopi painter, silversmith, illustrator, and potter. His Hopi name was Naqavo'ma, which means "the sun coming up day after day." His paternal grandfather gave him the name Qaavoytay, meaning "tomorrow," and Kabotie derives from that. Fred attended the Santa Fe Indian School, where he was prohibited from speaking his language and was urged to become a white man and a Christian. When John DeHuff was made superintendent of the school, he went against government policy and encouraged Kabotie to preserve his culture and make his art, for which DeHuff was demoted and forced to leave the school. Fred Kabotie went on to become an internationally known artist.
7. Fred Geary (1894–1946), from Missouri, was in charge of art and decorating for the Fred Harvey restaurant system of the Santa Fe Railroad. Although not Navajo himself, he did many illustrations for a magazine called *Navajo Medicine Man*. When painting the ceiling at the Watchtower, he was advised by Navajo medicine man Miguelito.

CHAPTER 6. *Edward Ranney, Lucy Lippard, and the Ancients Who Made the Nazca Lines*

1. Edward Ranney, *The Lines,* with an essay by Lucy Lippard (New Haven, CT: Yale University Art Gallery, 2014).
2. Lucy Lippard (1937) has too many books to list here, among them: *Mixed Blessings* (1990), *Undermining* (2006), and *Seeing Through the Seventies: Essays on Feminism and Art* (2013). Her *Down Country: The Tano of the Galisteo Basin, 1250–1782* (2010) will be of interest to readers willing to explore a fascinating and little-known area of New Mexico in a study as perceptive as it is exhaustive.

CHAPTER 7. *Leandro Katz:* The Catherwood Project

1. *Lunar Typewriter* (1978), chromogenic print in the collection of El Museo del Barrio, and *Lunar Alphabet II* and *Lunar Sentence II* (1978–1979), gelatin silver prints in the permanent collection of the Museum of Modern Art. Both museums are located in New York City.
2. *Proyecto para el día que me quieres y la danza de fantasmas* (*Project for The Day You'll Love Me and the Ghost Dance*) is a photographic project that documents the events around the 1967 capture and execution of Ernesto Che Guevara in Bolivia. Aside from its many gallery and museum showings, there is a 2010 book titled *The Ghosts of Ñancahuazú,* which includes a video of the half-hour film by Katz called *El día que me quieres.*

3. Juan Galindo (1802–1840) was born in Dublin, Ireland, and became an explorer and army officer. He went to Guatemala in 1827 and during that country's first civil war was wounded in battle. He stayed on, eventually becoming governor of the Guatemalan province of El Petén. This provided him with the opportunity of exploring many indigenous landscapes, including Palenque and Copán. He was not the first European to see these sites, but the first who considered the Maya an advanced civilization. Galindo wrote about his discoveries for *The London Literary Gazette* and the American Antiquarian Society, and it was these texts that convinced Stephens and Catherwood to undertake their journeys of exploration.

4. I have absolutely no indication of this from anything either man wrote, only my own intuition. I risk asserting it because I sense it in the way Stephens and Catherwood worked together.

5. Robert H. Webb, *Grand Canyon, A Century of Change: Rephotography of the 1889–1890 Stanton Expedition* (Tucson: University of Arizona Press, 1996).

6. This and all subsequent Katz quotes are either from *The Catherwood Project* website (http://www.leandrokatz.com/Pages/Catherwood%20Project.html) or from correspondence between Katz and the author over the years.

7. Leandro Katz and Jesse Lerner, "Writing with the Light of the Moon, A Conversation Between Artist and Poet Leandro Katz and Filmmaker Jesse Lerner," *Romance Philology* 73, no. 2 (Fall 2019): 531–46.

8. From a text first published in the Mexican magazine *Poliester* 3, no. 10 (1994). English translation by MR.

CHAPTER 8. *The Great Gallery and* Our History Is No Mystery: *Two Murals Across Time*

1. This chapter is an expanded version of a piece I wrote for *New Mexico Mercury*. It appeared in that online publication on July 12, 2013.

CHAPTER 9. *Gay Block Looks at People and Shows Us Who They Are*

1. Email to the author, November 30, 2020.

2. Ibid.

3. Ibid.

4. At six million dead, Jews were by far the greatest number of Nazi victims. But other groups—Roma, leftists, homosexuals, and those suffering from mental and physical disabilities—were also targeted.

5. Gay Block and Malka Drucker, *Rescuers: Portraits of Moral Courage in the Holocaust* was originally published by Holmes & Meier in 1992. The book

sold out, and a new redesigned edition was published in 2020 by Radius Books in Santa Fe. It was named one of the twenty best photography titles that year.

6. *Rescuers,* 10.
7. Conversation with the author, December 12, 2020.
8. *Rescuers,* 24–25.
9. Conversation with the author, December 12, 2020.
10. Email to the author, December 2, 2020.
11. Anne Wilkes Tucker, "Arles," *Wallpaper*, August 16, 2007.

CHAPTER 10. *Sabra Moore: In the Big Out There*

1. Email to the author, December 5, 2020.
2. Ibid.
3. *Heresies* was a feminist magazine published in New York City from 1977 to 1993. It was organized by the Heresies Collective. Each of the twenty-seven issues was collectively edited by a group of volunteers around a single topic: feminist theory, art, politics, patterns of communication, lesbian art and artists, women's traditional arts, violence against women, workingwomen, women from peripheral nations, and more. It was a major forum for feminist thinking. Initial members of the *Heresies* collective included Joan Braderman, Mary Beth Edelson, Elizabeth Hess, Ellen Lanyon, Arlene Ladden, Lucy Lippard, Marty Pottenger, Miriam Schapiro, May Stevens, and Sabra Moore.
4. Sabra Moore, *Openings: A Memoir from the Women's Art Movement, New York City 1970–1992* (New York: New Village Press, 2016), 35. Throughout the book, Sabra refers to the lover who abused her as "C."
5. Ibid., 41.
6. Ibid., 31–32.
7. Ibid., 32.
8. Sabra Moore, *Petroglyphs: Ancient Language / Sacred Art* (Santa Fe: Clear Light Publishers, 1997).
9. Moore, *Openings,* 1.

CHAPTER 11. *Jane Norling: Between Art and Activism*

1. In a letter from Picasso to Marius de Zayas, 1923.
2. Email to the author, December 7, 2020.
3. Email to the author, December 5, 2020.

4. Alfredo Rostgaard (1943–2004) was a leading Cuban graphic designer and artist. He contributed to Cuba's massive output of posters from the mid-1960s to the mid-1970s.
5. Diego Rivera (1886–1957), José Clemente Orozco (1883–1949), and David Alfaro Siqueiros (1896–1974) were the best known of the Mexican muralists. Their styles were markedly different, but they shared the progressive politics that emerged out of the Mexican Revolution of 1910 and a penchant for painting on large public walls. They created a renaissance in Mexican art that had an international impact.

CHAPTER 12. *Barbara Byers: Surviving in Art*

1. The Rapture is an eschatological concept held by some evangelical Christians. It concerns an end-time event when all Christian believers who are alive, along with resurrected believers, will rise into the clouds to meet the Lord.
2. The Posse Comitatus (from Latin for "power of the county") is a group of people mobilized by the conservator of peace—typically a sheriff—to suppress lawlessness or defend the county. The concept originated in ninth-century England simultaneous with the creation of the office of sheriff. The federal Posse Comitatus, quite literally, compelled all of the United States to accept the legitimacy of slavery. In an exhaustive study of lynching in Colorado, historian Stephen Leonard includes the people's courts, as well as possies that were led by sheriffs. Historical records link violent lawlessness and lynching to Posse Comitatus. The group has gone underground and continues to exercise its power especially throughout the American West.
3. Asemic writing is defined as a wordless, open semantic form of writing. The word *asemic* means "having no specific semantic content," or "without the smallest unit of meaning." It has been practiced in different styles for many years.
4. *Beneath a Trespass of Sorrow* (2014) and *Bodies / Shields* (2015), both published by Wings Press, San Antonio, TX, and *Into Another Time: Grand Canyon Reflections* (Albuquerque, NM: West End Press, 2004).

About the Authors

About Margaret Randall

Margaret Randall is a feminist poet, essayist, oral historian, translator, photographer, and social activist; she is the author of more than 150 books. In 2019, she received the Haydée Santamaría medal from Casa de las Américas in Cuba and the Poet of Two Hemispheres prize from Ecuador's Poesía en Paralelo Cero. In 2018, she was awarded the Medal of Literary Merit by Literatura en el Bravo, Chihuahua, Mexico. The University of New Mexico granted her an honorary doctorate in letters in 2019. In 2020, she was given the George Garrett Award by the Association of Writers & Writing Programs and the Paulo Freire prize by Chapman University.

Born in New York City in 1936, Margaret lived for extended periods in Albuquerque, New York, Seville, Mexico City, Havana, and Managua. Shorter stays in Peru and North Vietnam were also formative. In the 1960s, with Mexican poet Sergio Mondragón, she founded and for eight years coedited *El Corno Emplumado / The Plumed Horn,* a bilingual literary journal that published some of the most dynamic and

meaningful writing of the era. From 1984 through 1994, she taught at a number of U.S. colleges and universities, most often at Trinity College in Hartford, Connecticut.

Randall was privileged to live among New York's Abstract Expressionist artists and Beat and Deep Image poets in the 1950s and early 1960s, participate in the Mexican student movement of 1968, share important years following the Cuban Revolution (1969–1980), the first three years of Nicaragua's Sandinista project (1980–1984), and visit North Vietnam during the heroic last months of its war with the United States (1974). Her four children—Gregory, Sarah, Ximena, and Ana—have given her ten grandchildren and two great-grandchildren. She has lived with her life partner, the painter Barbara Byers, for the past thirty-five years. When marriage equality became legal in a number of states in 2013, they were able to marry.

Upon Margaret's return to the United States from Nicaragua in 1984, she was ordered deported when the government invoked the 1952 Immigration and Nationality Act (the McCarran-Walter Act), judging opinions expressed in some of her books to be "against the good order and happiness of the United States." The Center for Constitutional Rights defended her, and many writers and others joined in an almost five-year battle for reinstatement of citizenship. She won her case in 1989.

Recent nonfiction books by Margaret include *To Change the World: My Life in Cuba* (Rutgers University Press), *More Than Things* (University of Nebraska Press), *Che on My Mind, Haydée Santamaría Cuban Revolutionary: She Led by Transgression*, and *Exporting Revolution: Cuba's Global Solidarity* (all from Duke University Press). She edited, translated, and wrote the introduction to *Only the Road / Solo el camino: Eight Decades of Cuban Poetry* (Duke), and has translated several dozen other books of poetry, fiction, and memoir from the Spanish.

Margaret's most recent poetry collections are *As If the Empty Chair: Poems for the Disappeared / Como si la silla vacía: poemas para los desaparecidos* (2011), *The Rhizome as a Field of Broken Bones* (2013), *About Little Charlie Lindbergh and Other Poems* (2014), *She Becomes Time* (2016), *The Morning After: Poetry and Prose in a Post-Truth World* (2017), *Against Atrocity* (2019), *Starfish on a Beach: The Pandemic Poems* (2020), and *Out of Violence into Poetry* (2021), all from Wings Press. Several of these books also have bilingual Latin American editions.

Among Margaret's latest titles are her memoir, *I Never Left Home: Poet, Feminist, Revolutionary* (Duke), and *My Life in 100 Objects* (New Village Press), both out in 2020. In 2021, her book *Thinking about Thinking* (Casa Urraca Press, Pueblo de Abiquiu Library , New Mexico) was published.

About Mary Gabriel

Mary Gabriel is the author of *Ninth Street Women, Lee Krasner, Elaine de Kooning, Grace Hartigan, Joan Mitchell, and Helen Frankenthaler: Five Painters and the Movement That Changed Modern Art.* Her previous biography, *Love and Capital: Karl and Jenny Marx and the Birth of a Revolution,* was a finalist for the Pulitzer Prize, the National Book Award, and the National Book Critics Circle Award. Earlier books include *Notorious Victoria: The Life of Victoria Woodhull, Uncensored,* and *The Art of Acquiring: A Portrait of Etta and Claribel Cone.* She is currently writing a biography of Madonna, entitled *Madonna Risen: A Feminist Tale.*

About Ed McCaughan

Edward J. McCaughan, emeritus professor of sociology at San Francisco State University, is a researcher, writer, and curator. He is the

author of *Art and Social Movements: Cultural Politics in Mexico and Aztlán*, among other books, as wells as dozens of articles, including most recently "'We Didn't Cross the Border, the Border Crossed Us': Artists' Images of the U.S.-Mexico Border and Immigration" (*Latin American and Latinx Visual Culture* 2, no. 1, 2020). He lives in Santa María Atzompa, Oaxaca, Mexico, with his husband, the painter John Kaine.